CALLED TO THE CAMERA

BLACK AMERICAN STUDIO PHOTOGRAPHERS

Called to the Camera: Black American Studio Photographers is organized by the New Orleans Museum of Art and is sponsored by Catherine and David Edwards; Kitty and Stephen Sherrill; New Orleans Tourism and Cultural Fund; Tina Freeman and Philip Woollam; Liberty Bank; the Del and Ginger Hall Photography Fund; the A. Charlotte Mann and Joshua Mann Pailet Endowment; Milly and George Denegre; Andrea and Rodney Herenton; and Cherye and Jim Pierce. Additional support is provided by Philip DeNormandie; Aimee and Michael Siegel; Kenya and Quentin Messer; L. Kyle Roberts; Beaucoup Eats; Mr. and Mrs. Nelson Alexander; Deena Sivart Bedigian; Sesthasak Boonchai; Kim Boyle; Mel Buchanan and Lance Dickman; Claire Elizabeth Gallery; Pia Z. Ehrhardt; Jacqueline and Randall Hithe and Family; Rayne Martin; Colleen Mullins; Chantell M. Nabonne; Stephen Rosenfeld and Margot Botsford; and Tod and Kenya Smith. This project is supported in part by the National Endowment for the Arts. Research for this project was funded by the Mellon Foundation and the Stuart A. Rose Manuscript, Archives, and Rare Book Library at Emory University.

EXHIBITION DATES
New Orleans Museum of Art
September 15, 2022 – January 8, 2023

PRODUCED BY
New Orleans Museum of Art
Laura Povinelli, Rights and Reproductions Manager
Sesthasak Boonchai, Digital Imaging Manager

DESIGN
Morcos Key

TYPOGRAPHY
GT Alpina

PRINTER
Meridian Printing, East Greenwich, RI

COVER IMAGE
Hooks Brothers Studio
Untitled [Hooks School of Photography Students Looking at Prints] (detail), ca. 1950
Gelatin silver print

Distributed by Yale University Press
302 Temple Street
P.O. Box 209040
New Haven, CT 06520-9040
yalebooks.com/art

Library of Congress Control Number:
2022943021

ISBN 978-0-300-26738-9
(Hardcover)

Note on Format: For ease of reading, life dates for artists referenced in the essays that follow can be found in the "Exhibition Catalog" at the rear of this volume.

CALLED TO THE CAMERA

Black American Studio Photographers

Brian Piper with
John Edwin Mason,
Carla Williams,
and Russell Lord

Foreword by
Susan Taylor

New Orleans Museum of Art
Distributed by Yale University Press
New Haven and London

NOMA
New Orleans Museum of Art

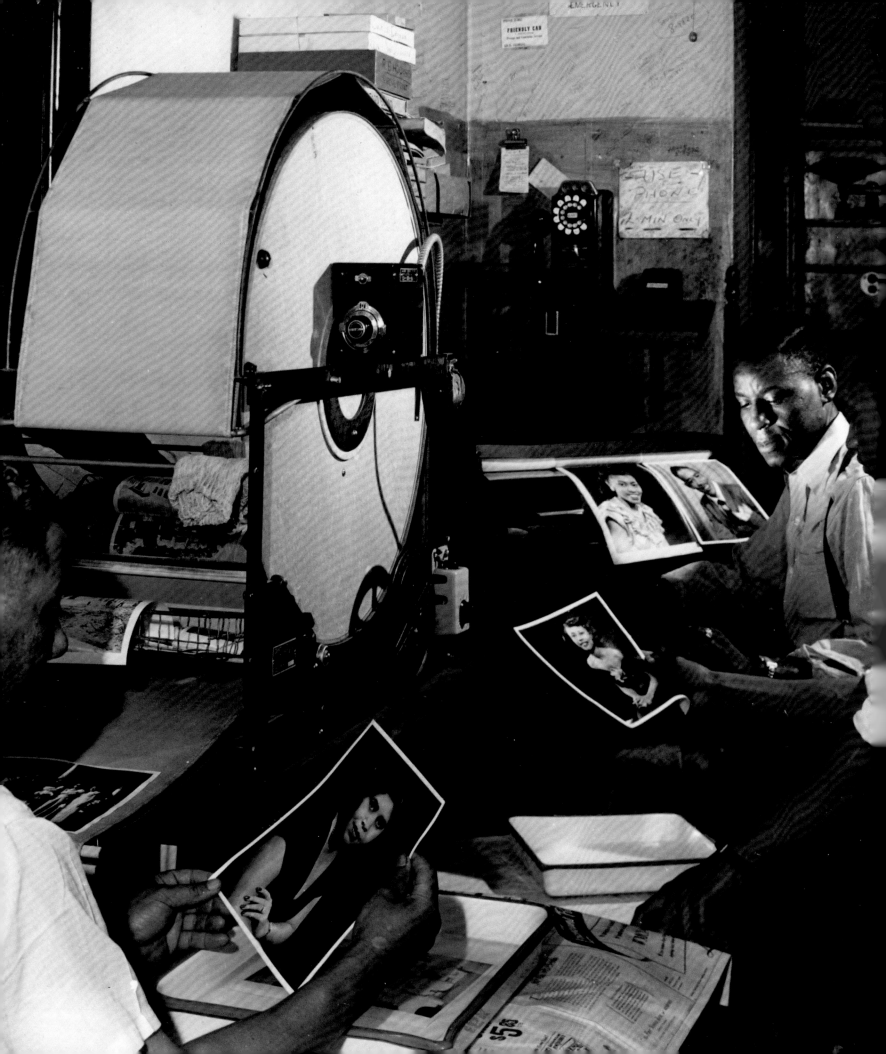

CONTENTS

Hooks Brothers Studio
*Hooks Photography School Students
at Print Dryer* (detail), ca. 1950
Gelatin silver print

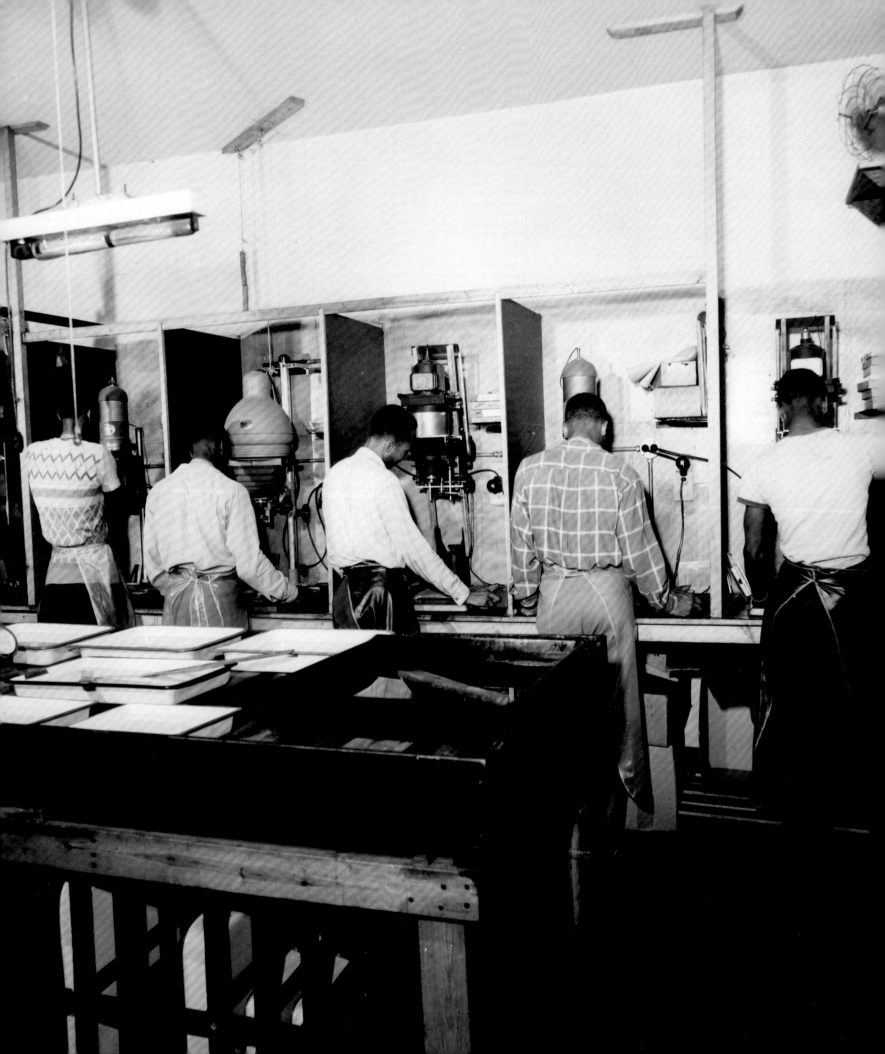

LENDERS TO THE EXHIBITION

Andrea and Rodney Herenton,
Memphis, TN

Bernard Dyer,
New Orleans, LA

Cincinnati Art Museum,
Cincinnati, OH

Cincinnati History Library &
Archives Cincinnati Museum Center,
Cincinnati, OH

Connecticut Historical Society,
Hartford, CT

The Elizabeth A. Burns
Photography Collection,
New York, NY

The Historic New Orleans Collection,
New Orleans, LA

The Jason L. Burns
Photography Collection,
New York, NY

Library of Congress,
Washington, DC

McDonogh 35 Senior High School,
New Orleans, Louisiana

The Metropolitan Museum of Art,
New York, NY

National Museum of African
American History and Culture,
Smithsonian Institution,
Washington, DC

Nolan A. Marshall, Jr.,
New Orleans, LA

Paulette Riley,
New Orleans, LA

Schomburg Center for Research in
Black Culture, New York Public Library,
New York, NY

The Stanley B. Burns,
MD Photography Collection,
New York, NY

Stuart A. Rose Manuscript,
Archives, and Rare Book Library,
Emory University,
Atlanta, GA

Xavier University of Louisiana,
Archives & Special Collections,
New Orleans, LA

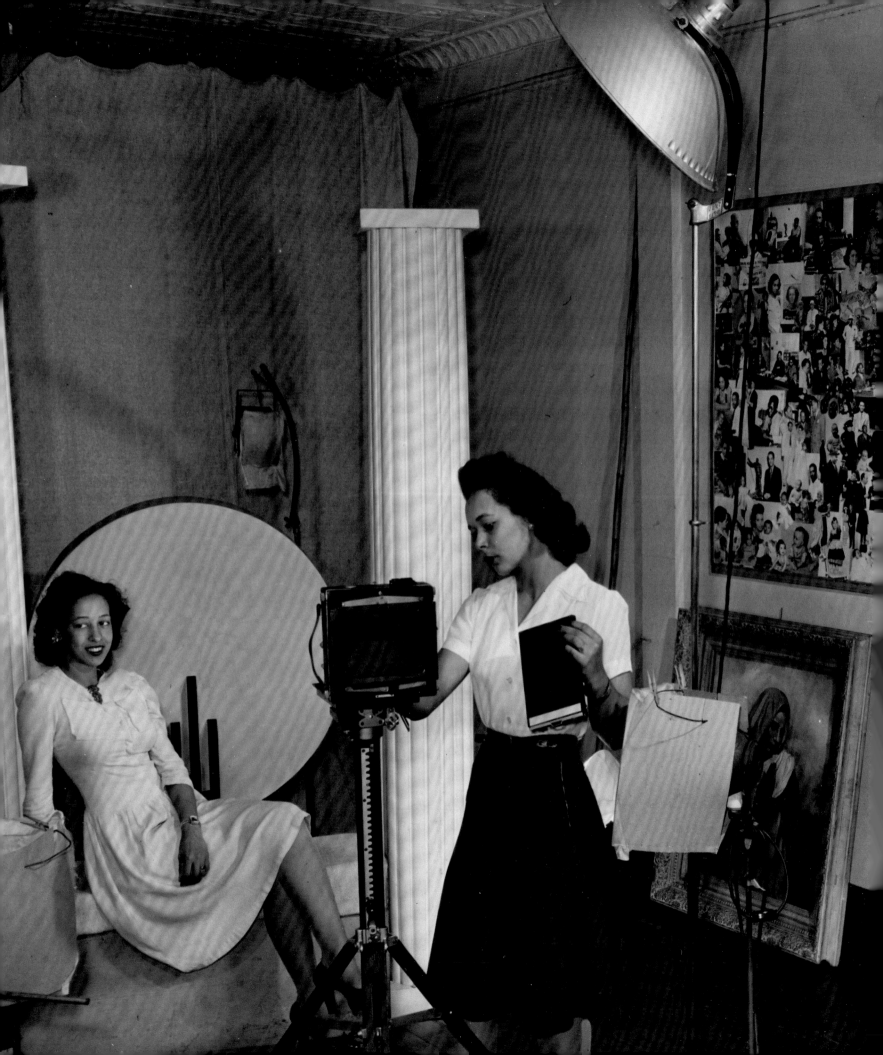

DIRECTOR'S FOREWORD

Susan M. Taylor

Montine McDaniel Freeman Director of
the New Orleans Museum of Art

The New Orleans Museum of Art has been exhibiting photographs for over a century, and collecting them for a half-century. In that time, the museum has built one of the nation's finest photography collections and has presented hundreds of exhibitions on topics as wide-ranging as war, healthcare, and climate change. Even within such a distinguished history of photography at NOMA, however, this exhibition is exceptional. *Called to the Camera* is the first major exhibition in any museum to consider exclusively a history of Black American studio photographers. As such, it represents a major step in the museum's long shift towards a more inclusive representation of photography. This is true in both the kinds of communities reflected in the works we present and in the different kinds of photographs we exhibit. Many of the beautiful objects included in this exhibition, for example, have long been excluded from the walls of major art museums, as a result of their commercial, or even, personal nature. And yet, it is through these kinds of works that we see most clearly the building of both a visual identity for Black Americans, and the development of their communities. In other words, in order to truly represent the diversity of this nation, we must, as this exhibition has done, challenge the prevailing notions of what and who belongs in an art museum.

In keeping with this spirit, both the exhibition and the book are the products of inclusive new processes with many different partners. Both would not have been possible without the input from a groundbreaking exhibition advisory group, the establishment of a new, accessible, exhibition funding level, and the enthusiastic participation of a number of individuals and institutions outside of the museum. I am grateful to the Wagner Foundation for their support of the exhibition advisory group that was convened to ensure that this show was fully informed. I am also grateful to Jonathan Key, Wael Morcos, and Chuck Gonzales of

Morgan and Marvin Smth
Untitled [One Model, One photographer working in studio, photocollage on wall] (detail), ca. 1945
Gelatin silver print

9

Morcos Key for designing the beautiful volume that you now hold in your hands, and to Jennifer Rittner for ensuring that the words within are equally sharp.

I would also like to acknowledge the great work that Russell Lord, NOMA's Freeman Family Curator of Photographs has done to lead the photography program at the museum and to create a base of support that can make such an ambitious project possible. Finally, special distinction is reserved for Brian Piper, curator of the exhibition, chief author of this catalog and a thoughtful and cheerful catalyst for the project overall. His scholarship on this topic began years ago, as the depth of his research demonstrates, but the great dedication, curiosity, and passion he has brought to this project suggests that his work on the subject is far from over.

Austin Hansen
Morgan Smith, Standing on a Lightpole, ca. 1942
Gelatin silver print

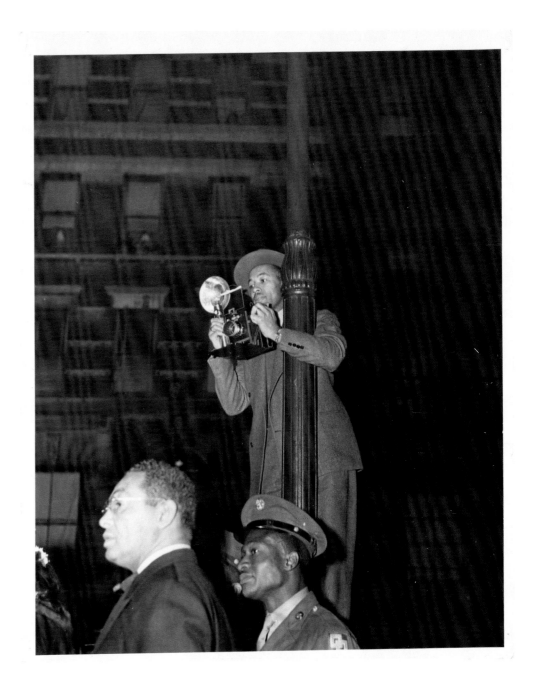

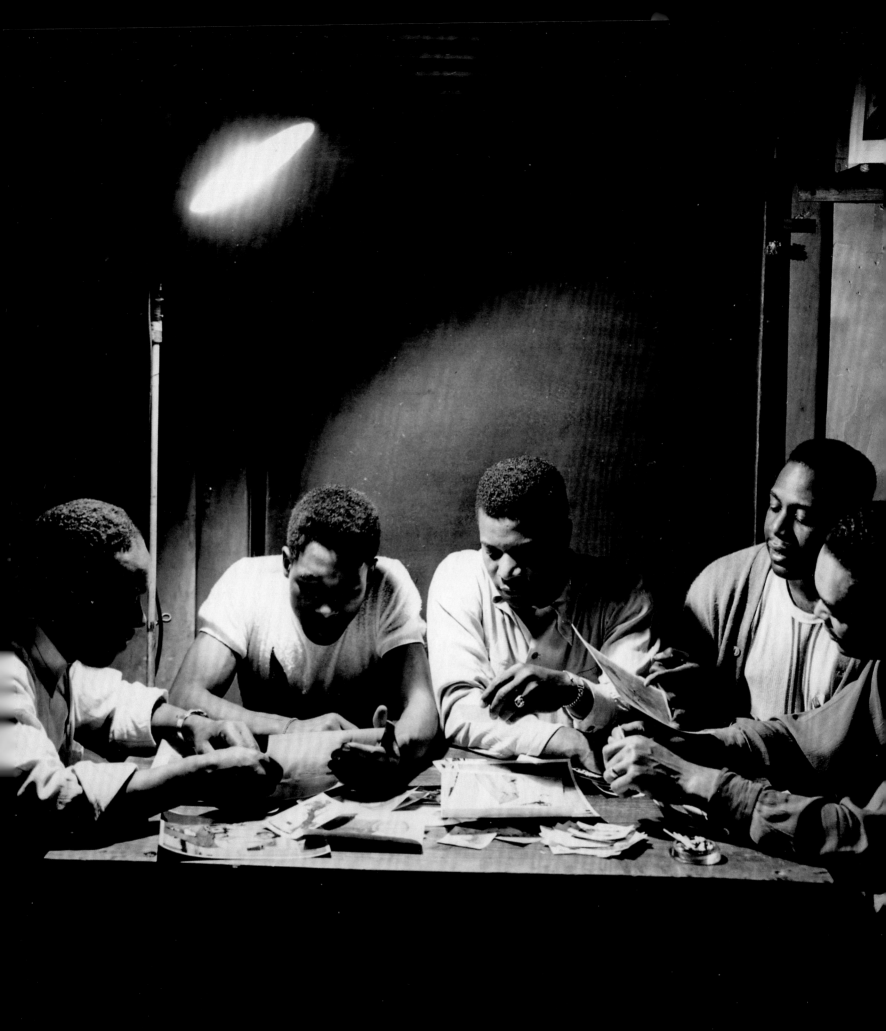

INTRODUCTION

Russell Lord

Gathered around a table, dramatically lit with a standing studio light, five Black men pour over a collection of loose photographic prints. The men are students at the Hooks Brothers school in Memphis, a studio photography training ground established after WWII when GI Bill funds supported tuition for returning veterans' education. An ashtray, overflowing with cigarette remnants and ash, occupies a corner of the table, evidence of a lengthy session of looking. The photograph is carefully composed to include not only the very human practice of sharing and discussing photographs, but also hints at the production of photographs, where they come from, and where they might be going. The scene is lit from the above left with a studio lamp, a dramatic reminder of the place of origin for photographs, and up in the right-hand corner on a shelf is a framed portrait, presented the way that any photograph might be when it reaches its final place in someone's home. With its equal attention to photographers and photographs, this one photograph articulates all of the central tenets of *Called to the Camera*: looking and making, labor and education, the individual and the collective, devotion and joy. What is more, the photograph both illustrates these things while simultaneously offering us an experience of those things: we are looking at the act of looking and learning about the process of learning.

Looking and learning from photographs is more important than ever. In a world where communication and education increasingly revolve around images of photographic origin, photographic or image literacy is one of the most important issues of our time. Once again, the Hooks Brothers image is relevant. We might, for example, consider how this photograph is an illustration of slow looking, how the simple act of leafing through physical objects increases the amount of time one spends considering an image. This kind of looking is also an active process, invoking levels of curiosity, inquisitiveness, and perhaps most importantly, skepticism, an antidote to the all-too-common passive enterprise of scrolling through (or past) photographs in digital streams. If we look as thoroughly at this picture as the students do at

Hooks Brothers Studio
Untitled [Hooks School of Photography Students Looking at Prints] (detail), ca. 1950
Gelatin silver print

theirs, we might also begin to consider how this is a photograph about photography, yes, but also about the history of image making, with its theatrical studio lighting and closed-frame action reminiscent of centuries of religious painting, a fitting analogy for a project whose title invokes ideas about cultural and spiritual callings.

The important point here is that this and every photograph belongs to multiple 'histories' and that in order to embrace all of them, as institutions we must reconsider the often very exclusive boundaries that still govern the bulk of museum photography acquisitions, exhibitions, and programs. Over the past decade, the Department of Photographs at the New Orleans Museum of Art has been building its capacity to originate a project like this one, a process that includes not only practical elements such as adding knowledgeable staff, creating personal and institutional relationships, and seeking out grants and funding sources, but also more conceptual elements like shifting capacity to understand the many different histories of photography and how and why they belong in an art museum. To this point, Brian Piper explains within these pages how the photographs included in this volume can be both typical and exceptional and how the labor behind these photographs, and their commercial purpose, do not reduce their importance as both cultural objects and beautiful images. This might seem obvious to many, but it is still not thoroughly integrated into the practice of many art museums. As further evidence, consider that this volume accompanies the first major exhibition to address this subject and that many of the works included still come from libraries, historical societies, archives, and private collections. *Called to the Camera* therefore represents a new beginning, the start of a journey to more fully integrate these histories into museum practice. It is, like the Hooks Brothers school photograph, full of promise for what we might create together. Let us all consider it a calling.

Hooks Brothers Studio
Untitled [Camera Room], 1947
Gelatin silver print

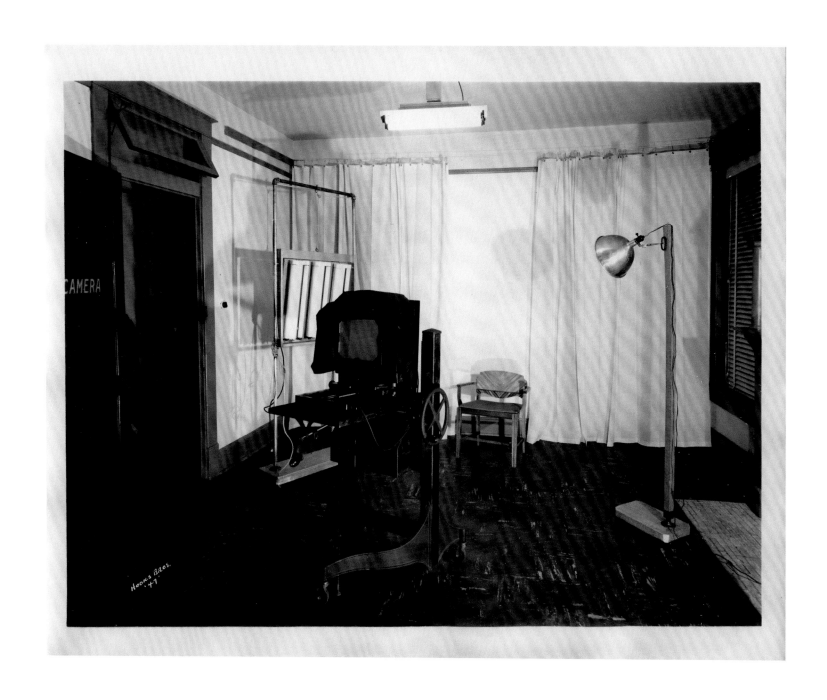

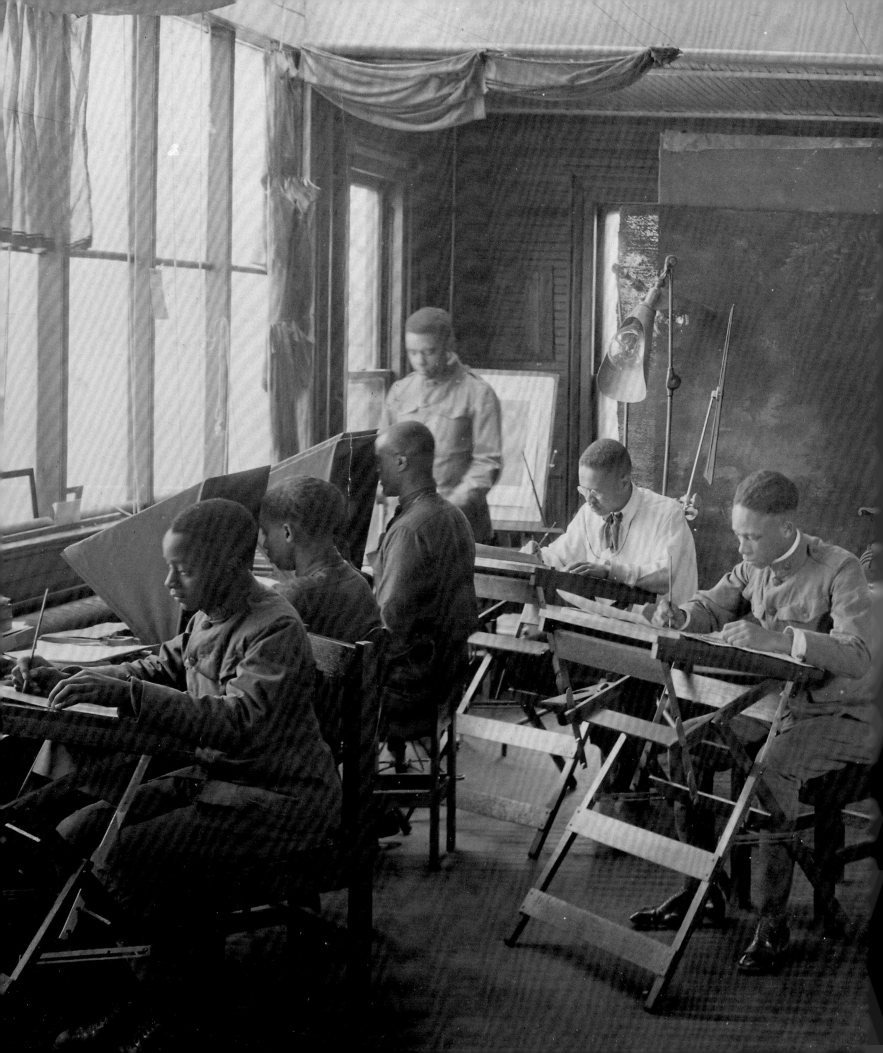

"WHERE THERE'S BEAUTY WE TAKE IT AND WHERE THERE'S NONE WE CAN MAKE IT:" THE WORK OF BLACK AMERICAN PHOTOGRAPHY STUDIOS

Brian Piper

When Cornelius M. Battey arrived in Alabama in 1916 as the new Director of the Photographic Division at the Tuskegee Institute he began arranging the school's photography studio to his liking. Battey had already achieved some renown as a photographer in New York and had owned a series of portrait studios bearing his name.[1] The photographer apportioned his new room in a similar way, full of the equipment and tools we see in this photograph: bulky, hooded cameras on wheels capable of holding large glass plate negatives, fancy posing furniture, a large reflective light diffuser, and shelves packed with dusty albums and manuals. Outside of the frame are the jugs of caustic chemicals, stained aprons, and darkroom trays for developing and printing. Battey's appointment represented something new for the photographer in that it provided some financial stability and the material resources to make photographs exactly the way that he wanted. Battey, like many Black photographers of his generation, favored highly stylized portraits that required complicated processes for printing and finishing, an aesthetic that had initially endeared Battey's work to Tuskegee founder Booker T. Washington.[2] Presumably, Battey made the photograph to the left because he had achieved his ideal conception of a photography studio, a space for the making of portraits by and for Black Americans.[3]

This specific studio space was new for the photographer in another way because it also served as a classroom. Washington had long envisioned a photography department at Tuskegee to train and professionalize generations of photographers. That dream had not yet come to fruition when Washington passed away in 1915, but Battey

Attributed to Cornelius M. Battey
Tuskegee Institute Photo Studio (detail), ca. 1920
Gelatin silver print

took up the charge when he arrived the next year. Here, we see that mission embodied by six young students hard at work. Most likely, at this moment these students were retouching negatives, spot-correcting prints, or hand-painting them in color, some of the finishing steps expected for high-quality studio portraits. Clearly staged, this image suggests that becoming a fine portrait photographer was a complicated journey requiring artistic talent, attention to detail, business acumen, strong interpersonal skills, and especially the mastery of many specialized techniques and processes. This photograph visualizes the kind of space - workroom, classroom, studio - where young photographers learned to record beauty but also to manufacture its expression.

Battey hung two photographs on the studio wall, illustrating for his students, and now us, some of what was at stake for an emerging Black photographer (see plate 51). Battey's own crisp portrait of Washington, the tuxedoed, resolute leader looking into the future, hangs at the far right. Next to the 'Wizard of Tuskegee' hangs a softly focused photograph, also possibly by Battey, of an older, bearded man in a rumpled suit and hat, perhaps a rural neighbor of Tuskegee. That picture may strike us as a stereotype today, but Battey understood that style of photograph as a romantic ideal rather than a derogatory convention. For Washington - as for Battey - photographs offered the ability to control one's own representation, but the practice of photography also became an imperative for its capacity to counter a white visual culture that was degrading and violent in its representations of Black people. Washington saw value in both types of photographs–the heroic, celebratory, and specific portrait as well as the idealized, artful, but generic representation–and used both in equal measure for different audiences, according to their politics and his own goals.[4]

In their future careers as photographers, these young students would make similar choices about what kinds of photographs they wanted to produce and how their communities would be represented going forward.[5] In this sense, the importance of the scene photographed here, of the origins of future image-makers, cannot be overstated. While becoming a photographer involved exacting and repetitive work familiar to many professions, it also meant an assumption of significant responsibility for young Black students like these. In the course of fulfilling this responsibility, Black studio photographers elevated photography from a vocation to a creative and professional calling. This picture is, therefore, a perfect beginning for a project that focuses both on the making and content of Black photography.

Called to the Camera: Black American Studio Photographers recasts the familiar arc of American photographic history by putting those very photographers, and their clients, at the center of that narrative. This exhibition and catalog consider how professional portrait photographs provided an essential means of representation and discovery for Black

Americans for much of photography's history. The project focuses on the daily work of the Black men and women who made those photographs to amplify that population's contributions to the history of photography. It carefully considers how and why these photographs were made, and for whom but without reducing them to commercial, conventional, or "everyday" products. Instead, *Called to the Camera* argues that a photograph can be both typical and spectacular at the same time.

Another important aspect of this project is the articulation of the spaces in which photographs were made. Many of these images remind us how special visiting a fine photography studio could be during the first half of the twentieth century. They illustrate that these were spaces conceived by the photographers to meet the specific needs and desires of Black people. Other images demonstrate how Black studio photographers produced a wide variety of work, created both inside and outside the physical walls of their businesses. All of these photographs were generative: of Black culture and American history, to be certain, but also of photography as we understand it today. As much as this exhibition is about the content of the photographs that follow, it is also about the photographers themselves, their working lives, and the world their photographs made.

The full story of *Called to the Camera* actually begins not with C.M. Battey, but in the first moments of photography itself. Shortly after the introduction of the daguerreotype in America in 1839, a small number of Black Americans began to make and sell daguerreotypes in businesses that initially were called "parlors" or "galleries" - represented here by names like Augustus Washington (American-Liberian, ca. 1820-1875), James Presley Ball (American, 1825-1904), Alexander S. Thomas (American, 1826-1910), James C. Farley (American, 1854-ca. 1910), and The Goodridge Brothers (American, Glenalvin Goodridge, 1829-1867, Wallace L. Goodridge, 1840-1922, William O. Goodridge 1846-1890). This first generation of Black photographers, were among the most successful Black photographers of the nineteenth century; and were also among the first people defining what photographic portraiture in the United States looked like and what the experience of visiting a photography studio entailed. During the same period, both free and enslaved Black Americans understood photography's importance and engaged with cameras in a variety of ways.[6]

The numbers of Black photographers grew in the first decades of the twentieth century behind a variety of factors that included migration to urban centers, a concentration of Black spending power and rise in Black-owned businesses, more widespread training and accessible equipment, and the aforementioned demand for affirmative images.[7] Recounting the names and work of every Black American working in photography studios during this period lies beyond the scope of this single volume. It *is* this book's goal, however, to highlight works by some

of the most consistently successful men and women operating their own portrait studios during the first one hundred and twenty years of photography in the United States. They pursued their trade in every region – in far more cities and towns than are represented here - and built professional networks that connected across the country. Often, Black professional photographers found themselves competing in a crowded marketplace against both Black and white photographers.

For many of these photographers, portraiture constituted the majority of their work, primarily in some kind of "brick-and-mortar" studio setting (fig. 1). While these portraits could be, and have been, described as "everyday," "vernacular," or derisively as "mundane," placing a wide array of these portraits together and reading them alongside each other illustrates the extent to which Black studio photographers produced a rich variety within some expected parameters. In 1909, Washington, D.C. photographer Addison Scurlock (American, 1883-1964) advertised his work as, "Photographs just a little different," a claim that hinted at his ability to make a unique likeness, only slightly outside of what Black Washingtonians had come to expect.[8]

The photographers included in *Called to the Camera* also produced a remarkable array of other kinds of photographs in the course of their careers. While personal cameras, snapshots, and photo albums proliferated in Black communities after Kodak introduced their first camera in 1888, the demand for professionally produced photographs remained steady and, in some ways, grew. As Black Americans built and expanded social organizations, commercial enterprises, and collective institutions, those groups wanted professional photographs to document and celebrate their activities (fig. 2). After 1930, growth of the Black-oriented newspapers and picture magazines created a steady need for images to fill their pages. In addition to portraits, Black studio photographers met all of these "outside" needs on freelance, contractual, and occasionally, speculative bases.

Regardless of their impetus, these photographs demonstrate how in step their makers were with aesthetic developments in photography on the whole, including movements like pictorialism and modernism. In the process, the photographers collected here turned their practiced skill and sophisticated eye outwards from their comfortable portrait rooms, demonstrating their ability to work across genres like documentary, advertising, fashion, and journalism. The work that photographers in *Called to the Camera* made outside of the studio is nearly as vast as their interior portrait practices. They form an important part of their legacies as working artists, and contributions to the field of photography as we continue to understand it. The legacy of these historically important photographers and their works continue to resonate today. *Called to the Camera* includes work by a number of contemporary photographers whose work reflects upon, refracts, or otherwise turns our

Fig. 1
James Van Der Zee
The Guarantee Photo Studio, ca. 1920
Gelatin silver print

Fig. 2
Hooks Brothers Studio
Untitled [Crowd on Embankment], ca. 1915
Gelatin silver print

Fig. 3
Jules Lion
Daguerreotype portrait of young
African American woman, 1850–1856
Daguerreotype, Ninth-plate
The Historic New Orleans Collection,
2021.0080

The beginnings of Black photography in this country proceeded in much the same way as photography's invention: a story of multiple people taking up cameras at the same time, sometimes independently, sometimes in partnership, and sometimes in competition. Instead of identifying a single originator, it seems more fruitful to speak of a first generation of Black American photographers. For some time, New Orleans lithographer Jules Lion (American, born in France, c. 1809–1866) has been acknowledged as the first person of African descent to practice photography, although recent scholarship has called into question his racial identity.[9] We do know, however, that Lion was one of the first photographers, regardless of race, to photograph Black sitters in this country (fig. 3). Other individuals included in this first generation of Black American photographers were largely born-free, primarily operating in the North. Glenalvin Goodridge (whose father had been enslaved) began as a daguerreotypist in York, Pennsylvania, and specialized in ambrotypes (a direct positive process on glass that produced a unique object), before relocating to Saginaw, Michigan with his brothers William and Wallace Goodridge. Born in Virginia in 1825, James Presley Ball first learned the daguerreotype process in Virginia from another free person of color, John B. Bailey of Boston, prior to 1845. After working as an itinerant photographer, Ball found his first permanent address and success in Cincinnati, Ohio; and for a time, he operated a gallery with his brother-in-law Alexander S. Thomas, originally from Louisiana (plate 3).

Ball became one of the first Black American photographers to achieve national recognition. Ball's "Daguerrian Gallery of the West" became a foundational space in American portrait photography, and an example of expectations for an elite photography studio. An 1854 profile of the gallery in *Gleason's Pictorial Drawing Room Companion*, described Ball's business as occupying the three top floors of a building, with multiple workrooms, and an 800 square foot gallery.[10] Often called "parlors" during photography's first decades, urban photography studios occupied the upper floors of buildings, in order to take advantage of natural light. Street-level displays of images under glass drew potential clients up several flights of stairs to have their portraits made. As a first impression, even the decoration of the staircase proved important for "characteriz[ing] the caliber of the establishment."[11] Customers then passed through the reception room to another sitting area where attractive objects served the "special role of inducing the sitter to relax, unwind, and prepare a self-image."[12] Should any noise drift up from the street a piano was on premises to drown out distractions and further soothe clients. Photographers of Ball's class intended their establishments to be oases, free from notions of work and toil, even as they engaged explicitly in commerce. At a proper

parlor like Ball's, the actual labor of photography was hidden from the sitters, who never saw those responsible for the finished product. Owing largely to population demographics in Cincinatti at the time, a majority of the portraits that Ball and his peers made before the Civil War were for white sitters.

Born a free person of color in Trenton, New Jersey in 1820, Augustus Washington learned to make daguerreotypes to support himself while a student at Dartmouth College. Leaving school early due to the financial burden, Washington relocated to Hartford, Connecticut, where he made portraits for white subjects, around 1846 (fig. 4). Only after migrating to Liberia with the American Colonization Society in 1852 did Washington consistently or exclusively focus his lens on Black people, including prominent emigrés like the family of Urias McGill (plates 4 and 5). Washington's photographs of Black American emigrés in Liberia testify to the belief held by his sitters that Black Americans could not live freely in the United States. After Reconstruction, as white Americans hardened and codified racial segregation, Black studio photographers made fewer and fewer portraits for white sitters, although there were always exceptions (fig. 5).

Fig. 4
Augustus Washington
Sarah Taintor Bulkeley Waterman, ca. 1850
Daguerreotype, sixth-plate

During the nineteenth century, famous Black Americans used photographic media as part of their efforts for social and political change. None did so with more regularity than Sojourner Truth and Frederick Douglass.[13] To finance her speaking tours, Truth sold cabinet cards and cartes-de-visite bearing her portrait, often imprinted with the phrase "I sell the shadow to support the substance." In an 1863 portrait Truth poses with a daguerreotype of her grandson, demonstrating her engagement as a consumer of photography, as well as its subject (fig. 6). Considered the most photographed American of the nineteenth century, Douglass continually used photography to visually demonstrate idealized qualities of self-possession and achievement. Over the course of his lifetime, Douglass shifted the way he presented himself in portraits – from militant young man, to esteemed civic leader, to elder statesman – in accordance with his stature and political goals (fig. 7). During his lifetime, Douglass is known to have sat for four Black photographers, including James Presley Ball (plate 9).[14]

Many sitters whose names have been lost to history also sat for portraits. This includes enslaved people who were photographed against their own will, as in the case of common portraits of enslaved caregivers (fig. 8). Nevertheless, there is growing evidence of enslaved people seeking out photographers of their own volition, which we might define against these other examples.[15] In their study *Envisioning Emancipation: Black Americans and the End of Slavery*, Deborah Willis and Barbara Krauthamer illustrate many of the ways that Black Americans used photographs to document their freedom around the period of the Civil War, including as records of their military service (plate 8). During

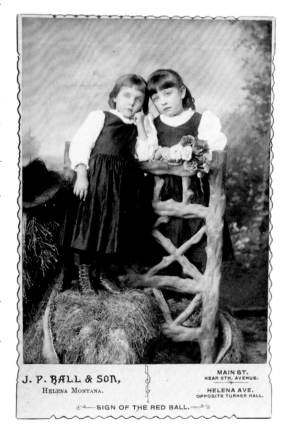

Fig. 5
J.P. Ball & Son
Two Young Girls, 1891-1900
Collodion printing-out paper on cabinet card

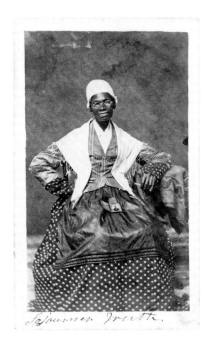

Fig. 6
Photographer unidentified (Battle Creek Michigan)
*Sojourner Truth [seated with a photograph of her
grandson, James Caldwell of Co. H, 54th
Massachusetts Infantry Regiment on her lap]*, 1863
Albumen print on carte-de-visite
Library of Congress, Washington, DC

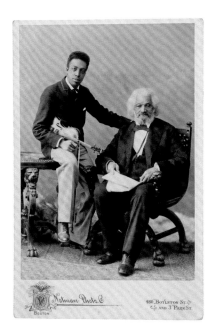

Fig. 7
Notman Photo Company, Denis Bourdon
*Frederick Douglass with his grandson,
Joseph Douglass*, 1894
Albumen print on cabinet card
Collection of the Smithsonian National Museum of
African American History and Culture, Gift of Dr.
Charlene Hodges Byrd, A2010.26.29.8.1

Reconstruction, photography enabled Black Americans to reconnect or stay connected across long distances, and articulate their newly achieved freedoms. While Black sitters often had to visit white photographers to have their portraits made, in the 1880s and '90s there were increasing opportunities to procure photographs from Black camera workers like James C. Farley, who managed the Richmond Photograph Company (plate 12).

Farley, like his peers, primarily made straightforward, sharply defined portraits adorned with props like furniture, books, or heavy curtains, false columns, and pastoral backgrounds meant to signify the middle-class status (or aspiration) of the sitter. Throughout the nineteenth century, Black and white Americans used portrait photographs to reify hierarchies of race and gender, using the visual markers of middle-class domesticity.[16] For Black Americans, portraits also worked against prevailing uses of photography by early pseudo-scientific racists to sort people into classes of racial and criminal "others," using photographs as "evidence" of fixed racial hierarchies. This was the case with researchers like Louis Agassiz, who famously commissioned daguerreotypes of enslaved people, and with photographers working for government organizations who were tasked with categorizing peoples as 'types' defined by generalized physiognomy, rather than individualized expression.[17] Middle-class portraits included a standard selection of the elements described above, or the adoption of a side-long pose, to suggest both the status and interior psychology of the sitter (fig. 9). For Black Americans during this period, a fine portrait could be both a refutation of the racist order, and a way to assert one's place in a different set of hierarchies. Still, during the same period, Black sitters also paid for photographs that suggest a variety of class identities, and the full story behind many of these images still remains a mystery to be explored. For instance, tintypes were so popular, so rapidly produced, so accessible, and so plentiful, they were often sold without any reliable attribution to maker or subject. Many come to us that way now, through history, as anonymous portraits. (See, for instance, plates 18 and 19).

As the twentieth century began Black leaders leveraged photographs to support or achieve their goals, taking advantage of faster camera technologies and better printing to circulate photographs more widely. Ida B. Wells-Barnett used her own portraits to demonstrate her education and refinement, and reappropriated photographs of lynchings as evidence of the perniciousness of white supremacy. In 1900, W.E.B. Du Bois organized a gargantuan photographic undertaking for the American Negro Exhibit at the 1900 Paris Exposition with the help of Atlantan Thomas Askew (fig. 11). Du Bois routinely published work by Black portraitists in *The Crisis*, including Battey, Scurlock, and others.[18] In the 1920s, Jamaican-born Marcus Garvey selected James Van Der

23

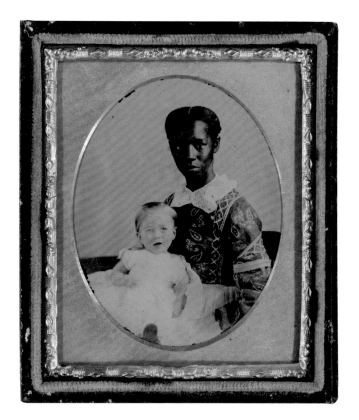

Fig. 8
Photographer unidentified
Caregiver with child, ca. 1860
Ambrotype, sixth-plate

Fig. 9
Photographer unidentified
*Untitled [Woman playing
tabletop instrument]*, ca. 1880
Tintype, sixth-plate

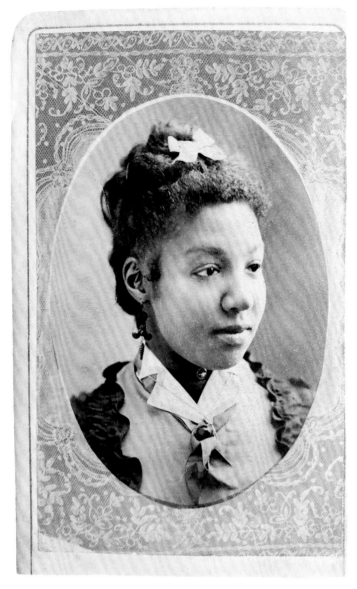

Fig. 10
Ball & Thomas Photographers
Mattie Allen, ca. 1874
Albumen print on carte-de viste

Fig. 11
Thomas E. Askew
Portrait of J.D. Rice, 1912
Gelatin silver print on card mount

Zee to provide official photographs for Universal Negro Improvement Association (UNIA), including grand spectacles of street demonstrations but also small portrait prints that could be given to supporters (plate 68).[19] All of these figures publicly made photography a central part of their strategies to demand freedom for Black people.

Although their politics and methods differed, the photography enthusiasts (and photographers) listed above shared what historian Kevin Gaines describes as "an intense concern with projecting a positive image," and desired "studio portraits of uplift and respectability – depicting Black families with attributes of cleanliness, leisure, and literacy [that] found expression in the sitters' posture, demeanor, dress and setting."[20] Most of the twentieth century portraits in *Called to the Camera* display these and other visual codes of middle-class "respectability." While celebrating portraits like these as a "political instrument, a way to resist misrepresentation," bell hooks reminds us that for all of their potential to liberate, professional portraiture also had great potential to reinscribe hierarchies of gender, class, and color, even in photographs made by Black studio photographers.[21]

Still, Memphis Judge D'Army Bailey, described the relationship between portraits and respectability politics another way, stating that,

> *We weren't sending messages to white people. We were sending messages to each other, sharing evidence of our vision of ourselves to our friends and family and carrying those visions forward to prosperity...photography provided an extension of ourselves at our best.*[22]

Judge Bailey had his photographs made by at least two of the studios in this exhibition, those of Ernest Withers and the Hooks Brothers: Robert and Henry (and later, Charles). In doing so, as Bailey's summation makes clear, his main concern was that those pictures projected his understanding of himself to his community, other Black Memphians.

By and large, Black studio photographers shared the same class concerns and ambitions as their portraits conveyed. At the beginning of the twentieth century Black Americans viewed photography as a viable and even lucrative, career. In a 1902 column in *The Colored American Magazine*, W.W. Holland (although only an amateur himself) found photography "so interesting, inspiring and of such financial worth" that he urged young Black people, especially women, to pursue it with fervor.[23] Numerous photographers joined Booker T. Washington's National Negro Business League (NNBL) after it was established in 1900. Annual conference organizers regularly included photographers on the program to speak about their businesses. Daniel Freeman of Washington, D.C., addressed NNBL conventions three times between 1913 and 1917. Speaking on "Photography as a Business," Freeman boasted of his financial success and accumulation of a "studio building [that stood]

four stories high with sixteen rooms; hot water heat with four other valuable pieces of property. Paying taxes on about $30,000 worth of real estate in the District of Columbia... [and]two automobiles."[24] In Freeman's words, "the business of the studio is fully as important as the photographic end,"[25] in part because a demonstration of his own class status marked Freeman as a professional who understood the visual codes of respectability and could translate them into portraiture (plate 62). By acquiring a professional space of his or her own, and outfitting it with the markers of respectability, a photographer could further tie class-based ideas of racial progress, luxury, and pride to the act of sitting for a camera portrait.

Another member of the NNBL in Washington, D.C., Addison Scurlock described a value in his photography business that extended beyond profits. In 1909 Scurlock urged his peers to "possess a spirit higher than mere commercialism . . . We should feel that it is a civic duty to use every means to develop our business to the point where it will add in a national way to the community."[26] Scurlock understood his photography business to be a vehicle for his own success, and also as a way to improve the lives of his neighbors. Writing in *The Crisis* in 1923, W.E.B. Du Bois urged more "young colored men and women to take up photography as a career." Du Bois highlighted the twin motivations of "good incomes" and "excellent social service," pillars that Scurlock would have likely seconded.[27]

In the first years of the twentieth century, most Black photographers produced portraits like the straightforward example by Baltimore photographer Arthur Macbeth that can be seen in plate 20. In that image, photographer and sitter also carry some nineteenth-century portrait conventions forward - specifically the young woman's pose with her hand on the back of a chair, likely familiar to her from older portraits (fig. 12). MacBeth's customers desired sharply-focused and precisely-printed likenesses, so that a viewer could clearly read the subject's face and, so it was argued, their character. After the 1910s, thanks in part to a growing emphasis on design as part of everyday life, to the American arts and crafts movement, and the contemporaneous spread of pictorialist photography by amateur photographers, it became expected for professional photographers to demonstrate some artistic intervention within the portrait frame. Pictorialism emphasized the camera's artistic possibility, favoring natural settings and soft-focus to produce ethereal and emotionally evocative images. Historian Christian A. Peterson writes that when portrait photographers began to adopt pictorialist techniques, they manifested through relaxed poses, soft-focus and shallow depth of field, and elaborate finishing techniques like charcoal retouching or tinting of prints.[28] Ever on the cutting edge, Scurlock Studio letterhead touted another slogan in 1909: "Representative of Pictorial Photography."[29] While he rarely

Fig. 12
Photographer unidentified
Untitled [Woman in striped dress], ca. 1860
Tintype, hand-tinted

made landscapes or scenic photography - *Waterfront* (plate 73) being a notable exception - Scurlock readily incorporated some of these pictorialist visual devices into a trademark style that became colloquially known as "the Scurlock look," which remained popular in Washington long after pictorialism had gone out of fashion.[30]

The initial enthusiasm for pictorialism amongst Black photography customers might be traced to the opportunities the style offered to embellish the sitter's beauty. Battey's portrait of Margaret Murray Washington is a fine example of the photographer's technique, featuring a very shallow depth of field and delicate retouching of the sitter's face that soften lines and smooth out features (fig. 13). In a successful pictorialist work, the hand of the artist is evident in the embellishments added from negative to print, a reminder for the viewer of the labor that went into the picture. While other styles of portraiture included here could hide the evidence of the artist's intervention, they often required equal levels of work to produce the desired outcome. Single studio names could obscure entire teams of people behind the scenes, working at incredibly precise tasks like retouching imperfections in a negative, or applying delicate watercolors to gelatin silver prints.

Often, this studio work was done by women. In Houston, Texas A.C. Teal owned two studios. His wife Elnora Teal managed one branch while he managed a combination studio and photography school (fig. 14). Elnora Frazier and Juanita Williams, photographers in their own right, worked for the Teals during the 1940s in a number of capacities, including mixing chemicals in the darkroom, developing film, handling reception duties, loading cameras, setting up lights, and making and hand-tinting prints.[31] In all, Williams estimated that the Teals employed six to seven people consistently. In Washington, D.C., Mamie Estelle Fearing Scurlock left a teaching career to join her husband in what would become the family business. She scheduled appointments, ordered supplies, and acted as business manager who oversaw the day-to-day operation of the studio. In Columbia, South Carolina, Wilhelmina Peral Selina Williams first worked alongside her husband Richard S. Roberts in his studio from 1920 to 1936 (plate 29). Williams made portraits when needed, kept the books, and arranged dressing rooms and public areas of the studio. Her daughter Wilhelmina Wynn recalled to photographer Jean Moutoussammy-Ashe that Williams made her most important contribution by making sitters feel at ease because clients "had confidence in her and I think they were then able to be more relaxed when Dad would take pictures."[32] Although their work often fell along a gendered hierarchy, these women were no less important to the success of Black portrait studios (fig. 15).

Though less frequent, Black women did own photography businesses outright.[33] In New Orleans, Florestine Perrault Collins operated her studio at several locations beginning in 1920 (see plates 26 and 28).

Fig. 13
Cornelius M. Battey
Margaret Murray Washington, ca. 1917
Gelatin silver print

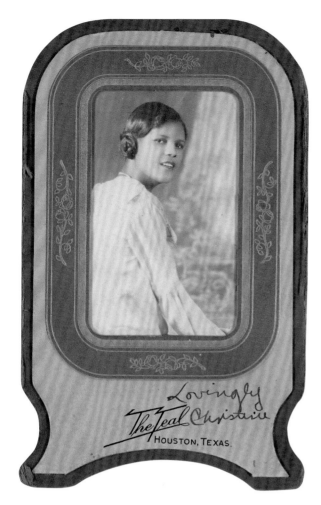

Fig. 14
The Teal Studio (A.C. Teal and Elnora Teal)
"Lovingly, Christine", ca. 1940
Gelatin silver print in card mount, inscription

Fig. 15
The Browns (Bessie Gwendolyn Brown
and George W. Brown)
Portrait of Nadine, ca. 1920
Gelatin silver print

Initially she received clients in her home living room to counter the objections of a husband who did not want her working outside of the home.[34] A few years later Collins moved into a mixed-use building, and then in 1934 moved the studio to the Black business district of South Rampart Street.[35] Still, her niece and biographer Arthe Anthony has stated that "the vast majority of [Collins'] work was confined to her studio" drawing a distinction between Collins' freedom to work outside of the studio with that of her male contemporaries."[36] Collins overcame those strictures to great success, becoming one of the most popular photographers in Black New Orleans and a direct competitor to Arthur P. Bedou, before she moved to Los Angeles in 1949 and retired from professional photography. Black women in a number of cities achieved similar success during the first half of the twentieth century.

To achieve and sustain that success, Black studio photographers often had to set themselves apart in competitive markets for portraits (fig. 16). In some places Black customers chose to patronize white photographers because of availability, affordability, or the perception of conferred status. Memphian Ernest Withers recalled when one woman told him that, "I don't need no neighborhood photographer. I'm not gonna dress my children up just to bring them right over here. If I dress my children up I'm gonna take them downtown to [white-owned] Blue Light."[37] This despite a common refrain that white photographers routinely misrepresented their likeness. W.E.B. DuBois lamented in the pages of *The Crisis* that,

> *The average white photographer does not know how to deal with colored skins and having neither sense of their delicate beauty of tone, nor will to learn, he makes a horrible botch of portraying them. From the South especially the pictures that come to us, with few exceptions, make the heart ache.[38]*

Du Bois went on to state that Black photographers could portray darker skin tones with nuance and beauty, name checking Scurlock, Battey, and Bedou.

Sensitively and realistically photographing a full range of skin tones was, for Black American studio photographers, a necessity on the job, and also a competitive advantage. In places with multiple Black photographers, the delicate portrayal of complexion constituted the baseline of necessary skill. Daniel Freeman stressed in 1915 that he had to work with "a variety of colors of faces, ranging from white, brown, black, etc., [and] many of these wearing white costumes which increase the contrast."[39] Decades later, Marvin Smith concurred that this was an important element of his success, because, "of course we come in various shades."[40]

SPECIAL OFFER CONTRACT

GOOD UNTIL USED. TRANSFERABLE.

A. P. BEDOU'S STUDIO
1707 BIENVILLE ST. PHONE MAIN 3853.
2 BLOCKS BELOW CANAL ST. TRANSFER TO CLAIBORNE CAR.

THREE FOR $1.50

By paying 50 cents for this contract, and $1.00 at the time of sitting, we will make THREE of our LATEST FINISH PHOTOS, same as sample shown. Satisfaction guaranteed. Only three Photos allowed on each contract at this price. Regular rates to those not having contract. Groups, 25 cents per person extra. Sittings at any time without appointment. Positively no contracts sold at Studio. These Photos can be had for 50 cents each if ordered when proofs are shown. The regular price of $1.00 at any other time.

Studio open 8 A. M. to 5 P. M. Sundays and Holidays 9 A. M. to 4 P. M.

(Signed) *A. P. Bedou.*

Special Representative's Signature..

REGULAR RATE $12.00 per DOZ. SPECIAL RATE $6.00 per DOZ.

MEADE & SAMPSELL, 528 GRAVIER. ST

31

Managing these concerns could be a particular challenge for Black photographers because for most of its history, photography's material technology has dramatically privileged whiteness. Film stocks, papers, chemical processes, and even digital technologies have been developed in ways that would optimize the light skin of the person imagined to be sitting for the photograph. Morgan Smith recalled of the 1920s and 1930s that, "most photographers who were photographing people of color, they had no color. You could see their lips and their eyes and their skin tones were not there, as far as I remember. In a sense it was sort of ghostly."[41] Lorna Roth also highlighted some of the most common issues faced by Black American consumers of photography: "reproduction of facial images without details, lighting challenges, and ashen looking facial skin colors contrasted strikingly with the whites of eyes and teeth."[42]

Prior to the 1960s, Black photographers could not look to published manuals or professional literature for solutions and learned through personal exploration and learning from their peers.[43] In oral histories collected by author Alan Govenar, several Texas photographers shared the different papers they preferred to print on. Louis Martin of Houston preferred Kodak papers and especially the "Charcoal Black" line because its high grain gave it a texture "like velvet," and "because with that paper [she] could make Black folks look prettier."[44]

One of the most important ways that Black photographers strove to overcome the bias built into photographic technologies was to learn to light their subjects proactively and effectively, either by amassing enough lights or learning how to arrange groups of people with varying skin tones in relation to the light source. That knowledge extended to sufficiently illuminating sitters' hairstyles. Morgan and Marvin Smith kept special spotlights "for high-lighting color and texture of the hair."[45] Robert Scurlock stressed the use of a designated "hair-light" or spotlight arranged above the sitter and aimed downward in order to "accentuate that shine texture and pattern of the hair" in his family's studio.[46] Given the deep and dynamic history of hair as a signifier of Black cultural and political identity, an understanding of how to represent their sitters' hairstyles properly marks another intervention that Black studio photographers made both in their communities and the history of photography.

Photographers could also control the outcome of their prints by retouching their negatives with pencils, altering the amount of light that passed through the negative when printing. Most often photographers used retouching to smooth out wrinkles, remove imperfections, or correct shading. Photographers could also use retouching to change the tone of a person's skin. For their part, Morgan and Marvin Smith claimed that they opposed heavily retouching skin tone and "making people look like they didn't look. We were very much against that....

Fig. 17
Morgan and Marvin Smith
Gordon Parks in the Smith Studio, ca. 1946
Gelatin silver print

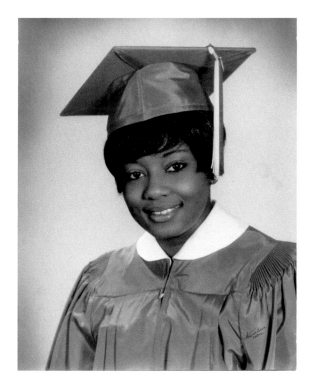

Fig. 18
Hooks Brothers Studio
Portrait of a Woman, Graduation, ca. 1965
Gelatin silver print

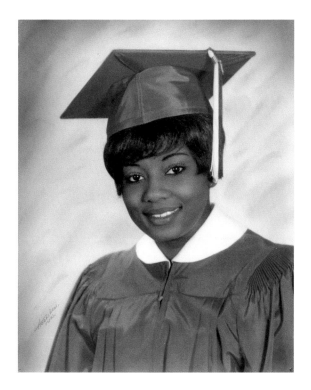

Fig. 19
Hooks Brothers Studio
Portrait of a Woman, Graduation, ca. 1965
Gelatin silver print, hand-tinted

We didn't do that."[47] Still, the M. Smith Studio engaged in retouching and a number of other steps that took place after the shutter clicked, and regularly employed young photographers, artists, and models to assist them. Hand-painting gelatin silver prints with watercolor or oil based pigments was another popular way to add a full range of color to sitters skin tones and clothing (figs. 18 and 19). These kinds of steps were a way for Black photographers to set their photography apart, as well as create value for their images.

Creating value constituted a part of Florestine Perrault Collins' success, as she offered a variety of photographic products at different price points, especially during the Great Depression. Collins sold a package of three 8x10 inch prints for a dollar, but also put an instant photograph booth in her studio to offer a less expensive option on South Rampart Street. Strips of photographs cost ten cents apiece, and Collins or an employee would hand paint the strips for an additional fee.[48] In New York, Winifred Hall Allen also installed an automatic photobooth in the front room of her studio, which sold a strip of six pictures for twenty-five cents in the 1930s.[49] Photographer Bernadine Wesley surmised that the photo-booth created a chance to upsell new customers, or "a way to attract people inside so that [Allen] could get a chance to practice seriously, when she could."[50] Wesley continued, "a picture to send your mother back down South was important...to show her you're doing alright. And so that meant there was always some business to come up with twenty-five cents." Portraits printed directly onto postcards served a similar function, made more urgent in the contexts of movement and displacement during the Great Migration (figs. 20 and 21). Rather than undercut the business of the studio a photobooths and quick-finish postcards could expand its reach by offering customers a variety of accessible price points (fig. 22).

The photographers in *Called to the Camera* were among the most successful in their field, and even for them, the profitability of photography could vary. Twin brothers Morgan and Marvin Smith migrated to New York from Kentucky in 1939 to be artists, and occupied a studio next door to the Apollo Theatre in Harlem on 125th Street soon after their arrival. Their location and their connections made the M. Smith Studio a destination for musicians, actors, and other Black celebrities. By 1945, their studio was described in the press as "quite the smartest place for folks who like to pose."[51] Employee Dorothy Corinaldi had a specific place in mind when she climbed the steps to the studio for the first time, recalling that "it felt like perhaps you were in Hollywood."[52] Marvin Smith challenged a 1998 interviewer who suggested that their prime studio location in Harlem must have been profitable: "The goldmine you speak about, [we] took two proofs for five dollars."[53] To supplement their everyday portrait practice, the brothers sold photographs to the New York *Amsterdam News* and picture magazines like

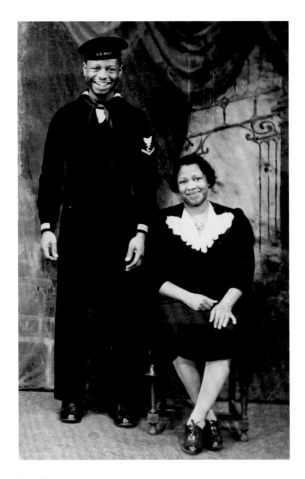

Fig. 20
William H. Jordan
Art & Ms. Sims, ca. 1940
Gelatin silver print on postcard

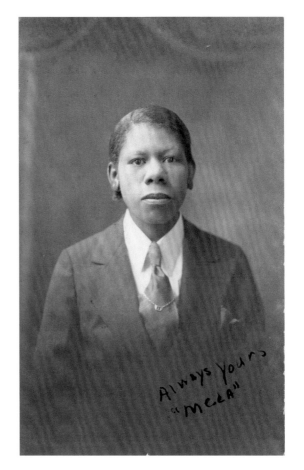

Fig. 21
Photographer unidentified
"Always Yours, 'Meda,'" ca. 1930
Gelatin silver print on postcard

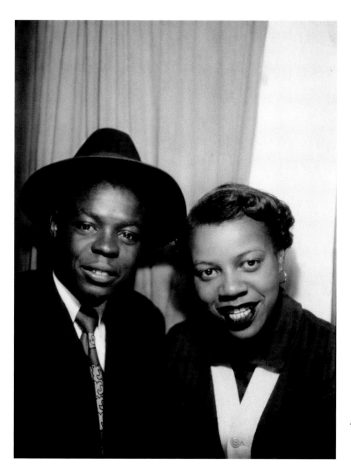

Fig. 22
Photographer unidentified,
likely an automatic photobooth
*Untitled [Man in hat, woman in black
and white dress]*, ca. 1950
Gelatin silver print, hand-tinted

Color, *Ebony*, and *Life*. No matter which brother took the picture, they used only the initial as in M. (as in M. Smith) in credit lines to share copyright and payment. For all of the Smiths' success and proximity to celebrity in the 1940s, by the late 1960s they had closed the M. Smith Studio and moved into the television industry.

Life as a studio photographer could be one of financial precarity. Though James Van Der Zee is now perhaps the best known of all African American studio photographers, the photographer found himself facing eviction and bankruptcy even as he was "rediscovered" in 1969.[54] Calvin Littlejohn reflected that in Fort Worth he "was the only Black photographer in this area… [and] was the only one who elected to starve and make a job out of it."[55] Photographers pursued a variety of strategies to create some security for themselves and their families. When Richard S. Roberts moved to Columbia, SC in 1920, he only worked in his studio during the afternoon, after his shift as a custodian at the U.S. Post Office.[56] By 1952 Robert and Henry Hooks had been making portraits for over four decades, but they touted a Hooks Brothers Studio Christmas "Gift Shoppe" selling pressure cookers, wallets, and jewelry in a Memphis *Tri-State Defender* advertisement. In the same edition, an advertisement from close competitor Ernest Withers asked, "What's Happening? Get Your Newspapers and Magazines from Ernest Withers. All Negro Publications Available Each Week."[57] In Memphis, readers of those publications would routinely see photographs by the Withers and Hooks studios published in the news, sports, and society sections of the paper.

The most common strategy photographers adopted to make more money was to diversify their practice by venturing outside of the studio. Though Benny Joseph of Houston strongly preferred making in-studio portraits, he "had to do it all to survive,"[58] which could include event photography, nightclub work, freelance photojournalism, and pictures for various Black-led organizations. Through the 1950s, much of this work was done for schools and other institutions that were either segregated by law, or created to serve the needs of Black Americans (such as churches or fraternal groups). In the process of making a living, studio photographers helped these different groups constitute themselves, visually and imaginatively. Historian Margaret Olin has described studio photographers as "always involved in community development," meaning that the photographer consistently empowered customers to define the boundaries of their particular group visually, whether through single portraits or group photography.[59]

Sometimes those photographs were made on the fly in social spaces or concert halls, where photographers would make snapshot photographs for groups and couples. Austin Hansen actually began as a nightclub photographer before he opened his studio. When Hansen first moved to New York from St. Thomas in 1928, he worked as a drummer and

earned only three to five dollars an evening. Playing a gig one night, Hansen watched a photographer take upwards of fifty photographs of nightclub patrons, selling them for a dollar apiece. Soon after, Hansen began visiting the same places he once played drums with a camera, recalling, "I made twenty-four shots in an hour! And then, you see, now I'm going into making this money...it's a business now" (plate 86).[60] Hansen went on to open a home studio before World War II, and then at a commercial address in Harlem after his service as a photographer in the U.S. Navy during the war.[61] When Ernest Withers opened his Memphis studio in 1946, just after WWII, he similarly sold nightclub photographs, setting out for music clubs in Memphis to take pictures of and for people enjoying themselves. He had a singular focus, stating, "I was there being seen, making pictures. You're always out to make money. I used to make forty, fifty, sixty dollars a night. Maybe a hundred."[62] Because it approaches the spontaneity of snapshots, nightclub photography foregoes some of the symbolic markers of whiteness or class pretension utilized by some African American portrait photographers.[63] Though made primarily in the interest of a quick sale, leisure photographs represented Withers' subjects without the repetitive stoicism of a studio portrait, but with no less self-regard. As John Edwin Mason describes in his essay in these pages, the line between public and private for Black subjects of photography, could be ever present and out of mind at the same time.

Withers, Hansen, and others of their generation also worked for their local Black newspapers, on assignment and on a freelance basis through the 1940s and into the 1960s. With unique access to Dr. Martin Luther King, Jr. and the Southern Christian Leadership Conference, Withers made some of the most iconic images of the civil rights movement, which were published in the *Tri-State Defender* and *Memphis World* (and nationally through the *Defender* papers). Perhaps none of his photographs is more famous than his picture of demonstrators at the 1968 Memphis Sanitation Workers Strike (plate 95).[64] Withers used a twin-lens "RollieFlex camera," which required him to work close to the action (as opposed to at a distance afforded by a telephoto lens), which occasionally put the photographer in physical danger, but resulted in intimate, dramatic photographs.[65] Hansen took news photographs for the New York *Amsterdam News* and Adam Clayon Powell Jr.'s *The People's Voice*. In the 1940's, Hansen was the "Mystery Photographer" for the latter paper, which offered a cash prize to anyone who came to the office and identified themselves as the unknowing subject of Hansen's street photography.[66] Much of the non-portrait photography in the exhibition, such as Hansen's cityscape (plate 85) or M. Smith's New Deal-style document of a crowd in Harlem (page 215), were likely produced as studio photographers arrived at newsworthy events, or saw something that they speculated they could sell to a publication,

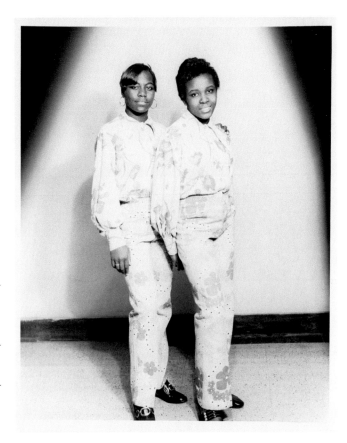

Fig. 23
Rev. Henry Clay Anderson
Studio Portrait of a Couple, ca. 1970s
Gelatin silver print

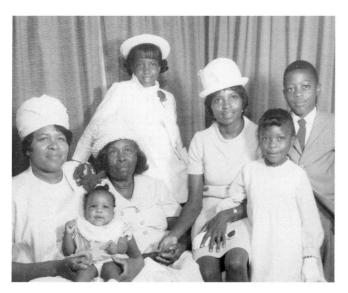

Fig. 24
Rev. Henry Clay Anderson
Studio family portrait, 1960s-1970s
Chromogenic print

and snapped a picture. (At least once, Austin Hansen caught Morgan Smith in the act, climbing a light pole to get a better vantage.) In the process they visualized their communities in exciting ways and improved as image makers.

Photographers could find a steadier source of work by making photographs for Black-led organizations and institutions. In New Orleans, few photographers made more portraits during the first half of the twentieth century than Arthur P. Bedou, whose studio work could be gauzy, delicate, and warm. Bedou worked prodigiously outside of his studio as well, maintaining relationships with a number of Black-led organizations in the city and throughout the South. For a time, Booker T. Washington counted Bedou among his favorite photographers, preferring his clean modernist look when he wanted to project an air strength or fortitude (plate 72). At home, Bedou did work for the historically Black Catholic university Xavier University of Louisiana, and the Archdiocese of New Orleans. At Xavier, he photographed class pictures and convocations, with a large format camera that rendered incredible detail. Bedou developed a reputation for fastidiousness and perfection when making a photograph, demanding endurance from his subjects until a cloud passed, or everyone in the group got the pose right.[67] Bedou also made excellent photographs of scenes he could not direct, like the action on the field at a Xavier Gold Rush football game (plates 80, 81, and 82). To effectively photograph something so fast-paced, Bedou used a smaller camera than he might have otherwise to make a faster exposure and freeze the action. (All three are contact prints, revealing the small size of the negative.) Although some of the photographers in *Called to the Camera* might have expressed preference for the controlled environment of the studio, they routinely showed their facility with a variety of cameras in more chaotic environments.

Standing contracts with large institutions could threaten to overtake the business of the studio. Addison Scurlock capitalized on family connections to Howard University to build a standing relationship as early as 1911. Scurlock made class portraits, composite photographs, and single-negative panoramas of large conference groups and events - with every face in the crowd in perfect focus (plate 93). He preferred working in the studio however, and once his sons George and Robert joined the family business in the 1940s, Addison focused on portraits while the younger photographers went out for assignments. George Scurlock recalled that he might be "at Howard university probably every day for quite a few hours and then during commencement period I was on the campus nine hours a day, taking class reunions... graduation banquets for all the schools: engineering, medical, dental school, law school."[68]

Prior to school desegregation, many studio photographers also contracted to make annual school portraits and yearbook photos for Black primary and secondary schools. Arkansas photographer Geleve

Grice told folklorist Robert Cochran that, "kids in the Black schools knew that kids in the white schools had prom photos and graduation pictures, and they wanted them too. Same with the parents. I knew if I didn't do it nobody else would."[69] In Greeneville, Mississippi H.C. Anderson called Coleman High School his "first real big job" when he successfully bid on the yearbook in 1949, after which he photographed Coleman events for the next decade.[70] Calvin Littlejohn recalled that he specialized in school pictures because newspaper work in Fort Worth did not pay much, and school photographs proved more consistent than things like wedding portraits.[71] In Louisiana, Nolan Marshall, Sr. traveled to Black public schools throughout the southern half of the state, taking photographs for as many as one hundred sixteen schools in a year. He also sold class rings and yearbooks on his routes.[72]

Making a profit on school pictures depended on volume, and made for difficult and time consuming work. For portraits, Marshall could expect to see seventy to eighty students a day, some requesting up to six different poses and outfits.[73] On one day in October 1964 at George W. Carver High School in Memphis, Tennessee, the Hooks Brothers made portraits for one-hundred eleven students, also with multiple sittings.[74] Yearbook photographs could be just as grueling. At another school the next month, the Hooks Brothers photographed a scheduled thirty-five different student groups in two days, working all day with no lunch breaks.[75] After visiting a school and collecting deposits from students, photographers returned marked proofs from which students made selections often by selecting packages that included a number of different size prints. Even when students paid a deposit for their portraits, completing the sale could take some effort. Geleve Grice recalled that, "sometimes [students would] pay part of the cost when I took the pictures and send me the rest later. Sometimes it took months."[76] Grice, Anderson, the Hooks, Marshall, and other photographers turned schools into regular and repeating customers, and provided an important service for Black students and their families (figs. 25 and 26).

When the Hooks Brothers Studio visited Carver High in 1965, eleven years after the Supreme Court outlawed segregation in education in *Brown vs. Board of Education of Topeka*, the photographers walked into a school that remained segregated by race.[77] At that point the studio had been in business for over six decades. In their photography, as in Memphis, much had changed but much also remained the same. When Robert B. and Henry A. Hooks opened their doors on Beale Street in 1907, they worked in much the same way that C.M. Battey would at Tuskeegee.[78] Large heavy cameras, fragile glass negatives, and expectations of delicately retouched and sensitively rendered prints. In a 1910 advertisement, Henry Hooks styled himself as a bit of an adventurer, in field coat and gloves, with a tripod camera and an array of portraits in attractive frames at his feet (fig. 27). This photograph, of course,

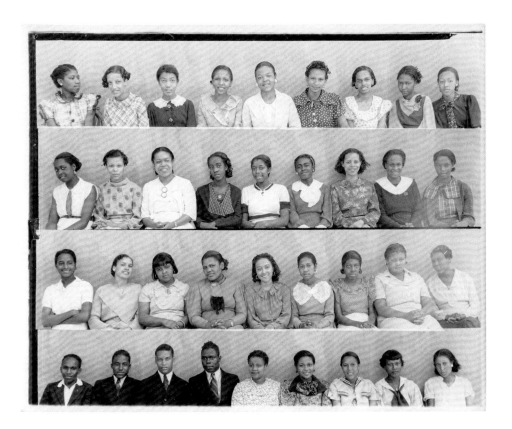

Fig. 25
Hooks Brothers Studio
Student Portraits, 1950s
Gelatin silver print

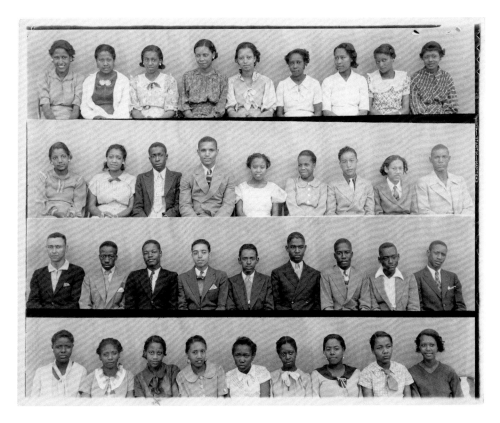

Fig. 26
Hooks Brothers Studio
Student Portraits, 1950s
Gelatin silver print

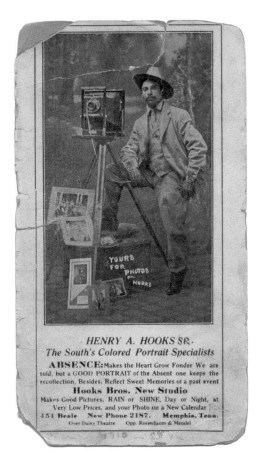

Fig. 27
Hooks Brothers Studio
Advertisement, Henry A. Hooks, 1910
Halftone ink print on cardboard

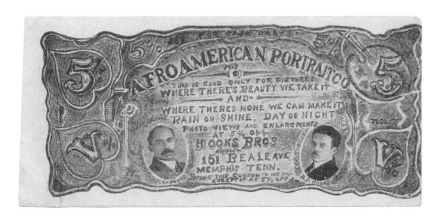

Fig. 28
Hooks Brothers Studio
Afro-American Portrait Co. Coupon, 1913
Halftone ink print

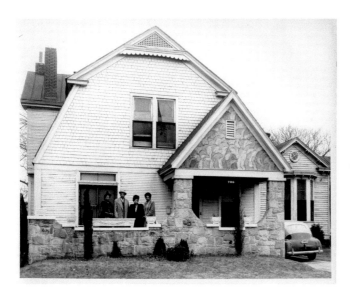

Fig. 29
Hooks Brothers Studio
Family in Front of Home, ca. 1955
Gelatin silver print

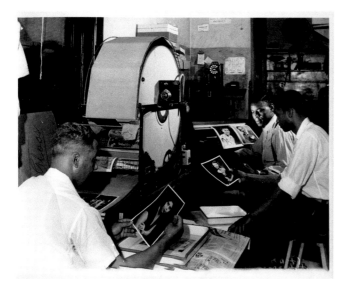

Fig. 30
Hooks Brothers Studio
*Hooks Photography School Students
at Print Dryer*, ca. 1950
Gelatin silver print

was a studio creation; one that modeled the kind of imaginative space the Hooks Brothers Studio would be, but also hinted at the brothers' intentions to be out in the world, making photographs for other people. That Hooks's pose appeared visually similar to popular conceptions of the intrepid photographer in the field, including in advertisements by firms like Kodak, positioned their studio in the public's mind as both capable and on the cutting edge. Advertising copy below the photograph - "The South's Premiere Colored Portrait Specialist" - referred not to the kind of photographs they made, but made clear who Henry Hooks claimed to be, and the very people whom he and his brother served.

Another work from the Hooks Brothers Studio is equally instructive in regards to how the photographers understood their mission. Reproduced here, it is a copy of a hand-drawn coupon styled like a dollar bill, offering five percent off of an order (cash only). Printed sometime before the 1960s, it bears the date 1913 and includes early photographic portraits of both Robert and Henry Hooks (fig. 28). Under the banner of the AfroAmerican Portrait Co., the Hooks promised that, "Where There's Beauty We Take It, And Where There's None We Can Make It."[79] On the surface, the slogan is a cheeky turn of an old joke among photographers, about a customer requesting a portrait not as they appear, but to be made better-looking by the photographer's magic. More critically, that statement might be understood as a summation of the work that the Hooks', and many other Black American studio photographers performed, both literally and metaphorically. Of course they took photographs of the resources they saw in their own communities, but they also created photographic space for the beauty of Black America in a field dominated by white Americans. Their studios were sites for the production of a photographic history, and of multiple ways of practicing photography while being Black. Working through periods when Black Americans might have struggled to find much beauty in the nation's mainstream visual culture, not to mention the political and social landscape, the beauty that Black studio photographers *made*, became that much more essential to their sitters and customers .

Over the course of the twentieth century, the Hooks Brothers went on to make their studio, and their cameras, indispensable to their community. Historian Earnestine Jenkins identified the photographers as visually articulating the "New Negro" aesthetic prevalent after 1900, for Black people throught the mid-South.[80] After WWII, they opened the Hooks Brothers Photography School. Their school trained returning Black veterans to become professional photographers, and capitalized on the available funds that their students could put towards education (fig. 30).[81] The Hooks Brothers Studio continued to make portraits for generations of Black Memphians, including everyday people and notables like singer Reverend Al. Green, and Robert Hooks's son Benjamin L. Hooks, longtime Executive Director of the National Association for

the Advancement of Colored People (NAACP). Henry A. Hooks, Jr. and Robert's son Charles J. Hooks came into the family business, eventually taking it over as a multi-generational enterprise. A deep dive into what remains of the Hooks Brothers Studio archive also reveals what a broad cross section of Black Memphis came before their cameras. What is immediately apparent, illustrated here in this select group of Hooks' images, is the scope of their photographic view: families, churches, businesses, birthdays, weddings, new homes and newer outfits, old loves and older lineages. The Hooks Brothers Studio's longevity made it an institution, but as *Called to the Camera* makes clear, Black photography studios like theirs proliferated throughout the country and shaped what we understand photography to be today, in so many ways. Well into the 1970s, The Hooks Brothers Studio fulfilled the promise and the imperative suggested by C.M. Battey's Tuskegee studio, and so many other spaces like it.

Hooks Brothers Studio
Afro-American Portrait Co.
Coupon (detail), 1913
Halftone ink print

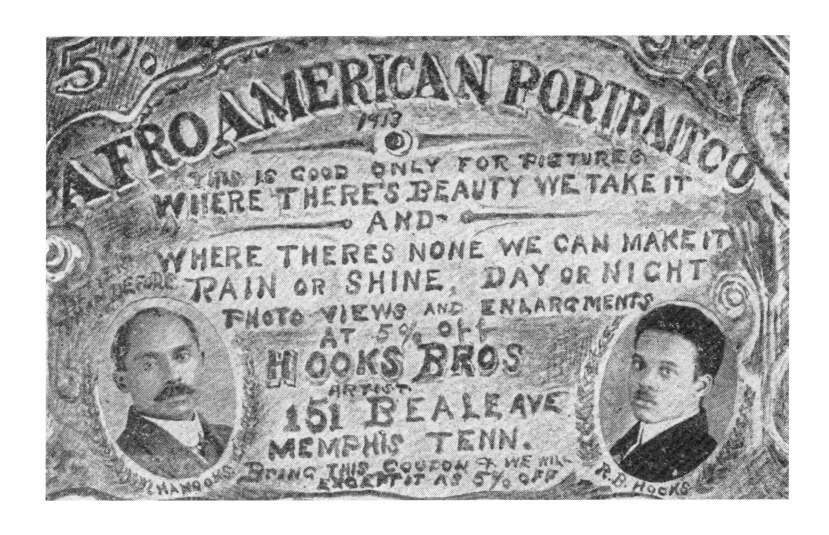

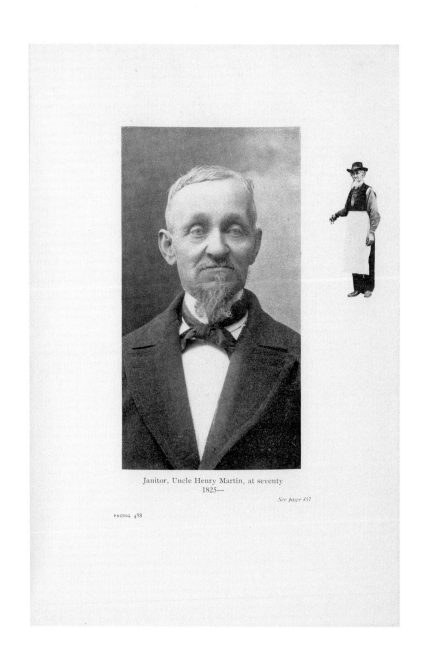

Janitor, Uncle Henry Martin, at seventy
1825—

See page 457

NOBODY'S "FAITHFUL SERVANT": HENRY MARTIN REPRESENTS HIMSELF

John Edwin Mason

UNIVERSITY OF VIRGINIA

Sometime in 1897, a elderly Black janitor and a wealthy white physician encountered each other on the grounds of the University of Virginia. This otherwise unremarkable meeting produced a valuable piece of evidence about how African Americans used photography to challenge the demeaning racial stereotypes of the Jim Crow era and to create more truthful visions of themselves. Black activists and intellectuals have long argued that because racist imagery was a vital element in the ideology of white supremacy photography was "a way to resist [visual] misrepresentation as well as a means by which alternative images could be produced."[82] The janitor's use of photography, as well as the words that accompanied it, demonstrate how this theoretical proposition was put into practice by everyday African Americans.

Henry Martin, the university's head janitor and bell ringer, who had been born into slavery, would not have been surprised when he was approached by David Culbreth, M.D., an affluent alumnus. During Martin's many decades of working at the whites-only university, he had won the affection of students, professors, alumni, and residents of nearby Charlottesville, Virginia. Many alumni went out of their way to say a few words to him when they returned to their *alma mater*. They were rarely disappointed. His courtesy and his memory, which allowed him to greet most of them by name, years after they had graduated, were legendary.

In his memoir Culbreth recalled a pleasant conversation with "this most respectful and courteous colored janitor."[83] As the two men parted, Martin

asked me if I would… like to have his picture, and upon my thanking him for the compliment, he expressed the intention of having some taken in the near future.... True to his word a year later, September, 1898, he sent the photograph which has been reproduced in this volume.[84] (See fig. 31.)

Fig. 31
David M.R. Culbreth
The University of Virginia: Memoirs of Her Student-life and Professor, 1908
Pages 488-89

It was a simple gesture, but it carried a significant message. Martin, who had endured decades of being spoken for by others, had seized an opportunity to speak for himself in the powerful visual language of portraiture. In doing so, he gave a private portrait a public purpose -- to challenge misrepresentations of himself.

Martin was well aware that he had long been misrepresented by others, in words and in images. His very visible position as the janitor and bell ringer at the Rotunda -- the symbolic heart of the university that Thomas Jefferson founded in 1819 for elite white men -- made him one of the most recognizable people in the region. He was also one of the most written about and photographed. Time and again white people pictured him as the perfect servant, deferential and diligent. Yet they also recognized his dignity and humanity. This combination of condescension and respect marks virtually every representation of him.[85] The respect was partly based on Martin's dignified bearing and commanding presence. But it was also a function of how well he seemed to perform the role that whites expected him to play. Culbreth provides an example. Martin, he wrote, had gone about his "duties for years, nay, generations... most faithfully. ..He knew his part in life and played it well. ...He also fully recognized that he was neither a professor, a student, nor a white man."[86] The university's student newspaper, *College Topics*, struck a similar tone in an article that it published about Martin when he retired.

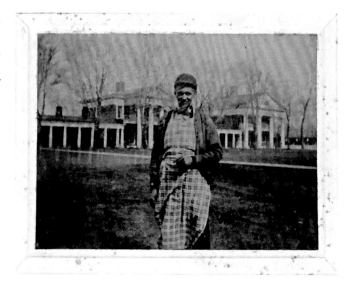

Fig. 32
Photographer unidentified
Snapshot portrait of Henry Martin,
wearing his janitor's apron, on the grounds
of the University of Virginia, 1896
Gelatin silver print
Collection of the author

> *This grand old darkey is effectionately [sic] remembered by the hundreds*
> *of men who have attended the University of Jefferson [sic]... within the*
> *past sixty years. His noble character, his courtesy, immutable principles*
> *of justice, right and honor have all appealed to every one [sic] who has*
> *come in contact with him.*[87]

When Culbreth remarked that Martin "knew his part in life," he was speaking about more than his job as a janitor. The comment encoded a deeper meaning. Culbreth, and many others, cast him as a living reminder of the contented "faithful slave," a central component in white supremacist myth-making about the pre-Civil War South. White people projected their ideological and psychological needs onto Martin, imagining that, as a free man, he still embodied an ethos that made him a perfect servant. *The Daily Progress*, Charlottesville's white newspaper, stated this view in unambiguous terms, when it wrote that Martin was "the personification of the qualities that go to make the faithful servant. ...His are the sentiments of the ante-bellum negro."[88]

Martin rejected these representations of himself. In a letter that he dictated for publication in *College Topics*, he emphasized that he was "employed as a janitor" by the university, not by it or anyone as a servant.[89] He most forceful self-representation, however, was visual.

The photograph that Martin commissioned and presented to Culbreth shows no trace of his job as a janitor nor his association with the university. It is a studio portrait, made by a professional photographer or a skilled amateur, that shows him posed against a plain backdrop, perfectly groomed and wearing formal clothes. It is a portrait befitting a statesman or, perhaps, a dignified Baptist deacon, which indeed he was. The photograph contrasts starkly with the smaller image next to it in Culbreth's book and the often-reproduced snapshot portrait, both of which show him wearing his janitor's apron (fig. 32).[90]

The portrait that Martin commissioned resembles countless other photographs from the late nineteenth and early twentieth centuries in which African Americans the right to represent themselves. And it served a similar purpose. As Maurice Wallace and Shawn Michelle Smith have argued, the new technology of photography offered Black people "an unprecedented opportunity for self-representation" -- that is, an opportunity to show themselves as they wished to be seen.[91] "To publicly present one's self... as successful, dignified, and neatly attired," Kevin Gaines has written, "constituted a transgressive refusal to occupy the subordinate status prescribed for African American men and women."[92] When Martin presented this portrait to Culbreth, he was, in effect, telling him that he was not the relic of slavery that the doctor imagined him to be. He was anyone's equal -- a man and a citizen.

Most portraits like Martin's remained private, displayed on the walls and mantelpieces of homes or in photo albums, seen only by family and friends. bell hooks has described how the homes of Black people became "private, Black-owned and -operated gallery space[s]... where in the midst of segregation... dehumanization could be countered."[93] On-going research being conducted by the Holsinger Studio Portrait Project, at the University of Virginia, strongly suggests that Martin made a practice of giving copies of his portrait to white people, taking them out of the home and into the public arena. Each time he did this, he challenged the way that a white person pictured him, literally and figuratively. The man in these portraits was neither the janitor in the apron nor a faithful servant. Thus he conferred on his image the public role of contesting the racial visual stereotypes of the Jim Crow and creating new ways of seeing and understanding a representative African American. It was, perhaps, a small gesture. As Gaines points out, many "whites... remained unmoved by African Americans' attempts at respectful self-representation."[94] Yet this gesture was reproduced countless times, in countless places, by Black people throughout the country. The cumulative effect was to undermine the visual underpinnings of white supremacy, helping to set the stage for the civil rights revolution to come.

THE ART OF BEING SEEN AS BEING SEEN

Carla Williams

In An Eye For the Tropics: Tourism, Photography, and Framing the Caribbean Picturesque (2007), scholar Krista A. Thompson described a new phenomenon taking place in the early 2000s among young people in the Caribbean. They were hiring photographers to act as paparazzi to photograph them entering the prom or showing up at their birthday parties. As a lover of the material culture of photography, I was fascinated and quickly flipped through the book, only to discover that there were no actual images to be seen. Being photographed and, moreover, being seen being photographed, was the thing—no photographs had actually been made by the photographers. And that was the point; their paying subjects only wanted them to perform the photographic act to create a dynamic moment, not a static memory.

By 2010, mainstream news outlets like CNN were reporting on this practice; and today, anyone can order the paparazzi experience online from pretty much anywhere. With Merriam-Webster officially adding the word "selfie" to the lexicon in 2014, and high-definition cameras and editing software in nearly every pocket, studio photographers have seemingly gone the way of newsies, travel agents, and telephone operators. What was once a ubiquitous professional service in cities and towns across the United States, is now something that we all routinely do ourselves. Who needs to pay for a flattering likeness when they can just hold out their arm, press a screen, and then add edits and filters that will seamlessly eliminate those crow's feet or that double chin? In 2022, if the self-image you share hasn't been honed to perfection, what are you even doing?

In the midst of all of this image control, however, studio photographers are seemingly busier than ever. For years now, if you've watched any reality television housewife whose story line began to ebb, it was all but guaranteed that within a couple of episodes she would manufacture a reason for a televised, professional photo shoot. And as goes the

Nyejah Bolds
Will and Meredith McKelvey engagement photos, New Orleans, 2019
Courtesy of Will and Meredith McKelvery and the artist

minor celebrity, so goes the audience. It used to be that one's wedding was the significant formal photographic event; now, it is standard practice to have professional photo shoots starting with the engagement announcements. What was once satisfied by a few excited phone calls to loved ones is now every pregnant woman on Instagram giving her best Demi Moore to immortalize the pending blessed event. Indeed, just as Kindle has so far failed to kill printed books, the camera phone has not supplanted the studio photographer.

It would be easy enough to attribute this to a renewed appreciation of artistry, that rather undefinable quality that elevates one maker's eye above the others, but that doesn't really satisfactorily explain the lure of the lens. What, then, is so special, so irreplaceable for the subject being "called to" the camera? Because despite the ease and convenience, it really isn't enough to just picture oneself, is it?[95] It's also not as affirming just to be witnessed in the flesh if the apparatus of truth is not also present.

I would venture to say that few in the twenty-first century are thinking about Frederick Douglass when they pose for the camera. But as the most photographed American of the nineteenth century, Douglass well understood the power of photography, and savvily wielded it as a tool to reshape the collective image of Black Americans. Douglass sat for studio portraits, or "photographic self-representation," as he regarded them, more than 160 times in his prime. At the height of her popularity "selfie queen" Kim Kardashian claims to have made 1,500 selfies in a single day. It's safe to say that being seen in the manner of your choosing is still of some consequence.

After nearly two hundred years of photography, of believing photographs as evidence, cherishing them as memories, and idolizing the icons they immortalize, we have internalized the power of being seen by the camera; there is nothing else as validating, no other medium that even comes close to it. We don't even have to think about it; it's automatic, natural, like a genetic memory. We innately know what to do and moreover, why we do it: We make photographs because photographs make us matter. So we primp, we prance, and in the blink of an eye, we strike the pose.

Fig. 33
Carla Williams
Untitled (Self-Portrait), 1985
Gelatin silver print
Courtesy of the artist

THE WASHINGTON
DAGUERREAN GALLERY.

Strange! Passing Strange, Yet True!

A DAGUERREOTYPE MINIATURE, CASE INCLUDED, FOR 50 CENTS,
AT THE WASHINGTON DAGUERREAN GALLERY,
NO. 136 MAIN STREET,
(A FEW DOORS NORTH OF THE CENTRE CHURCH.)

France purchased this art from Daguerre and Niepce for the benefit of the world. Why should not the Daguerreotype be within the reach of every body? Why may not, every man delight to "view his shadow," traced by the sun and descant on his own perfections? While others are advocating every man a house, free soil and free speech, it remains for WASHINGTON to advocate and furnish free Daguerreotypes, for the next 60 days. He has on hand the largest and best assortment—more than 30 different varieties and styles of cases, frames and lockets, all of which he can sell cheaper than any other establishment. Thankful for the past, he hopes by an increase of patronage to be able to continue his system of large sales and small profits.

He has made this business his profession, and is determined to take AS GOOD, OR BETTER LIKENESSES than any one in this State, at *prices cheaper than any one* in this city—prices as cheap as they can be for such work as will give credit to his skill as an Artist, and satisfaction to his Patrons.

His knowledge of this Art during seven years, and his daily experience, and constant and extensive practice the past five years, have been such that he can, at almost any time, produce Likenesses equal to his

PREMIUM DAGUERREOTYPES!

in distinctness, softness of light and shade, and all those qualities combined which constitute a Daguerreotype accurate as a likeness, and beautiful as a picture.

These are executed on the finest silver plates, and warranted not to fade, nor change by the influence of time or climate. In case of any change, they may be returned to the Gallery; and so of all likenesses by him during the last four years.

The fact that Daguerreotypes, when not properly taken and finished, have been known sometimes to spot, and undergo other changes, shows at once that fixed and responsible establishments furnish the public advantages, and such a warrant, as travelling saloons and itinerant artists, from the very nature of their locomotive character, cannot possibly give.

LADIES

are informed that dark dresses, as silks, alpacas, muslin de laines, &c., are most suitable to produce a beautiful drapery; and that this is the only gallery in Hartford, that has connected with it, a *Ladies' Dressing-Room, and has a female in constant attendance to assist in arranging their toilet.*

Persons wishing Likenesses, after sitting, are under no obligation to take them away unless they are satisfied in every respect.

Portraits, Engravings, and other Daguerreotypes, neatly copied. Also, Likenesses taken of Invalids and Deceased persons, at their residence, either in the city or country.

He has just received a spendid variety of gold and plated lockets, also, a beautiful assortment of Pearl Papier Mache and Turkey Morocco, clasp Book-Cases. These with his best pictures are most appropriate and durable Mementos.

He is determined to give Families the best pictures, and best bargains that can be made in this State. In some instances, watches, jewelry and country produce will be received in exchange for Likenesses.

He has recently spent three months in New York, and availed himself of all the latest improvements in the Art. But he makes no boast. Aware that an intelligent public need only to know facts, he respectfully invites them to call and examine. As Patrons or Visitors, they will equally receive his polite attention.

☞ Prices varying from *Fifty Cents*, to $10, according to the size, quality, and style of the plates, cases, frames, lockets, or bracelets.

*** Instructions given in the Theory and most improved Practice of Daguerreotype, with superior advantages for experimenting.

☞ Don't forget to visit 136 Main street.

WASHINGTON & CO.

HARTFORD, July 20th, 1851.

FOUNDATIONS

In the first decades of photography in the United States, Black Americans took up positions behind the camera with a spirit of experimentation and entrepreneurial vigor. These operators, a term adopted for those who worked the camera, were among the first people defining what photographic portraiture in the United States looked like and what the experience of visiting a photography studio entailed.

Reflecting the popular conventions of Western portraiture, this selection also showcases the variety of different products Black photographers offered their clients. Through the second half of the nineteenth century, as new kinds of photographic media emerged and gained popularity, Black studio photographers excelled at every kind and format, including daguerreotypes, ambrotypes, and tintypes. When negative-positive processes became more practical, they printed using chemical solutions of saline, albumen, and collodion. They sold portraits in cases, affixed to cartes-de-visite, and cabinet cards, all according to popular trends and the intended use of the sitter.

Some of the examples included in this section were made by photographers whose names are no longer known and were likely white. The sitters for these portraits, just as those posing for known Black photographers, demonstrated a number of motifs that one might trace through the history of Black photography. Famous figures like Frederick Douglass and Sojourner Truth embodied the idea that having one's photograph made constituted an act of self-possession and self-definition for Black Americans. For the lesser known or anonymous subjects included here portraits proved equally potent, a medium through which they could represent themselves, assert their citizenship, or forge relationships. For the people pictured in this section, both before and after the abolition of slavery, their portraits were a means to visualize themselves on their own terms.

Plate 1
The Washington Daguerrean Gallery.
Strange! Passing strange, yet true!.... 1851
Broadside

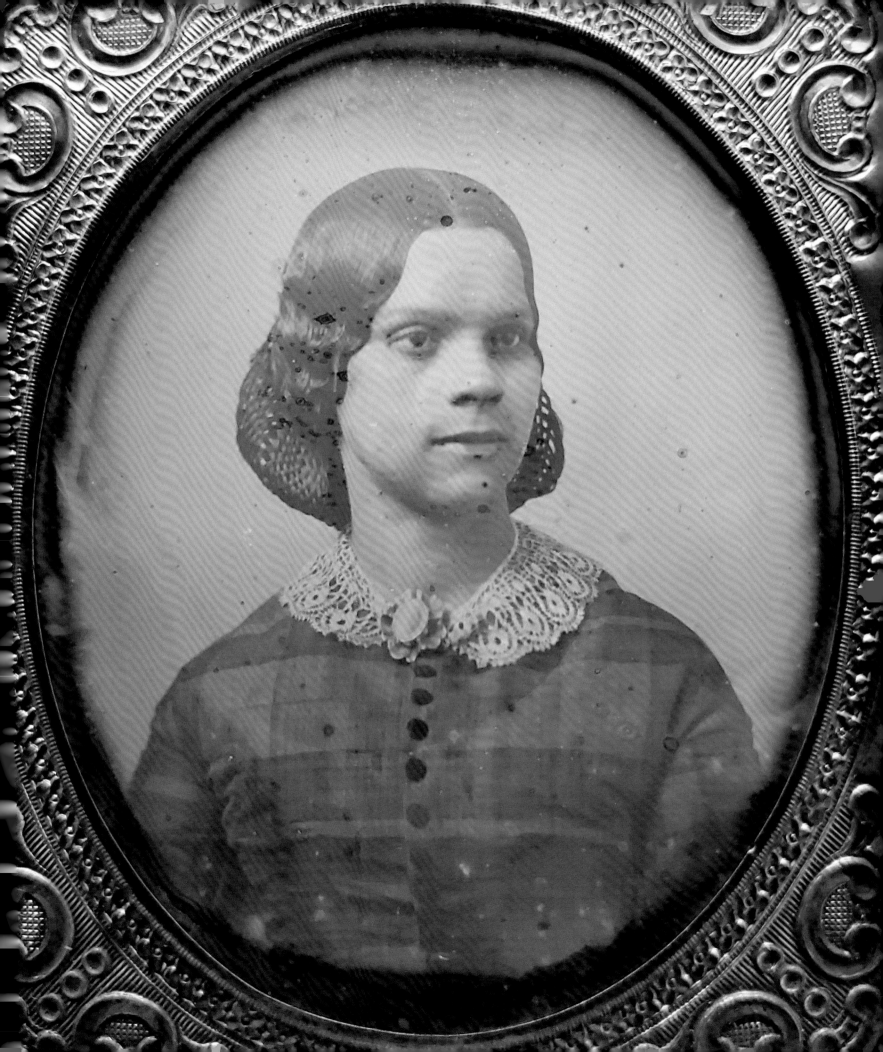

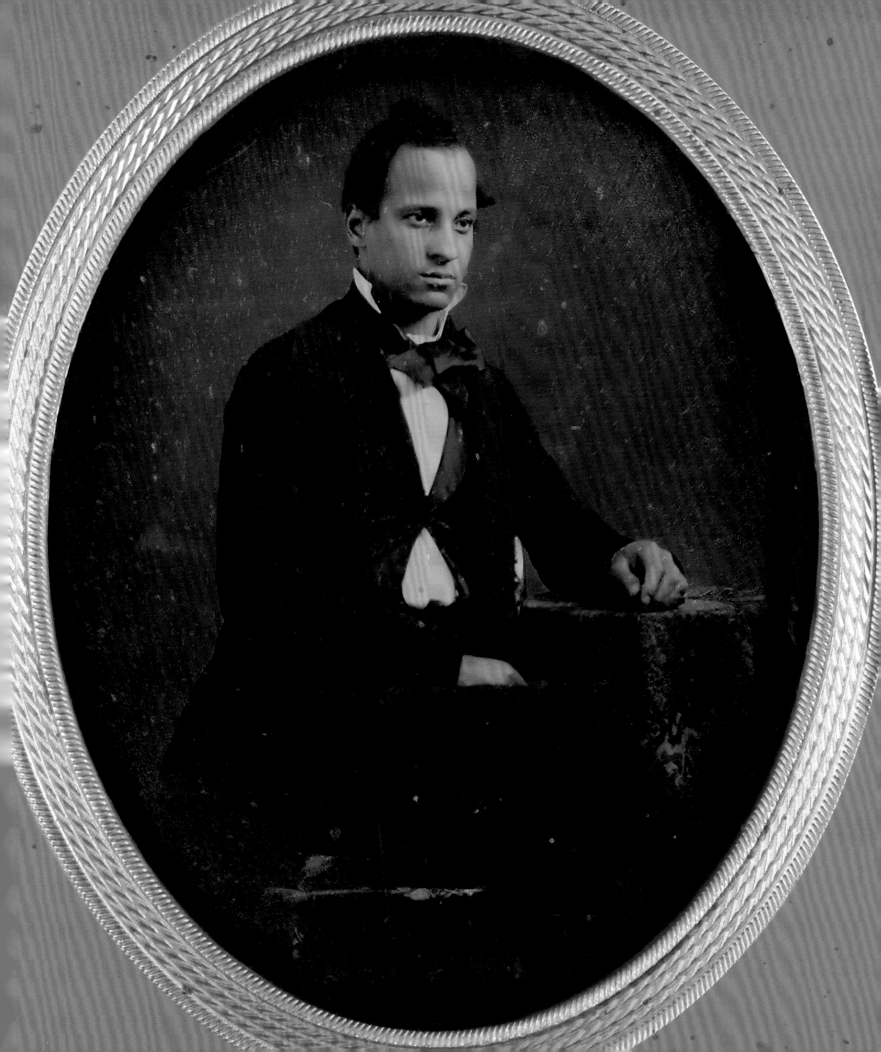

Plate 4
Augustus Washington
Sarah McGill Russwurm, holding a
daguerreotype case, ca. 1854-1855
Daguerreotype, sixth-plate

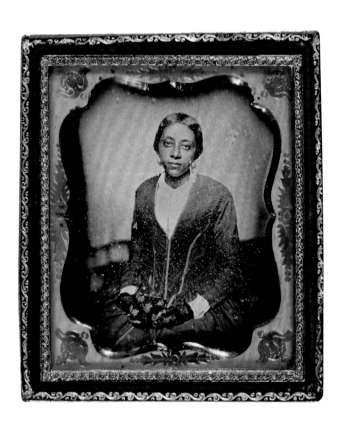

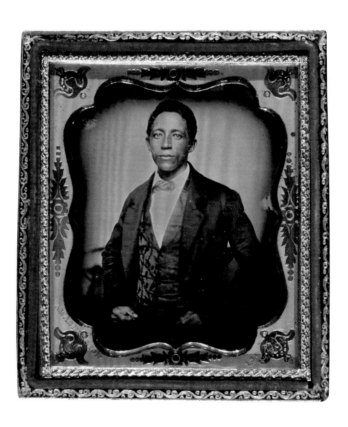

Plate 6
Photographer unidentified
*Untitled [Portrait of a man with parted
hair holding a small book]*, ca. 1855
Daguerreotype, sixth-plate

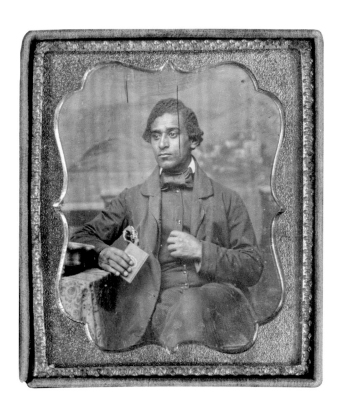

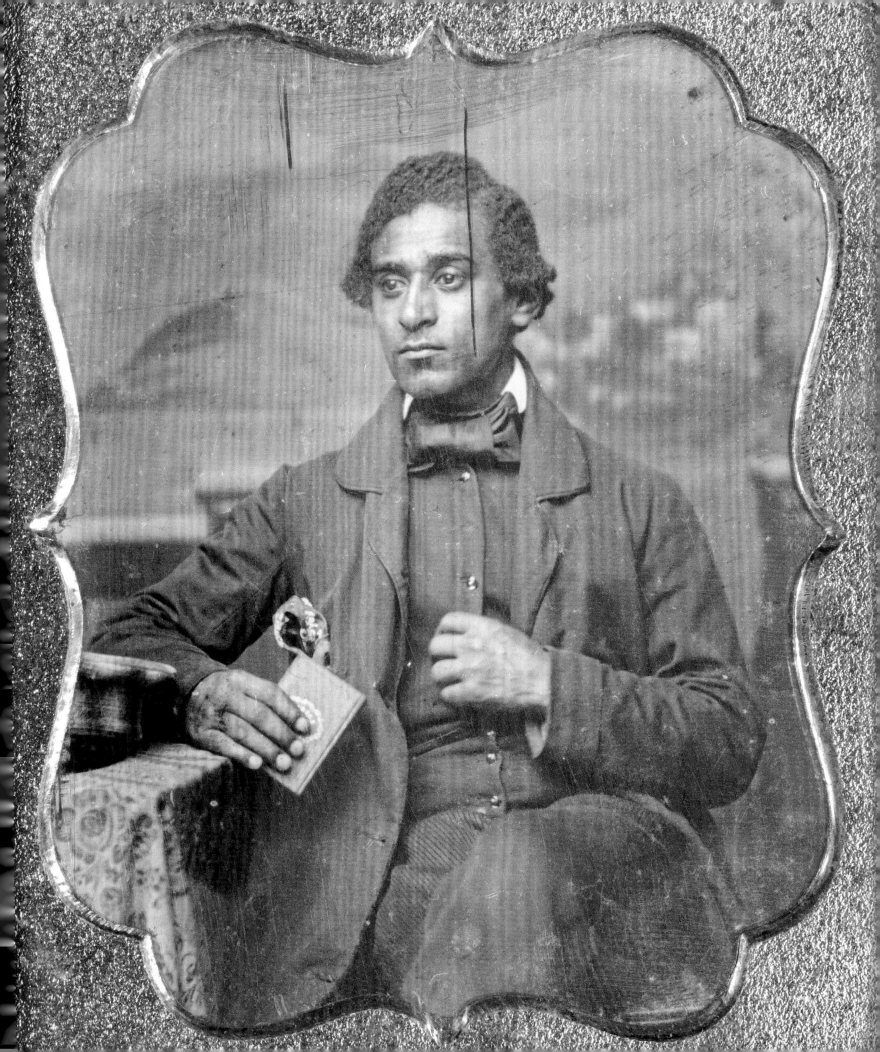

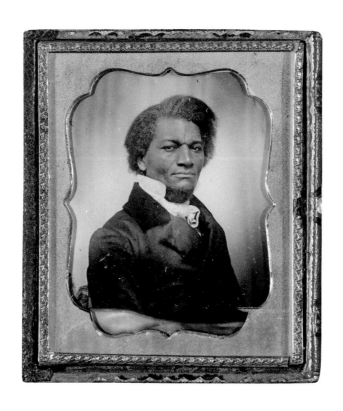

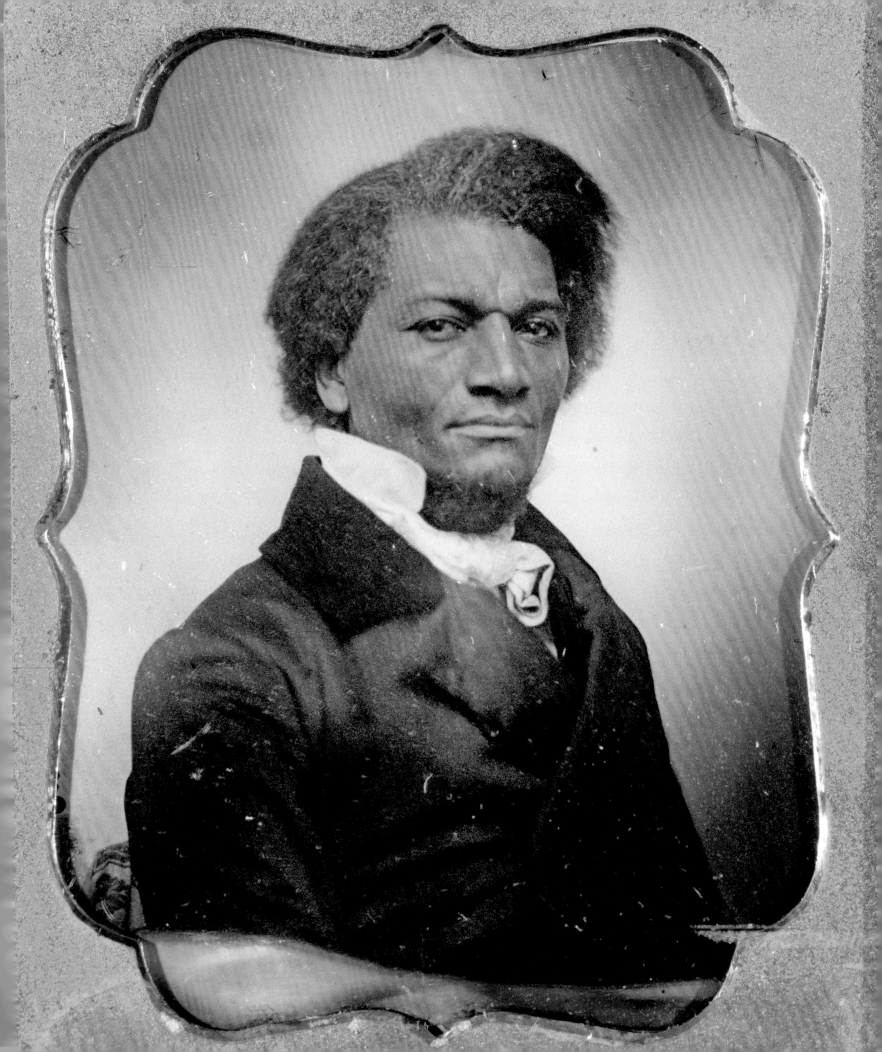

Plate 8
Ball and Thomas Photographic Art Gallery
Portrait of a Sailor, 1861-1865
Albumen print on carte-de-visite

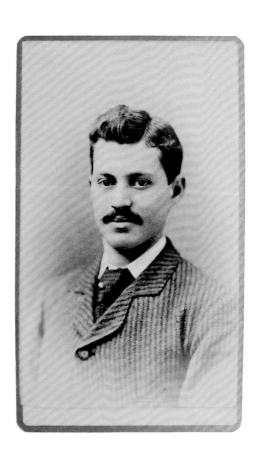

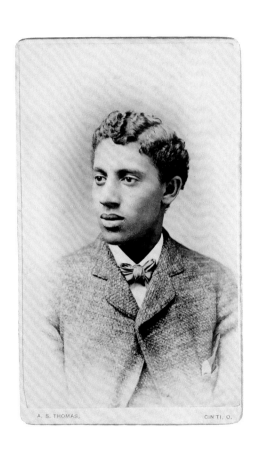

Plate 12
Richmond Photograph Co.
(likely James C. Farley)
Portrait of a Woman, ca. 1885
Albumen print on carte-de-visite

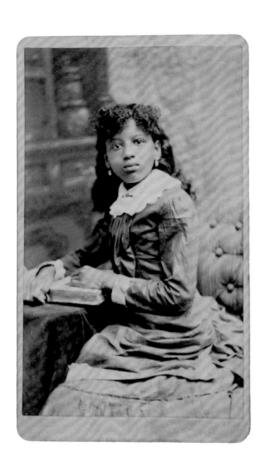

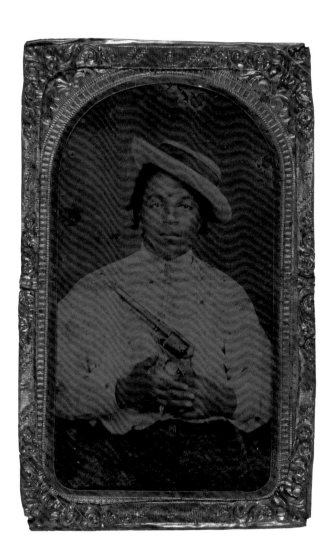

Plate 14
Goodridge Brothers Studio
William Goodridge and
William O. Goodridge, Jr., 1883
Tintype

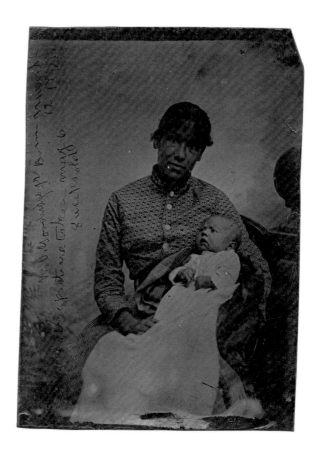

Plate 15
Goodridge Brothers Studio
William Goodridge Jr.,
November 9, 1883, 1883
Tintype

Plate 16
Goodridge Brothers Studio
John F. Goodridge, Age 1 Year, 1886
Tintype

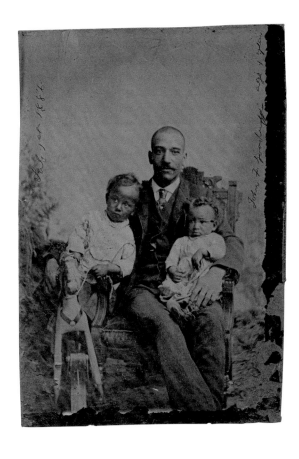

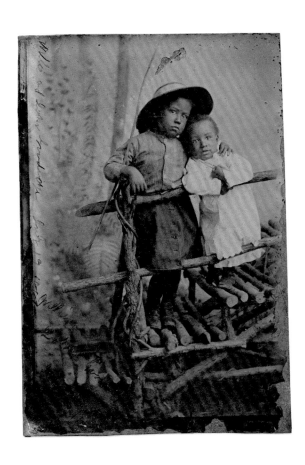

Plate 17
Goodridge Brothers Studio
William and John Goodridge, 1887
Tintype

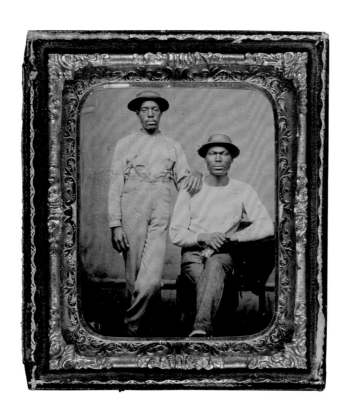

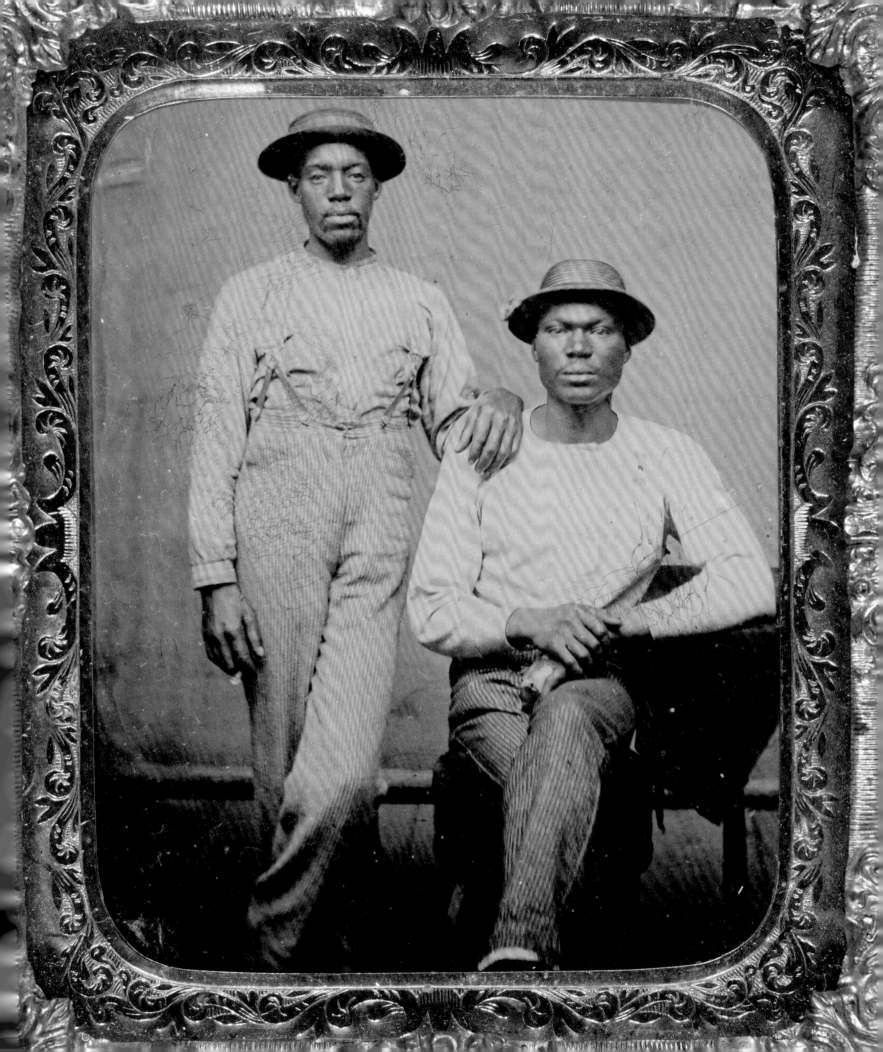

Plate 19
Photographer unidentified
Untitled [Portrait of Woman and
Man, Foliage Backdrop], 1890s
Tintype, sixth-plate

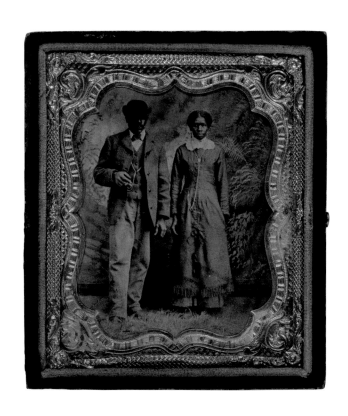

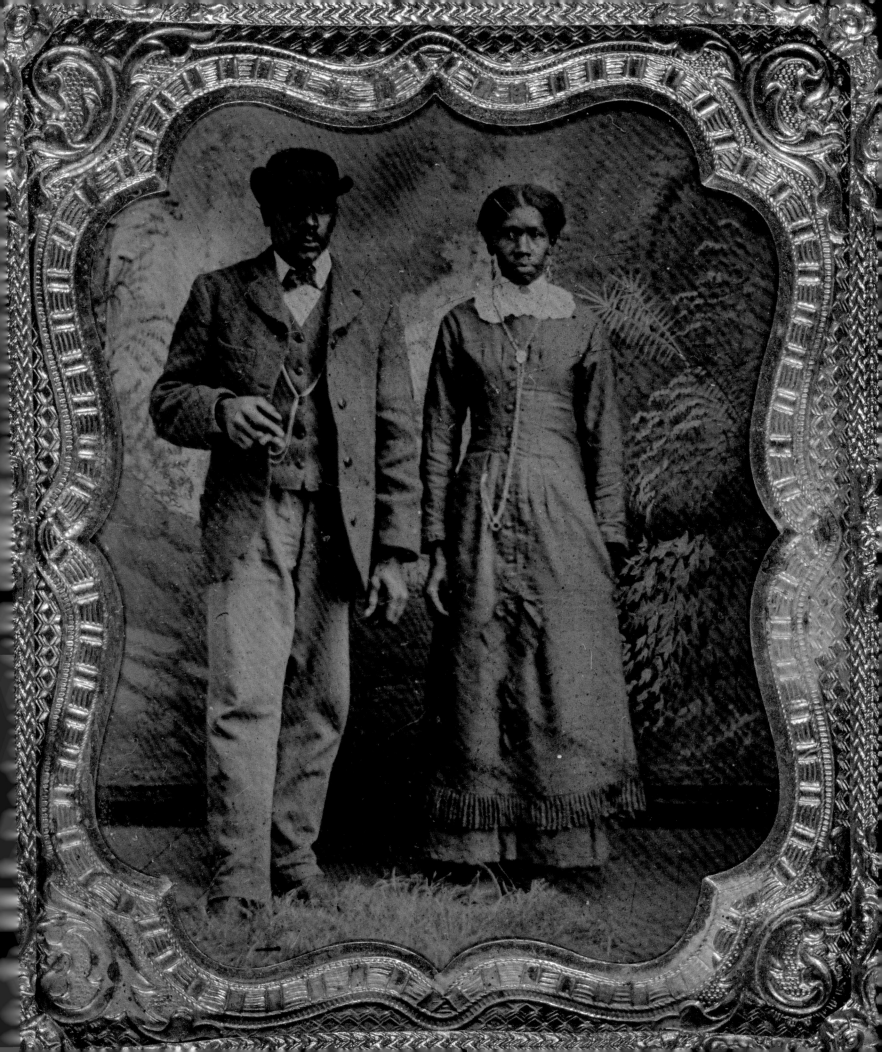

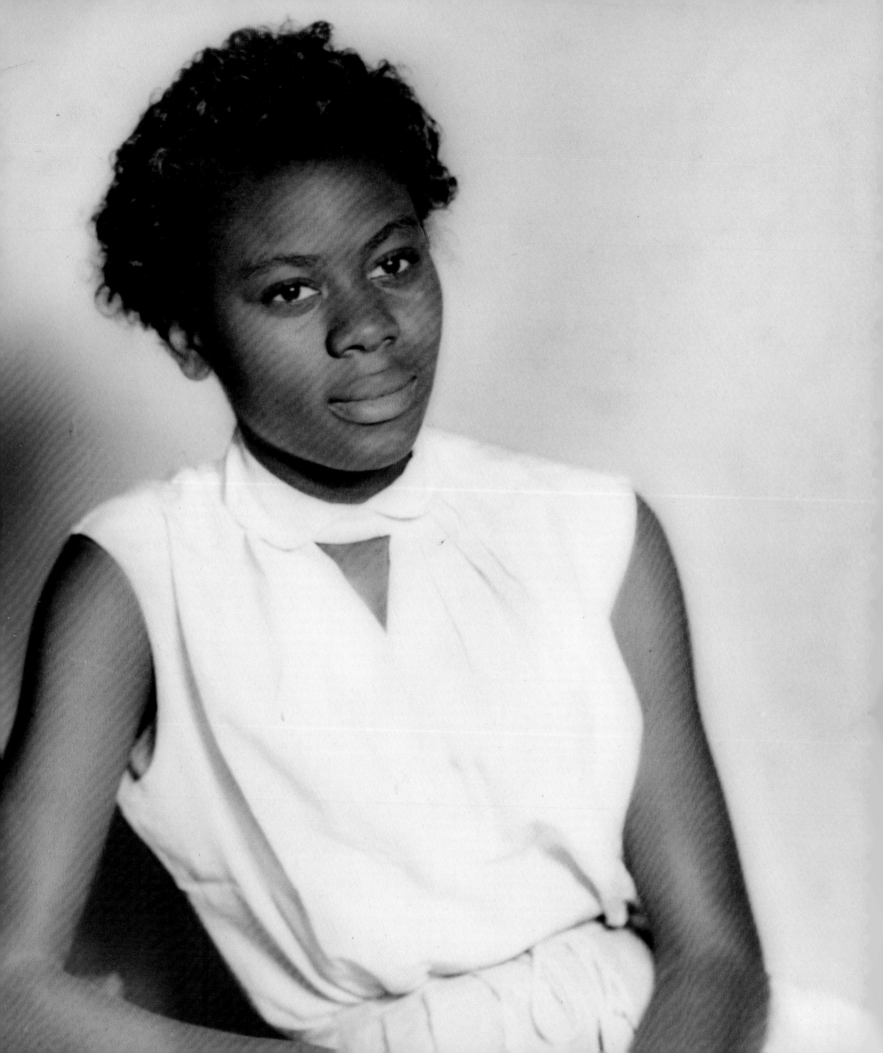

THE PORTRAITS

At the beginning of the twentieth century, increasing numbers of Black photographers opened portrait studios to meet the demand for quality photographs, and in the hopes of making a decent living. Accordingly, the variety of photography available to Black Americans blossomed. To be sure, the portrait remained the central unit of exchange, both visually and monetarily for studio photographers, but the styles and presentation of those portraits could be as diverse as the Black communities in which they were made. Different kinds of photographic papers, printing processes, and commercially produced packaging gave each photographer a way to distinguish themselves in competitive marketplaces. The portraits reproduced in this section, most of them of single figures, have been chosen to represent a range of different elements that Black studios chose to help represent their clients at the beginning of the twentieth century – from overstuffed Victorian stage sets to dark mottled backdrops, elaborate retouching to straightforward intimacy of a snapshot, gauzy soft focus to crisp modern lines. These plates also illustrate that, although often described as "black-and-white," photography in this era was far more varied. Black studio photographers produced this variety through a selection of printing papers, and through various chemical processes that tinted or colored the final print. The warm colors of their commercially-produced presentation sleeves, meant to make their portraits look their best and maybe advertise the studio name, demonstrate a deliberate effort to complement the rich tonal range of these portraits.

The portraits in this section were made over several decades and in a wide constellation of places. Nevertheless, despite their aesthetic diversity, they are conceptually related. Together, they display a general adherence to the visual codes of respectability politics, or the idea that confirming to middle class and gender norms might refute racist stereotypes and ease a path for Black Americans to gain full human rights. Although many of these sitters' names are currently unknown, they were likely middle- or upper-class individuals. Through markers like formal wear, faux-domestic interiors, and ceremonial dress, sitters expressed a deliberate understanding of themselves and signaled their status, real or perceived, to any viewer. The studio therefore became a performative space in which one's identity was expressed through the gesture of one's hand, the pose of one's body, looking directly look into the camera or off into the distance, a bared shoulder, etc. Again, the variety of performative acts reflects the diversity of Black American identity across time and geography.

Rev. Henry Clay Anderson
A hand-tinted portrait of a young woman (detail), 1950s
Gelatin silver print, watercolor

Plate 20
Arthur L. Macbeth
*Portrait of a Woman, posing
beside a chair*, ca. 1910
Gelatin silver print on
original card mount

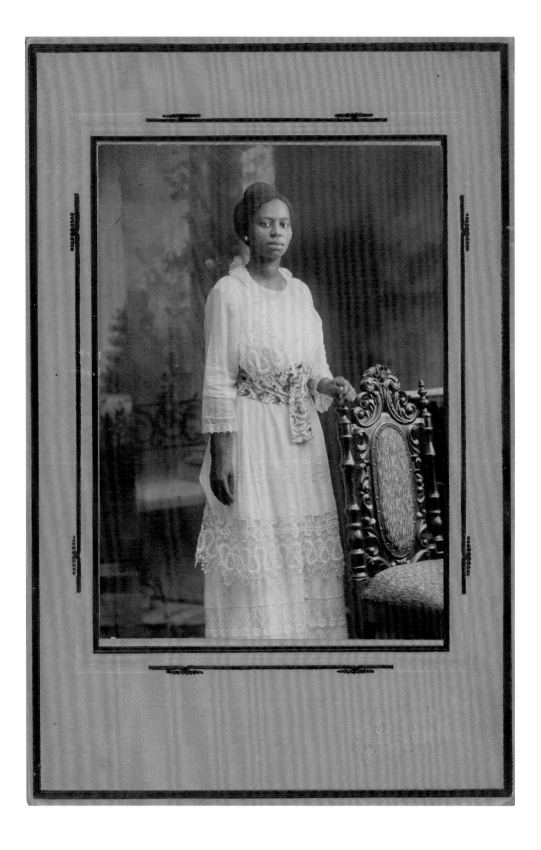

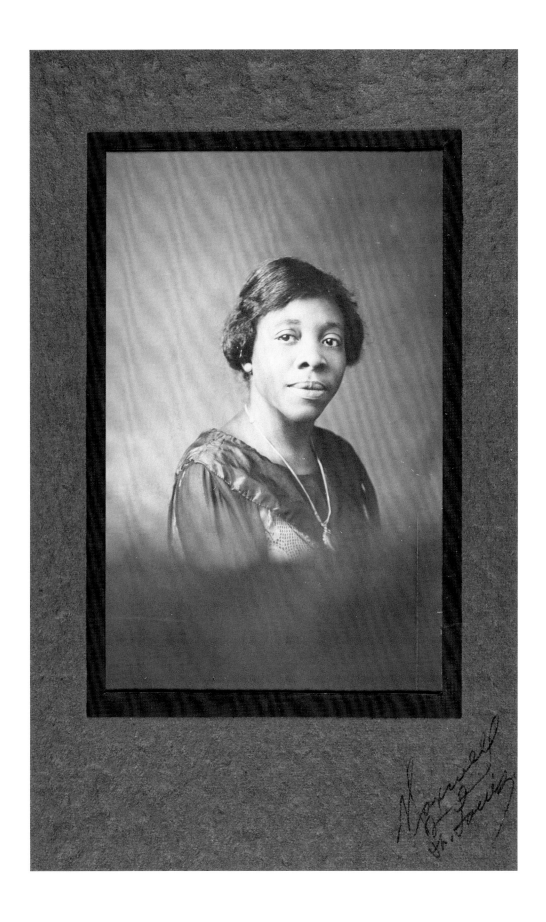

Plate 22
William P. Greene
R. Emmett Stewart, ca. 1910
Gelatin silver print on
original mount

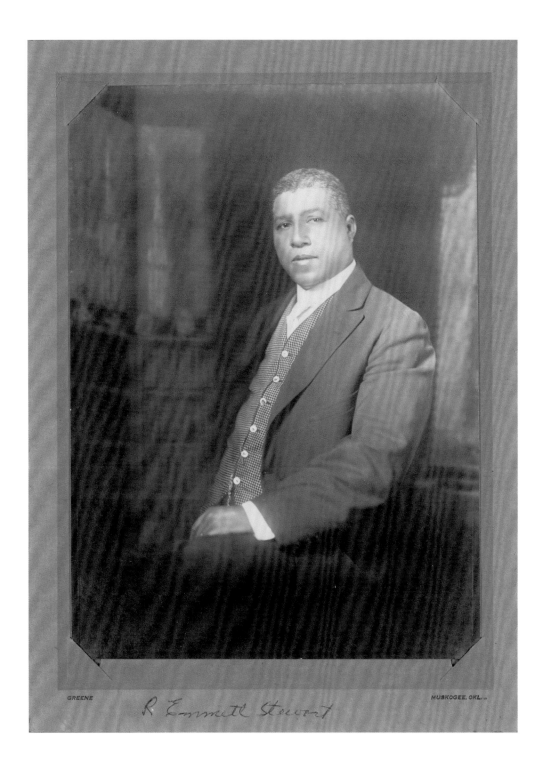

Plate 23
Addison Scurlock
*Portrait of Man, with
Mustache*, ca. 1915
Gelatin silver print on
original card mount

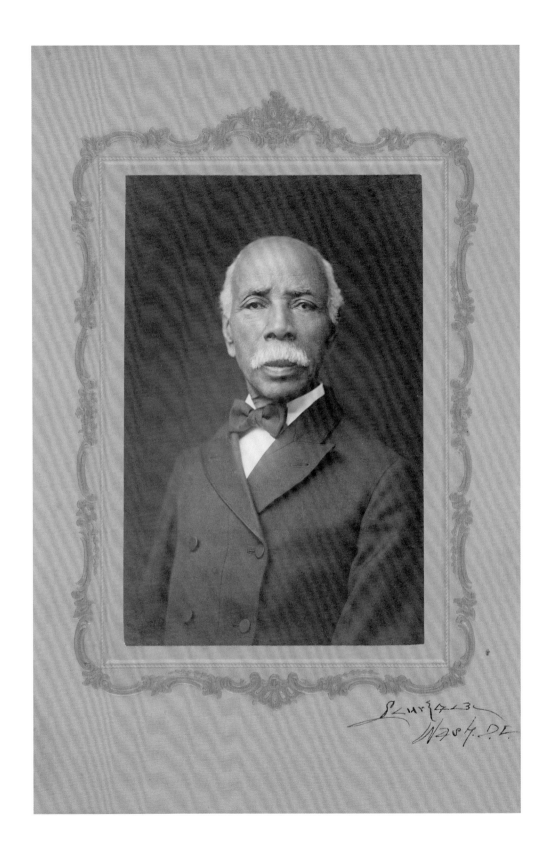

Plate 25
Addison Scurlock
*Portrait of a Man, with
Two Dogs*, ca. 1915
Gelatin silver print in
original mount

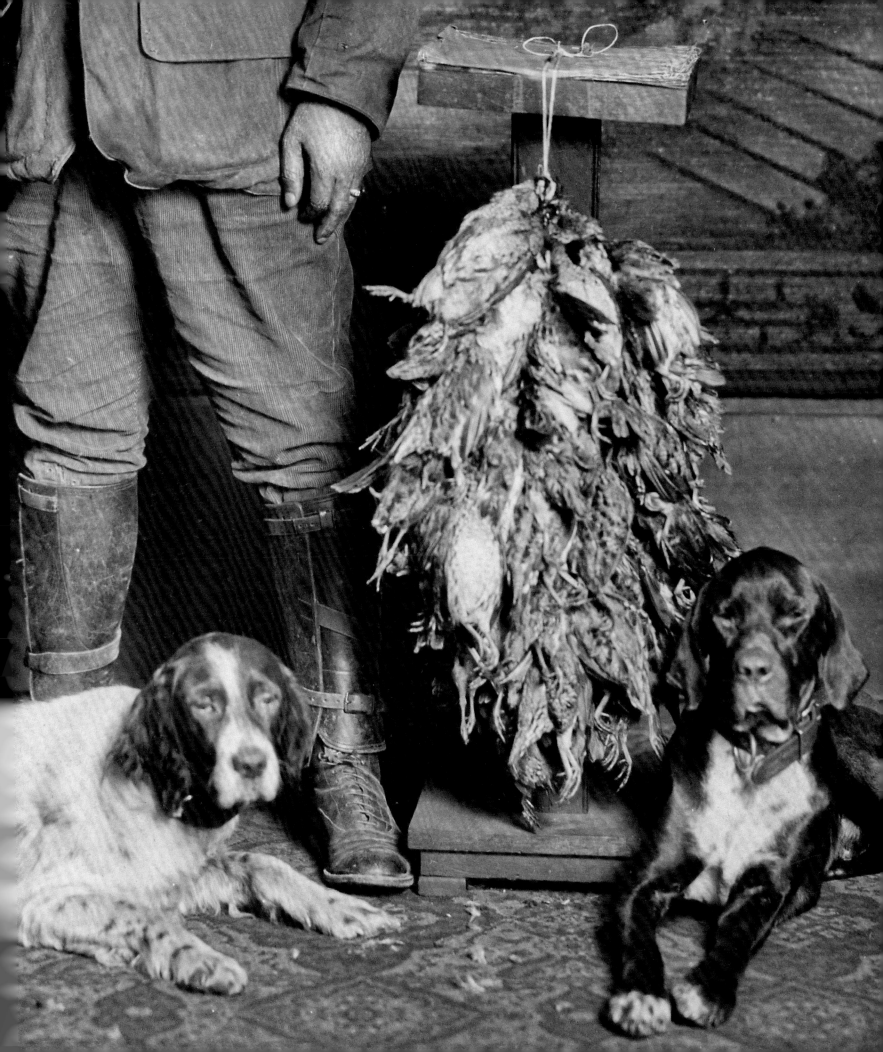

Plate 26
Florestine Perrault Collins
*Portrait of a young woman
dressed in white*, 1920-1928
Gelatin silver print in
original mount

Plate 27
Paul Poole
Portrait of a Woman,
Wearing Graduation Cap
and Gown, ca. 1930
Gelatin silver print in
original mount

Plate 29
Roberts Studio
*Portrait of a Woman, holding
a bouquet of roses*, ca. 1925
Gelatin silver print in
original mount

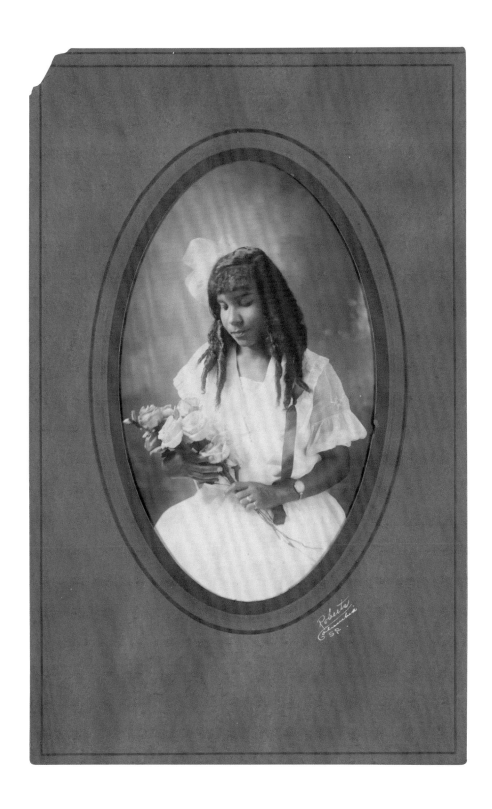

Plate 30
Walter Baker's Studio
Portrait of a Woman, holding a
bouquet of flowers, ca. 1920
Gelatin silver print, hand-tinted,
in original mount

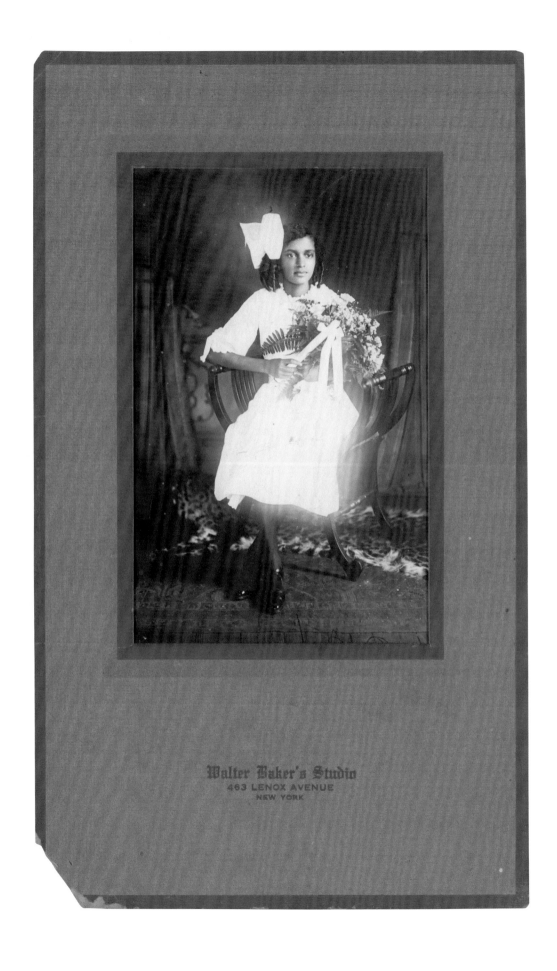

Plate 31
Woodard's Studio, Kansas City
*Portrait of a Woman,
with Flowers*, ca. 1925
Gelatin silver print on
original mount

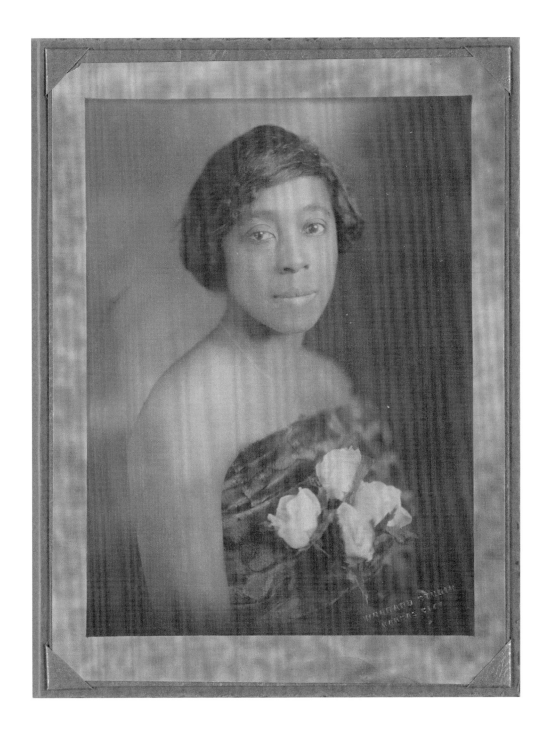

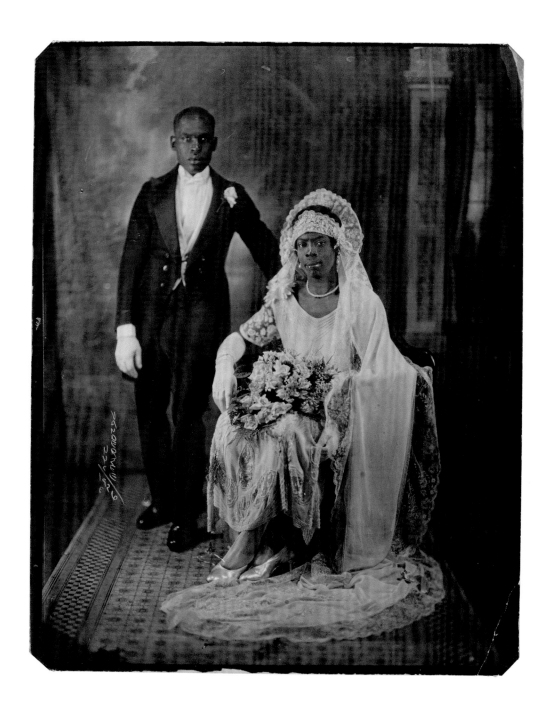

Plate 33
Allen E. Cole
*Portrait of a Woman,
seated*, ca. 1925
Gelatin silver print in
original mount

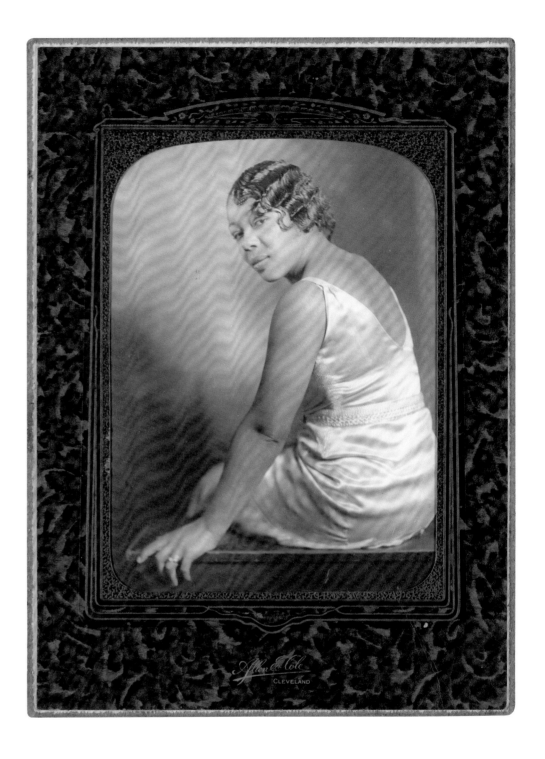

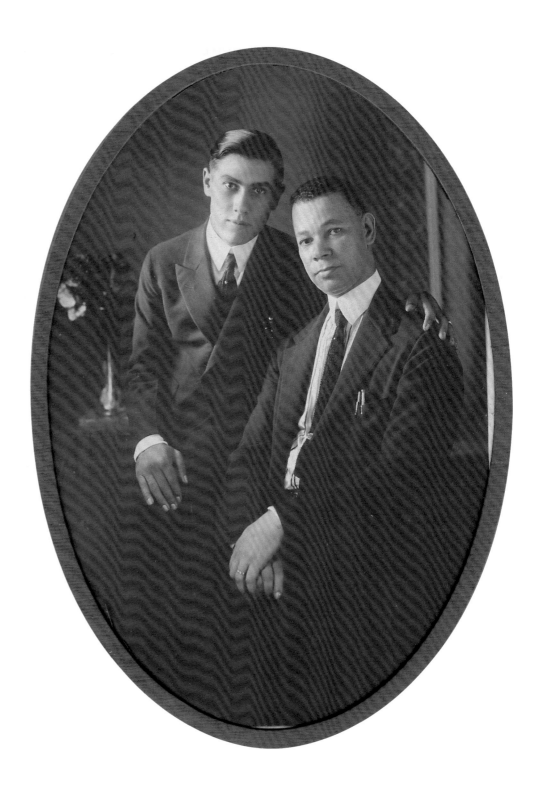

Plate 35
Hooks Brothers Studio
*Untitled [Two Women
on a Bench]*, 1941-1942
Gelatin silver print

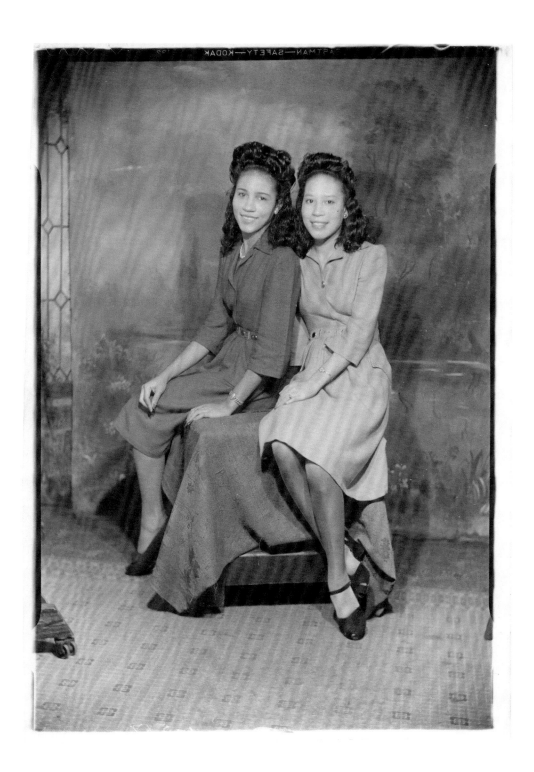

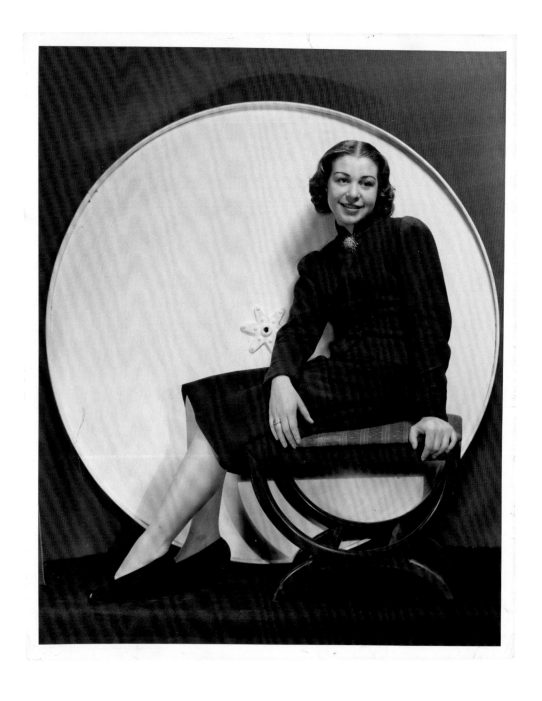

Plate 37
Morgan and Marvin Smith
Milton Jackson, 1946
Gelatin silver print

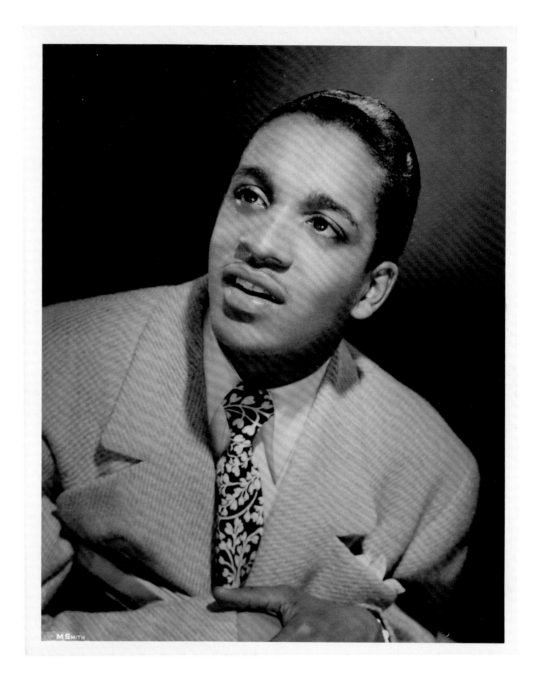

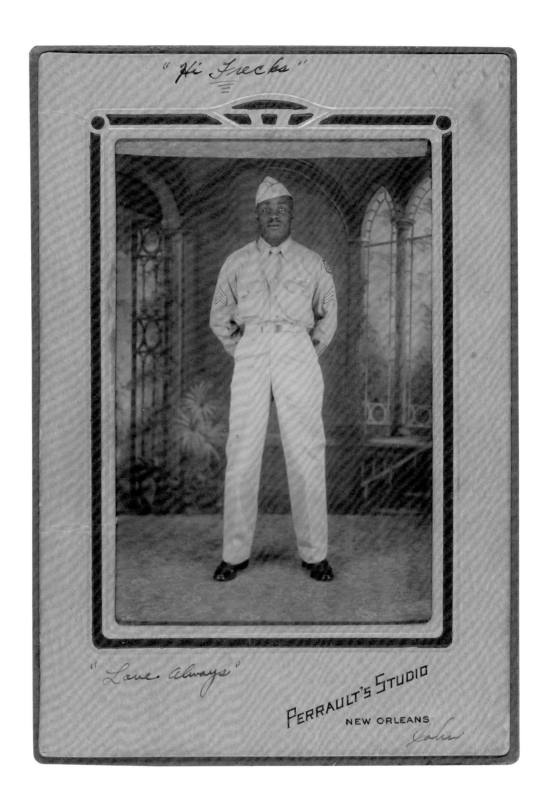

Plate 39
Hooks Brothers Studio
Untitled [Woman in oyster print dress], ca. 1950
Gelatin silver print in
original mount

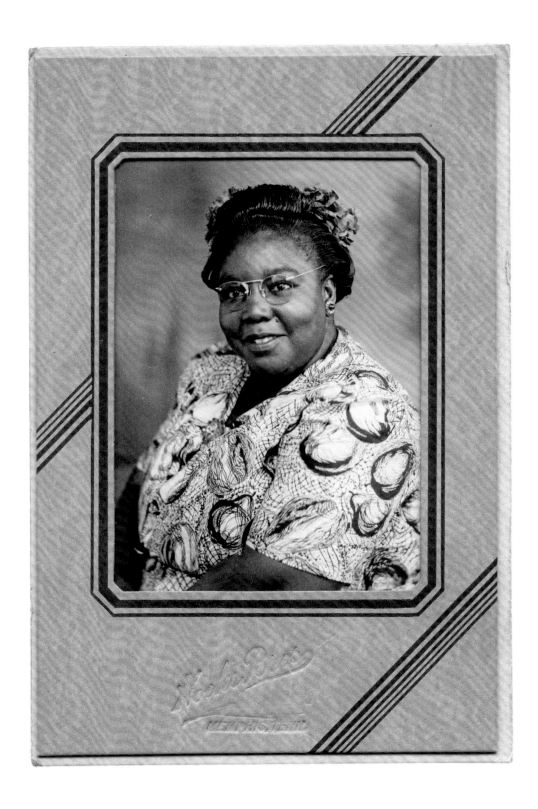

Plate 40
Rev. Henry Clay Anderson
*A hand-tinted portrait of a
young woman*, 1950s
Gelatin silver print, hand-tinted

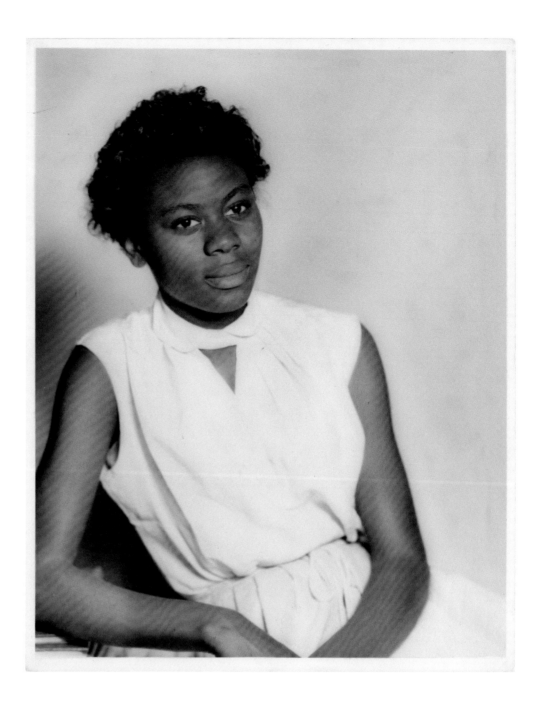

Plate 41
Rev. Henry Clay Anderson
Indoor portrait of a woman, 1950s
Gelatin silver print

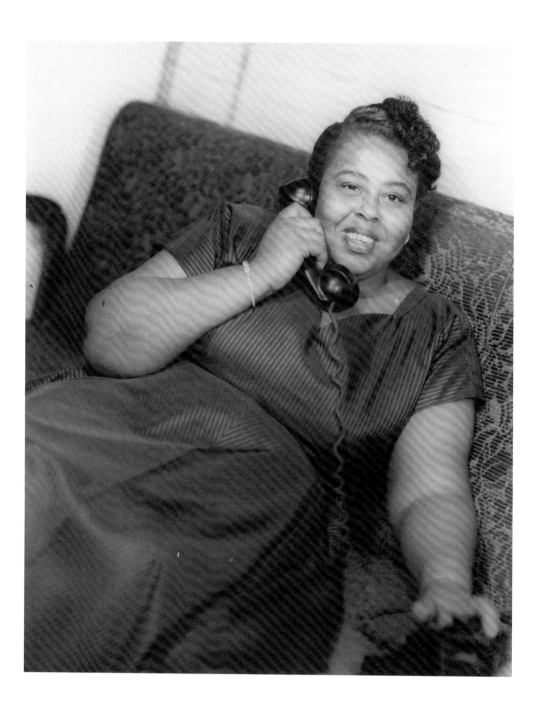

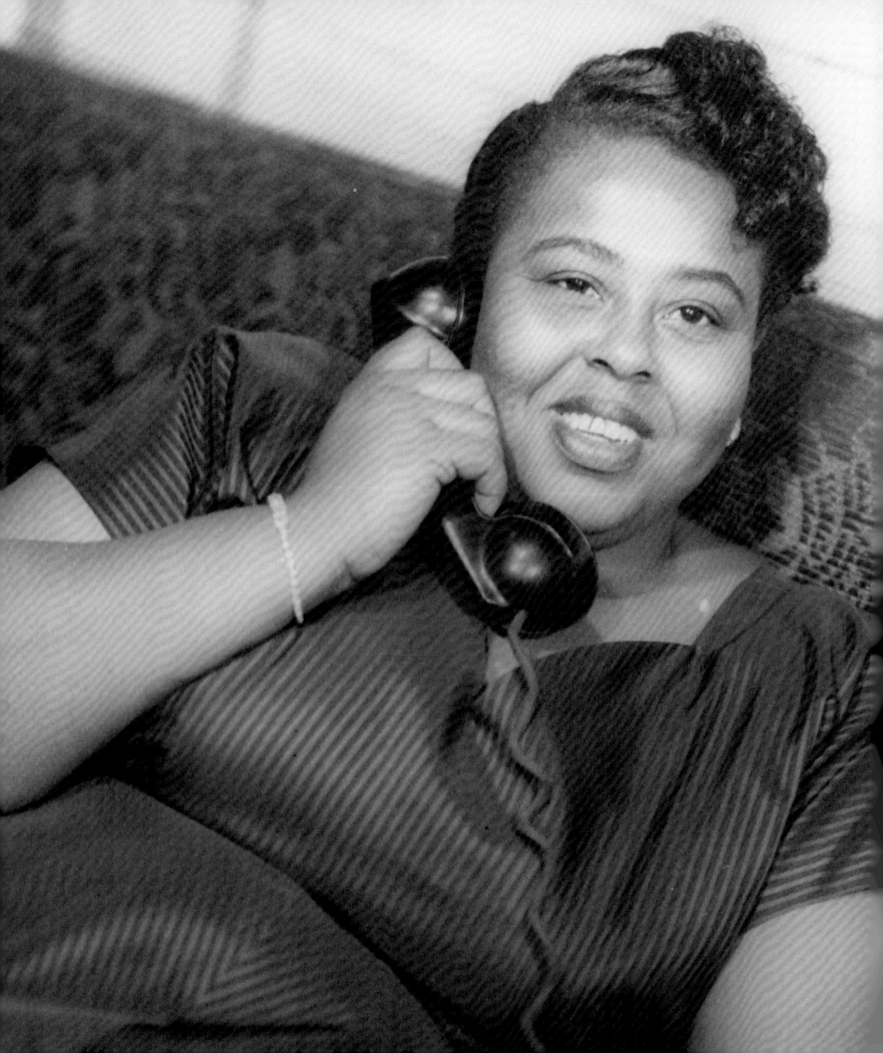

Plate 42
Rev. Henry Clay Anderson
*Studio Portrait of Father
and Child*, 1950s
Gelatin silver print

Plate 43
Austin Hansen
Portrait of a Couple, 1960s
Gelatin silver print

Plate 44
Austin Hansen
Mrs. Smalls, 1960s
Gelatin silver print

Plate 46
Rev. Henry Clay Anderson
Studio portrait of a young man in an Army uniform, 1960-1970s
Gelatin silver print

Plate 47
Hooks Brothers Studio
Portrait of a Woman, 1972
Gelatin silver print

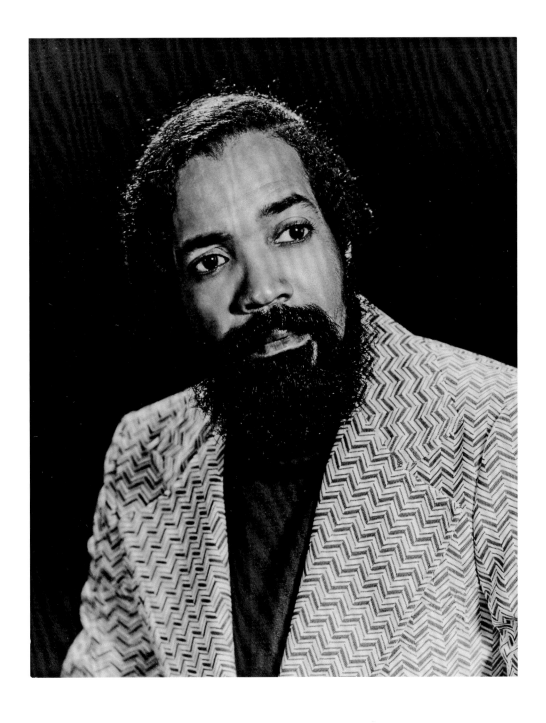

INSIDE THE STUDIO

Focused on the business-at-hand, Black studio photographers made far fewer photographs of their working spaces than they did of their clients. Still, the following photographs of studio rooms and the activities that occurred therein stand as important records of the labor that these photographers executed. Moreover, they are photographs about photography and about photography professionals. Some of these images are staged, like when Morgan and Marvin Smith stepped in front of the camera to illustrate their craft with full light rigs and models. Students at the Hooks Brothers' Studio photography school experimented on both sides of the camera, illustrating the many different phases of the work in which a studio photographer was engaged. Here, these pictures appear in equal turn documentary, graphic, or theatrical. In number, these may be the smallest subgenre of photographs produced by Black American studio photographers, but they are crucial as evidence of Black photographic labor, education, and professionalism.

They also call our attention to photography studios as spaces where Black Americans gathered regularly. The photographs cannot precisely relay what sorts of conversations swirled around the studio when, for instance young activist Roy Innis sorted prints for Austin Hansen or Al Green pantomimed for the Hooks Brothers, but they can serve as a kind of visual synecdoche for the role photography studios served as an incubator for Black political and cultural activity. These photographs, as well as the group portraits included here, illustrate the photography studio as a truly generative space in Black American community life. If the studio photographers included in this volume made it possible for Black Americans to visualize themselves individually, those same photographers also served to represent Black Americans collectively: in families, as institutions, and as political bodies.

Addison Scurlock
Studio Interior (detail), 1911
Gelatin silver print

Plate 49
Austin Hansen
Roy Innis drying pictures for
Hansen in Studio on
135th Street in Harlem, 1958
Gelatin silver print

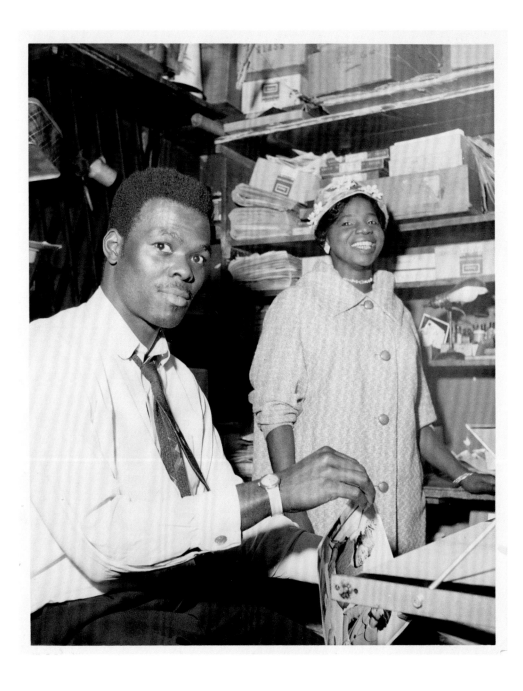

Plate 50
Addison Scurlock
Studio Interior, 1911
Gelatin silver print
Scurlock Studio Records, ca. 1905-1994,
Archives Center, National Museum of
American History, Smithsonian Institution,
Washington, DC

Plate 51
Attributed to Cornelius M. Battey
Tuskegee Institute Photo Studio, ca. 1920
Gelatin silver print

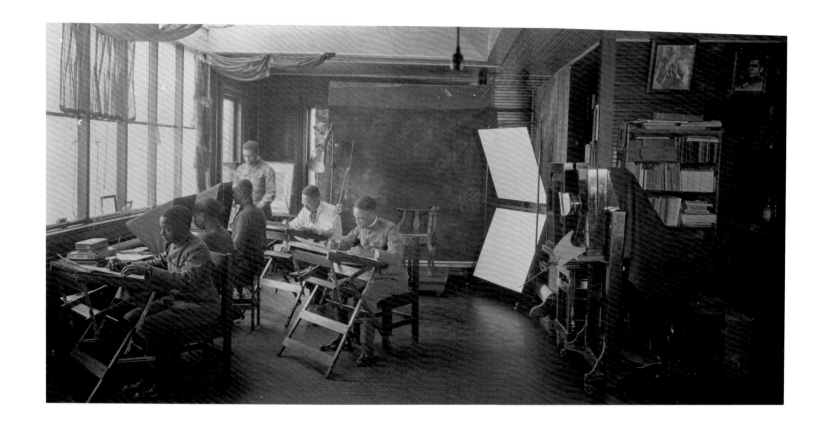

Plate 52
Hooks Brothers Studio
*Untitled [Hooks School of Photography
Students Looking at Prints]*, ca. 1950
Gelatin silver print

Plate 53
Hooks Brothers Studio
*Untitled [Hooks School of
Photography Students]*, ca. 1950
Gelatin silver print

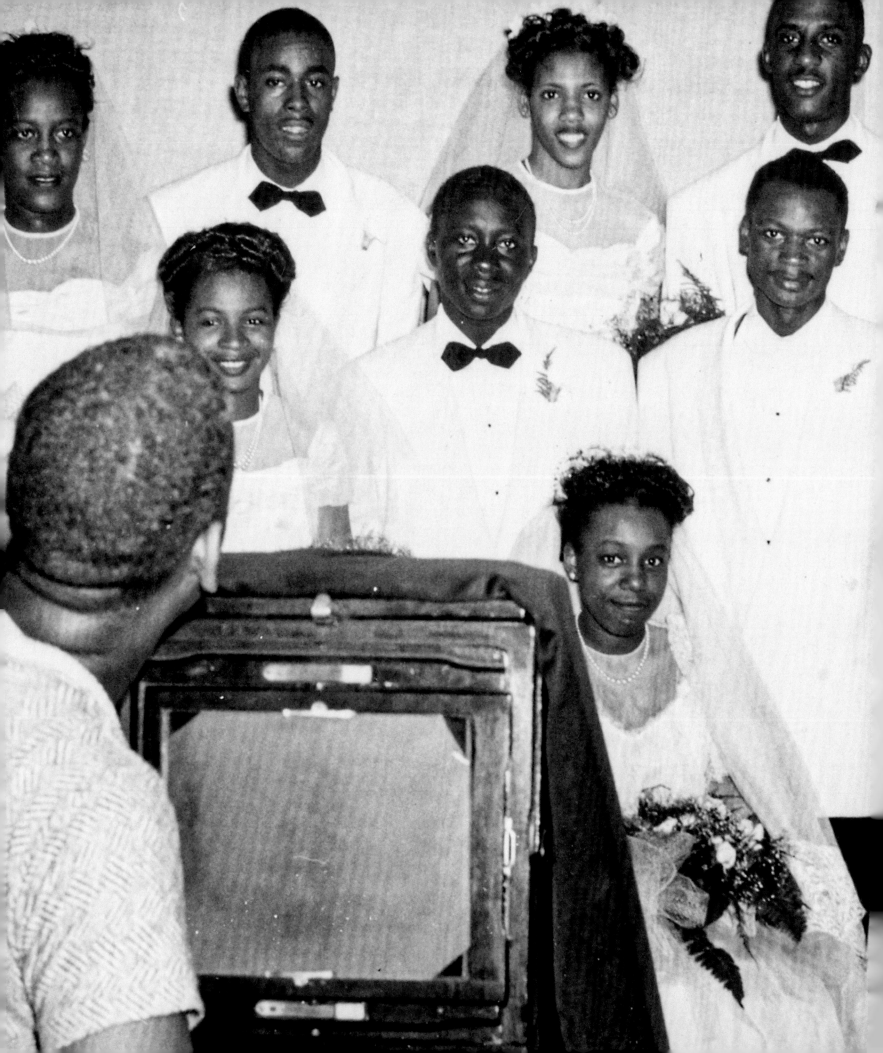

Plate 54
Edgar W. Moorer
Wedding Party in Studio, ca. 1955
Gelatin silver print

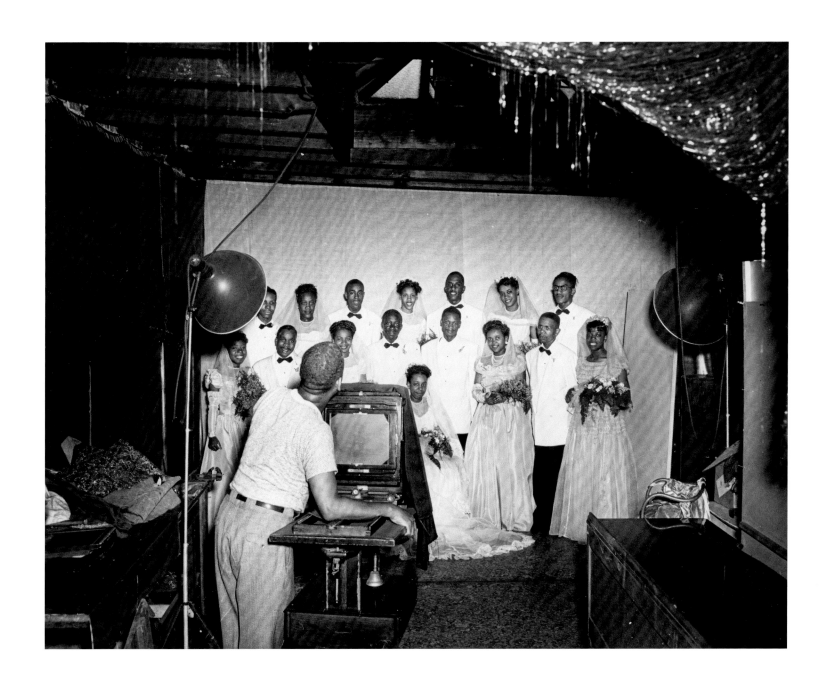

Plate 56
Morgan and Marvin Smith
*Untitled [One Model, One
photographer working in studio,
photocollage on wall]*, ca. 1945
Gelatin silver print

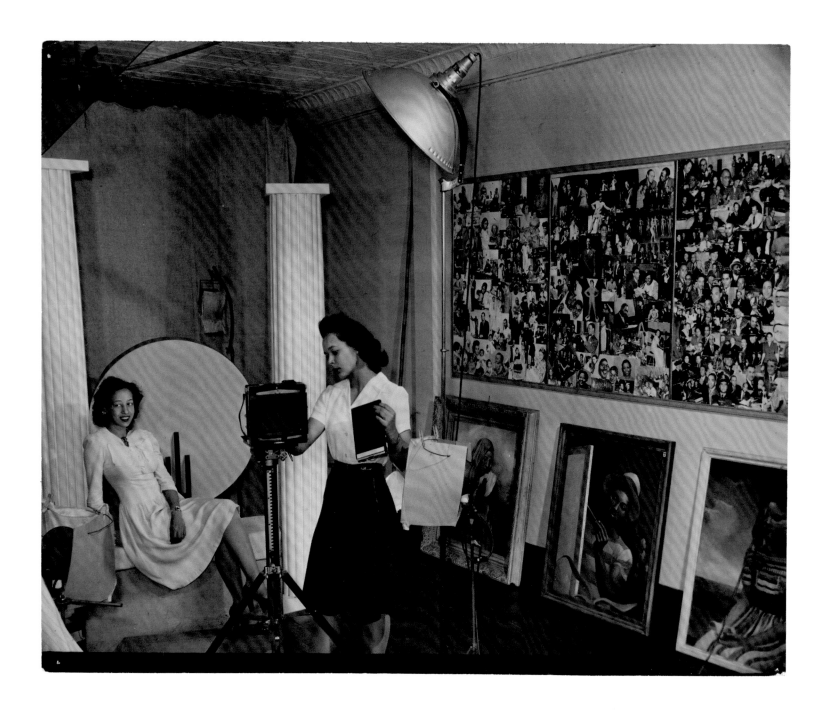

Plate 58
Morgan and Marvin Smith
Paul Meeres Jr. and Partner,
M. Smith Studio Backdrop, ca. 1948
Gelatin silver print

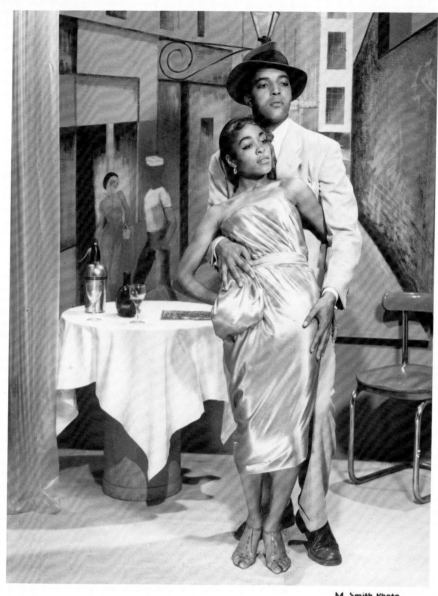

M. Smith Photo

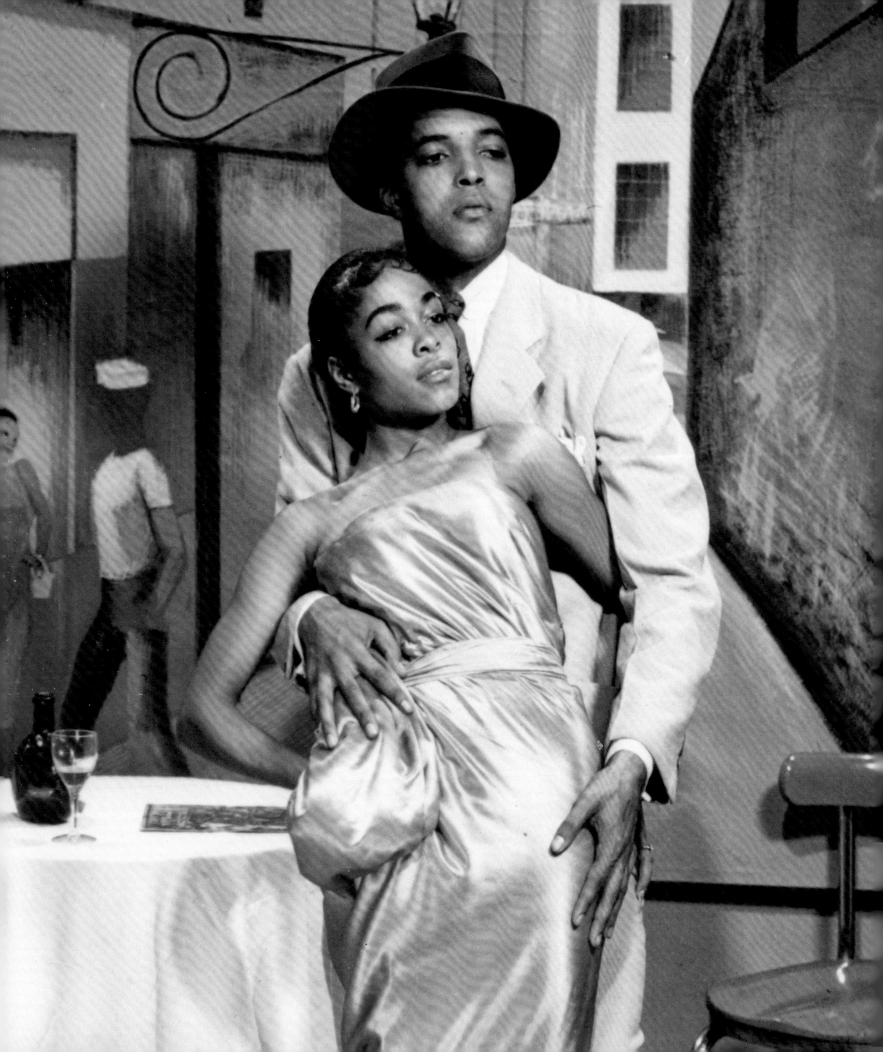

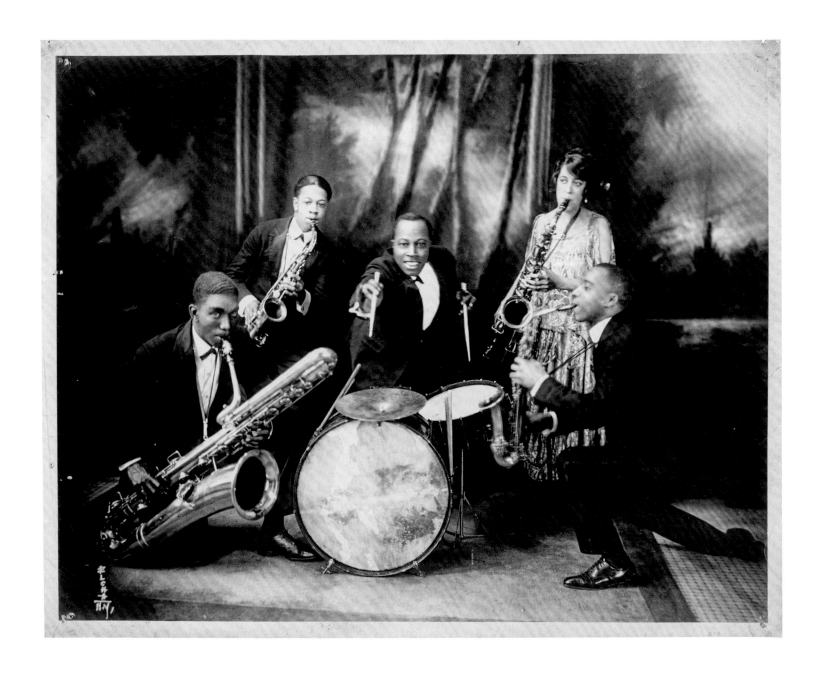

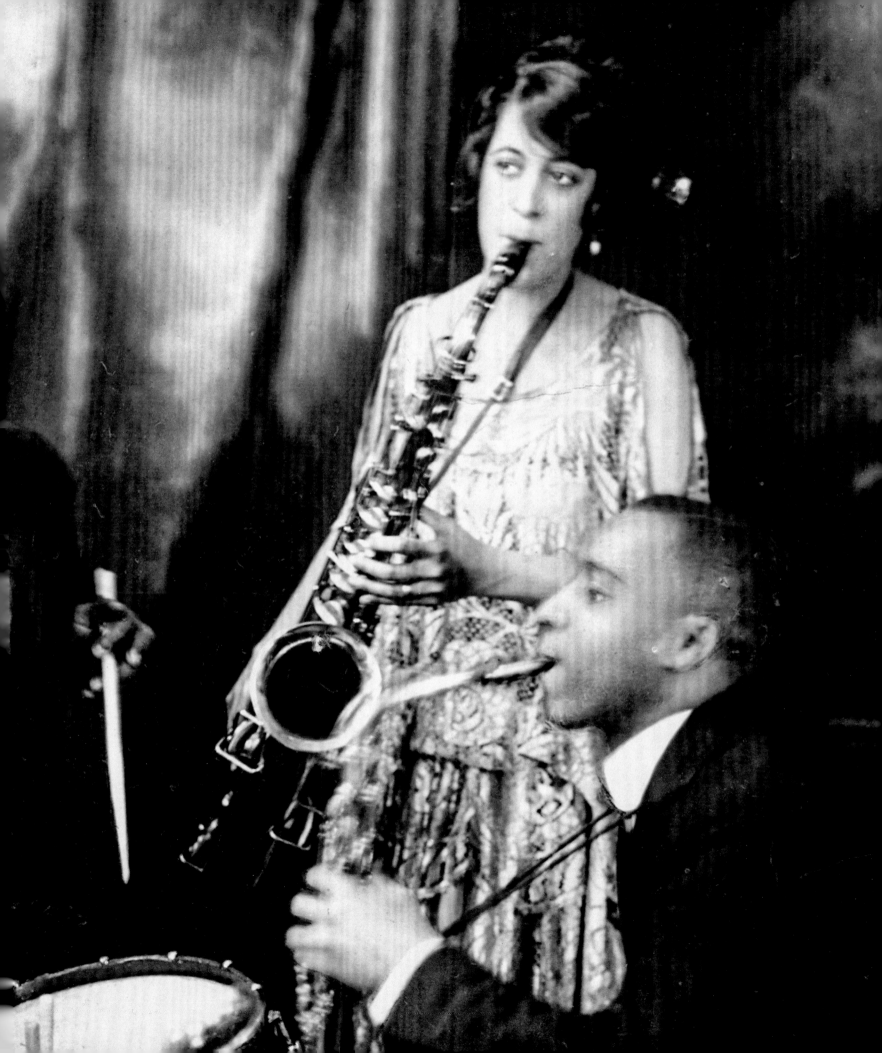

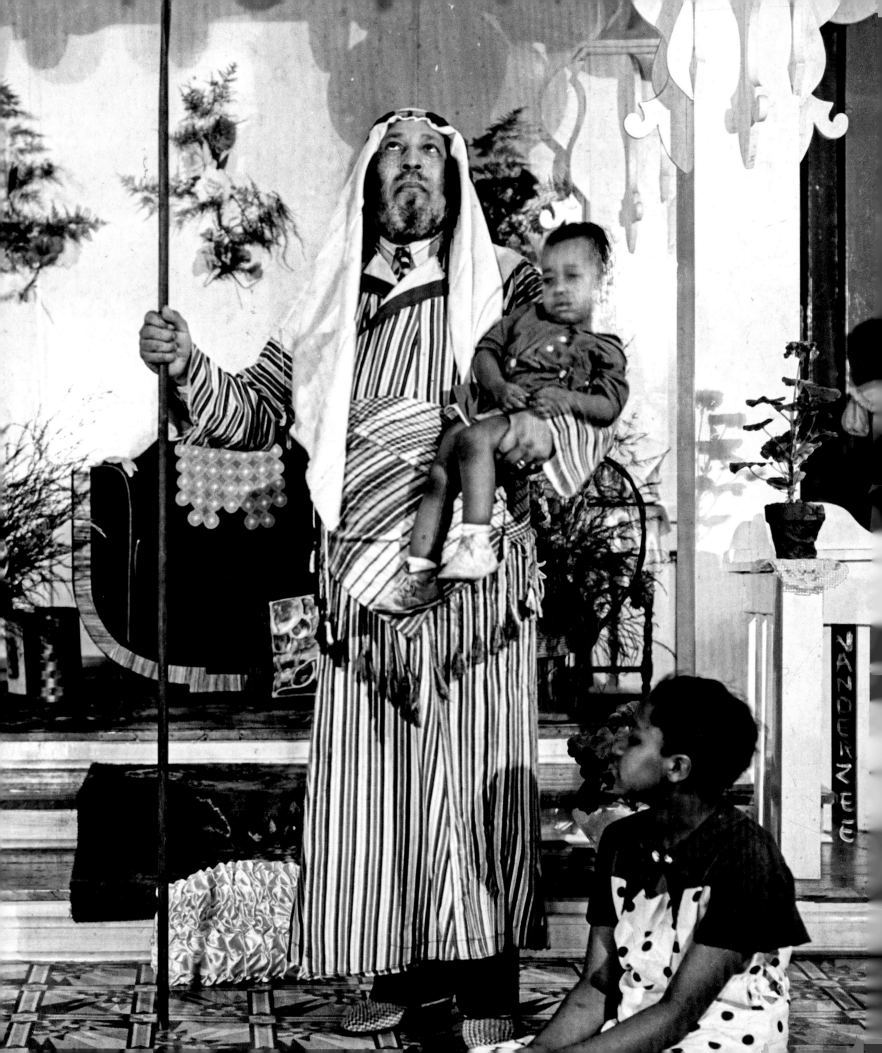

Plate 61
James Van Der Zee
Daddy Grace, 1938
Gelatin silver print

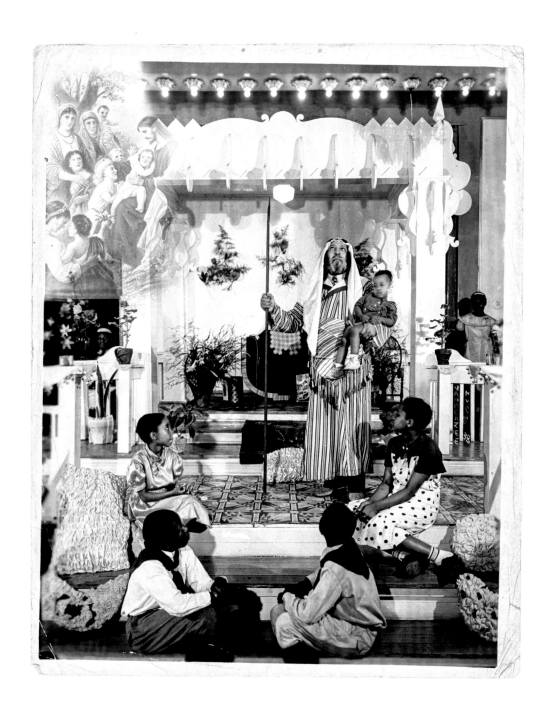

Plate 63
Hooks Brothers Studio
*Untitled [Man in Dollar Bill Suit
with Group]*, ca. 1940
Gelatin silver print

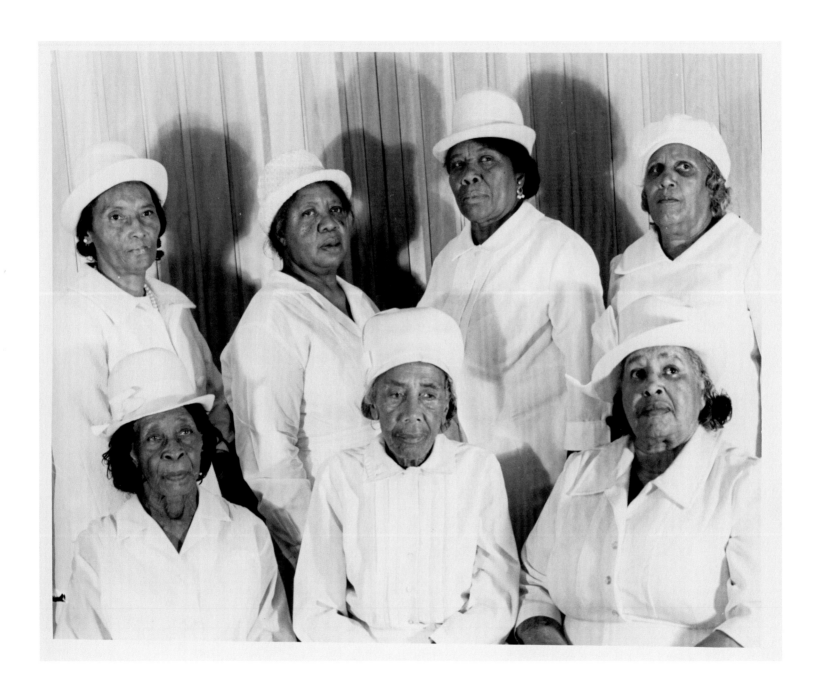

Plate 66
Hooks Brothers Studio
*Al Green in the Hooks
Brothers Studio*, ca. 1968
Gelatin silver print

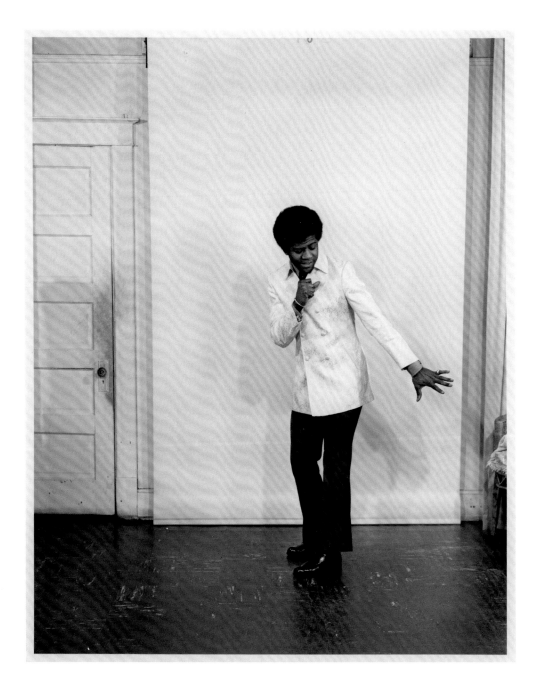

Plate 67
Hooks Brothers Studio
*Untitled [Studio Curtain
Study]*, ca. 1960
Gelatin silver print

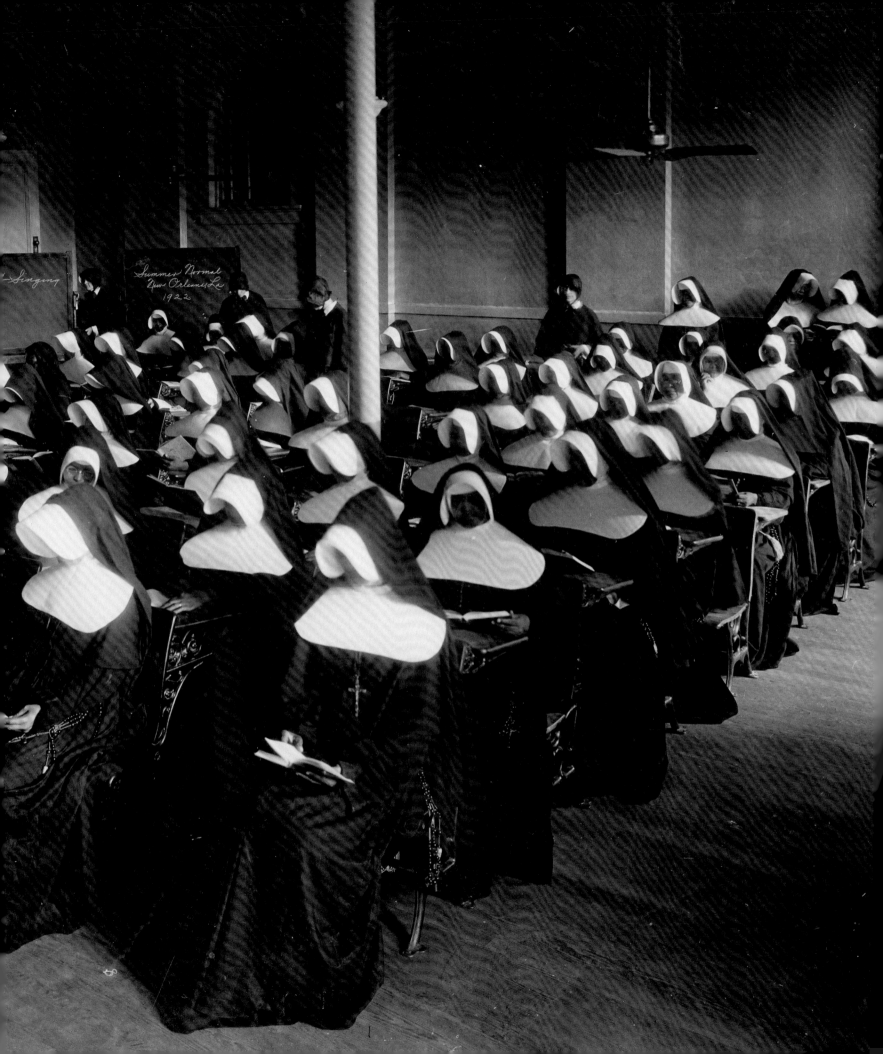

BEYOND THE STUDIO

While the portrait studio was a central focus for the photographers collected in this volume, the demand for other kinds of photography and the necessities of running a business regularly drew photographers outside of their home base and into the community. Here, we begin to see the wider variety of work that Black American studio photographers produced every day. Some of these works reflect long professional engagements, such as Arthur P. Bedou's photographs for Tuskegee Institute or Xavier University of Louisiana. Conventions and fraternal gatherings routinely contracted a professional to record the occasion, represented here by panoramic prints produced by Addison Scurlock and William E. Woodard. Some studio photographers, like Ernest Withers, routinely moonlit as photojournalists selling images to the Black press, and in the process made some of the most iconic historical images of the civil rights movement. Here, again, photographers helped constitute community through photographs of the people, events, and locations that they moved through in their daily lives.

Black photographers who spent most of their time in a space where they could control the light, subjects, or any number of other things in front of their camera, also made photographs out in the world and in real time. This required the use of different cameras that could fit larger groups of people into one picture or freeze fast-moving action. Most of the photographs reproduced here come from paid assigments, and were requested by clients who wanted the same quality a studio photographer provided but in a different, and sometimes more challenging, setting. As the photographs in this section illustrate, when Black American studio photographers stepped outside of the portrait range, they flexed their creativity and skill to produce an equally compelling and important body of images.

Arthur P. Bedou
*Sisters of the Holy Family,
Classroom Portrait* (detail), 1922,
Gelatin silver print

Plate 68
James Van Der Zee
Marcus Garvey, 1924
Gelatin silver print

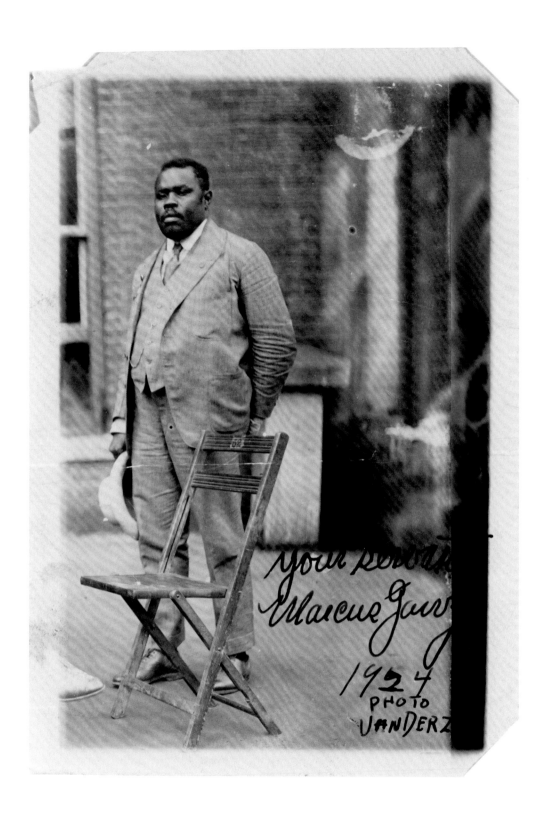

Plate 69
Photographer unidentified
"To My Sweet Baby Brother,
From Sister," ca. 1945
Gelatin silver print in
original mount

Plate 70
Arthur P. Bedou
Sisters of the Holy Family,
Classroom Portrait, 1922
Gelatin silver print

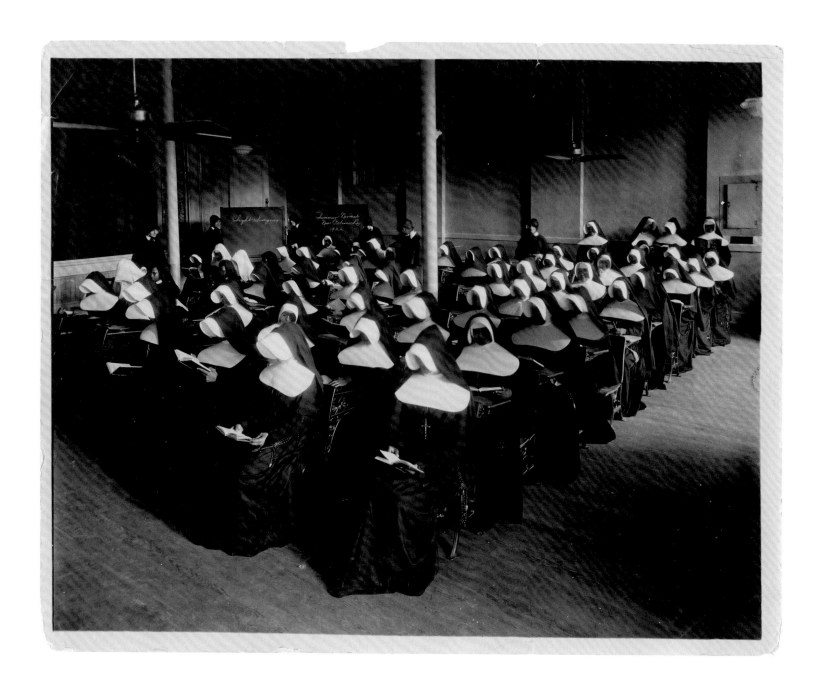

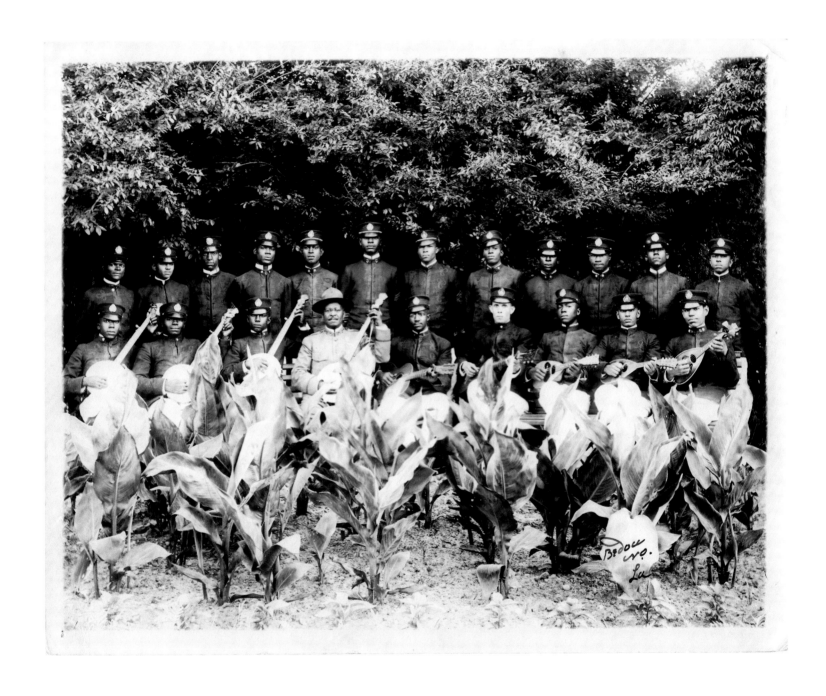

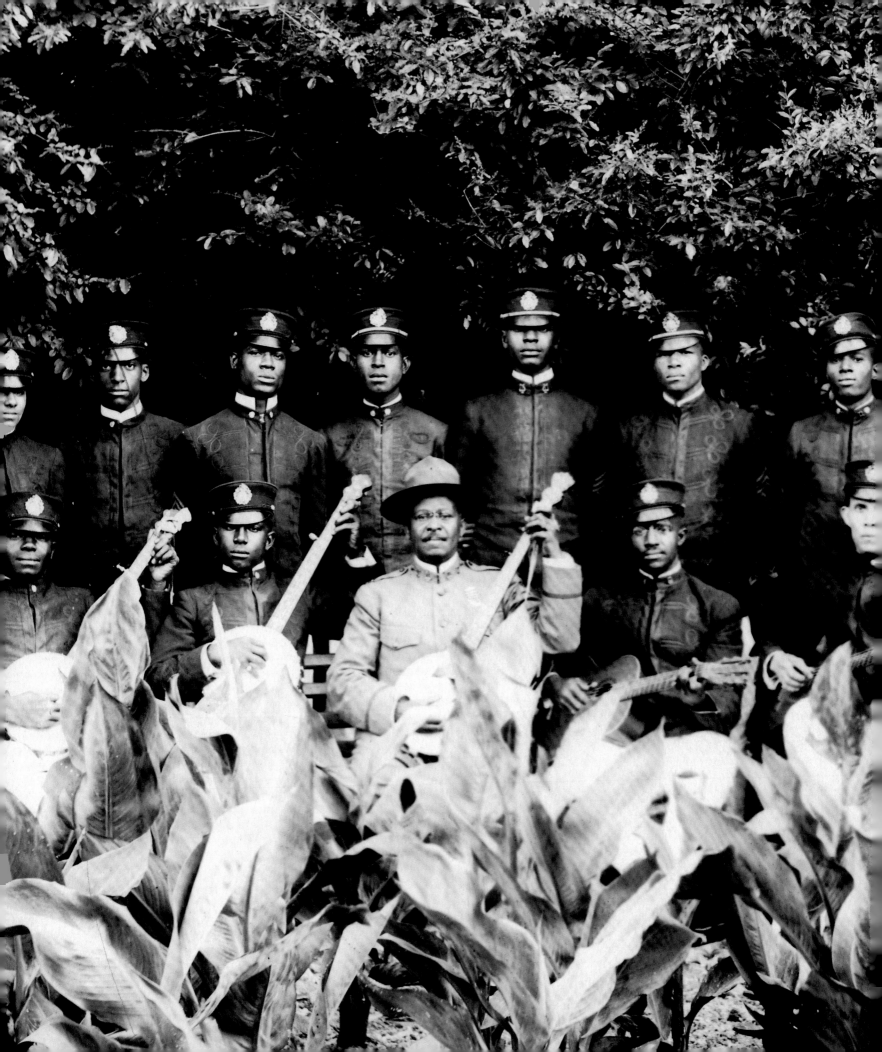

Plate 72
Arthur P. Bedou
Booker T. Washington on
His Favorite Mount Dexter, 1915
Gelatin silver print

Plate 73
Addison Scurlock
Waterfront, ca. 1915
Gelatin silver print
Scurlock Studio Records, National
Museum of American History

Plate 74
Hooks Brothers Studio
*Untitled [Woman and Man
posing on a car]*, ca. 1955
Gelatin silver print

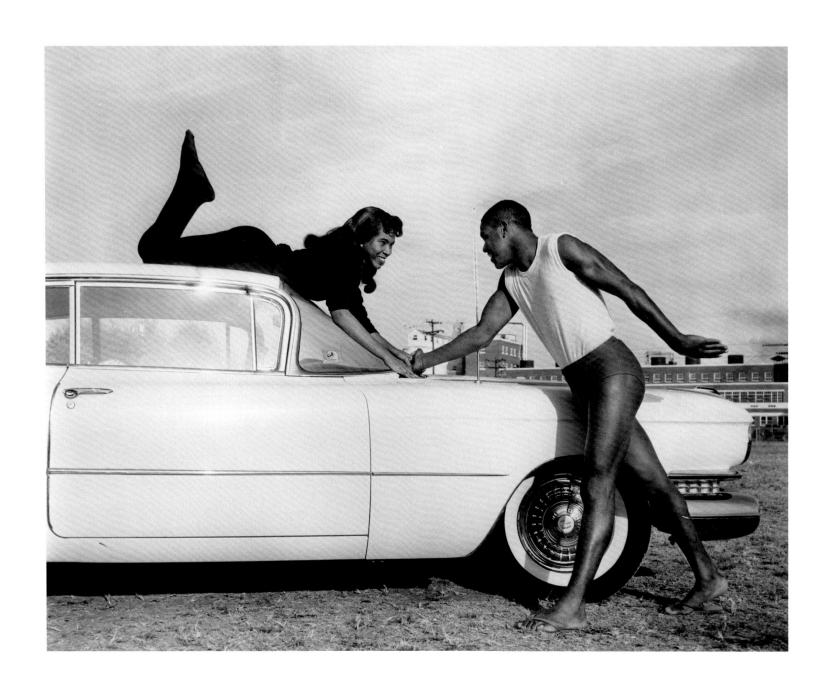

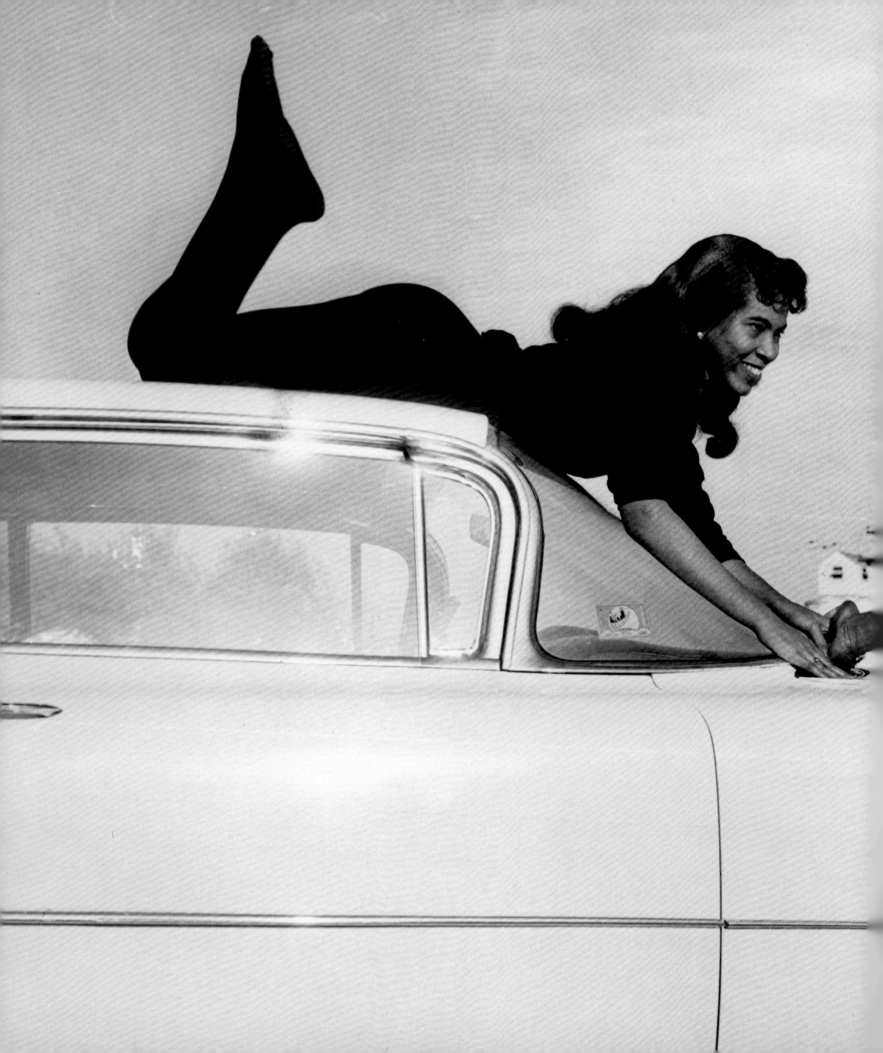

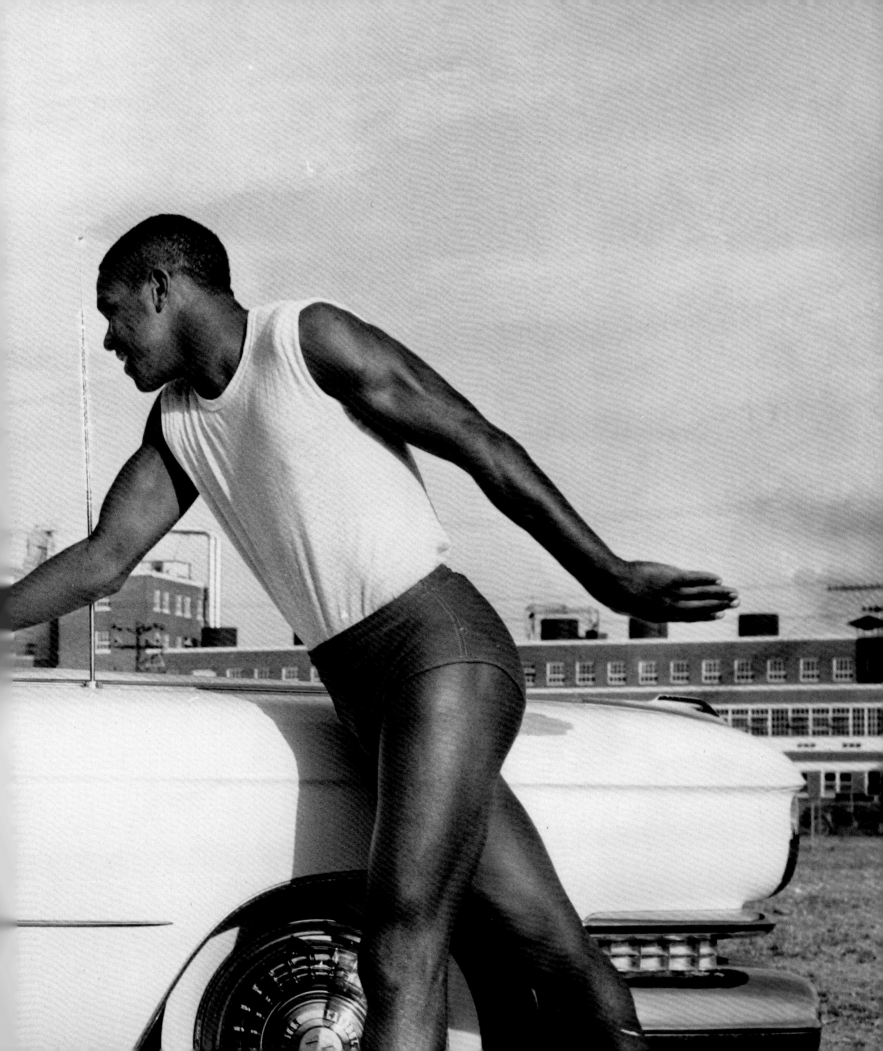

Plate 75
Austin Hansen
*Members of Grand United Order of Odd
Fellows in America Parade in Harlem*, 1950s
Gelatin silver print

Plate 76
Nolan A. Marshall, Sr.
*Mr. Numa Rousseve Teaching Painting Students
at Xavier University of Louisiana*, ca. 1955
Gelatin silver print

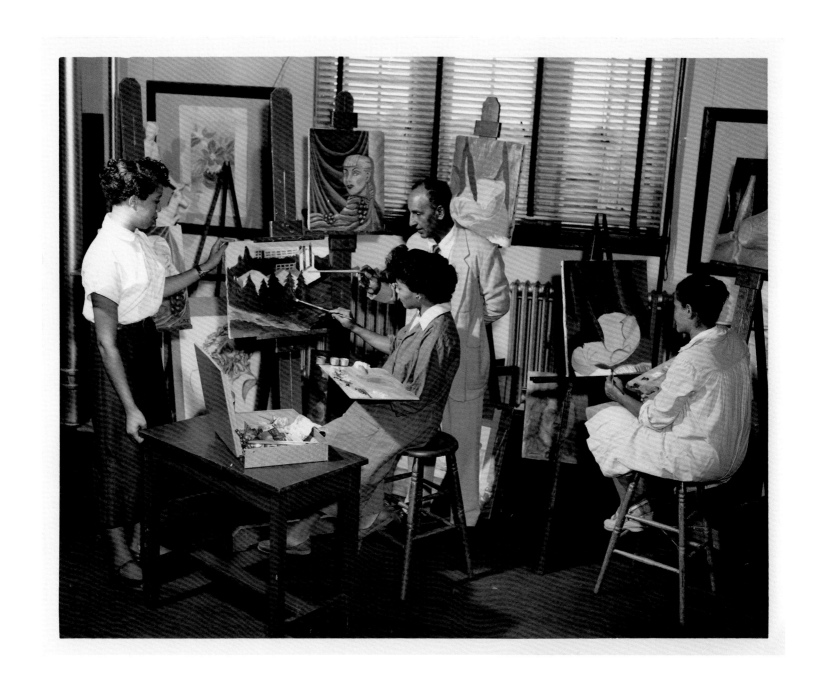

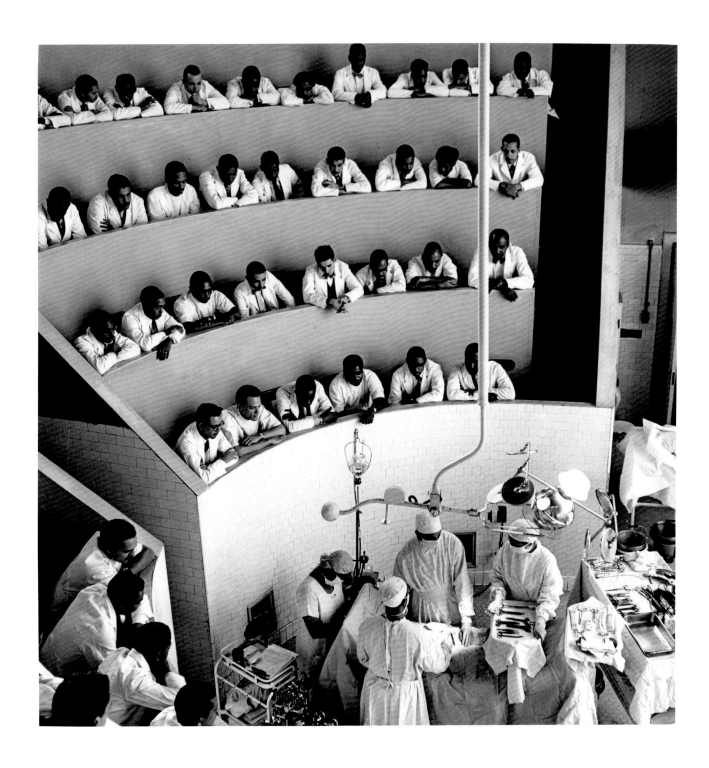

Plate 78
John W. Mosley
In the Stands, Howard University vs.
Lincoln University Football Game, ca. 1940
Gelatin silver print

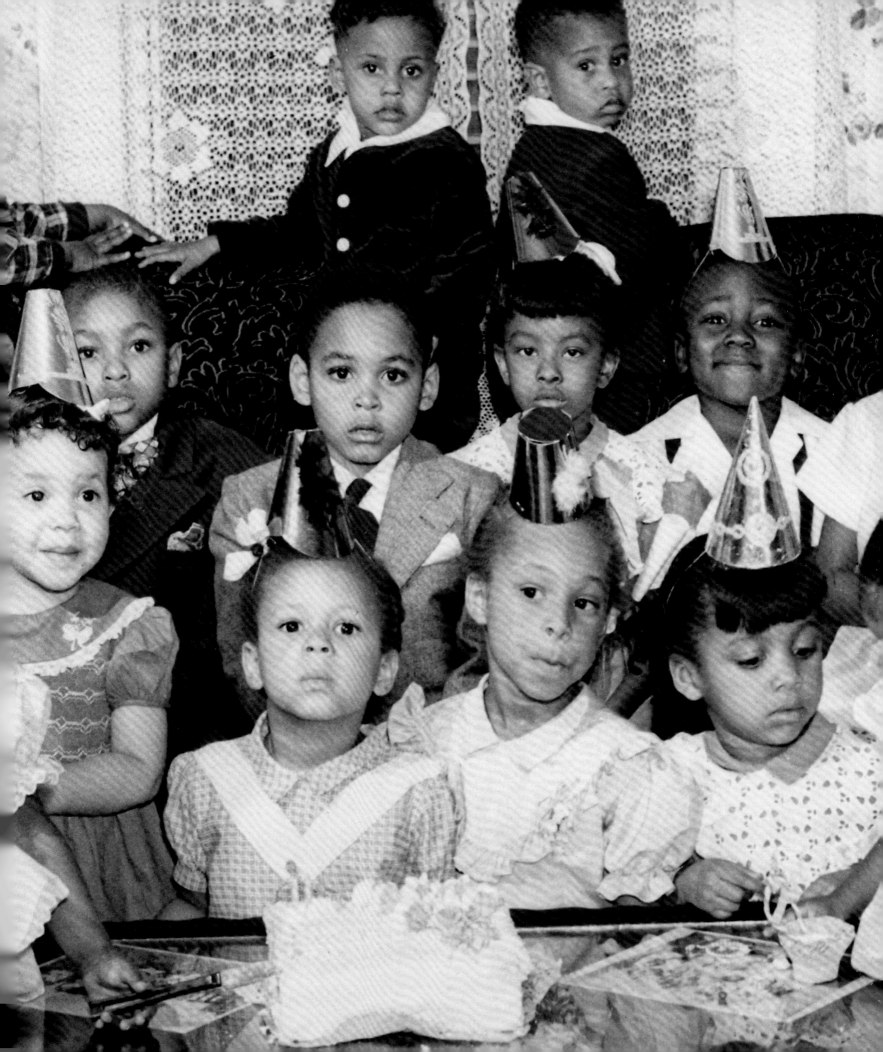

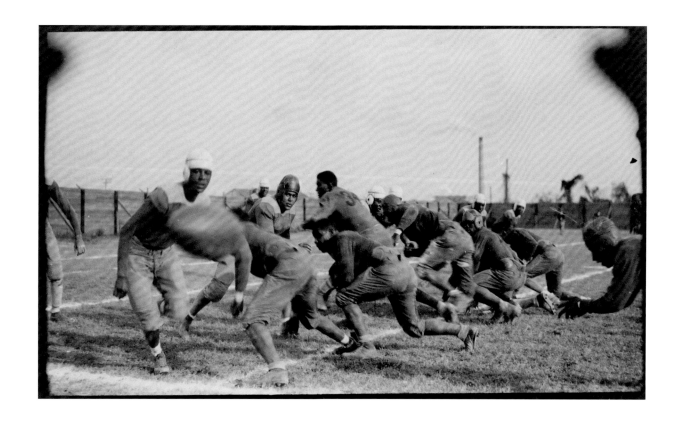

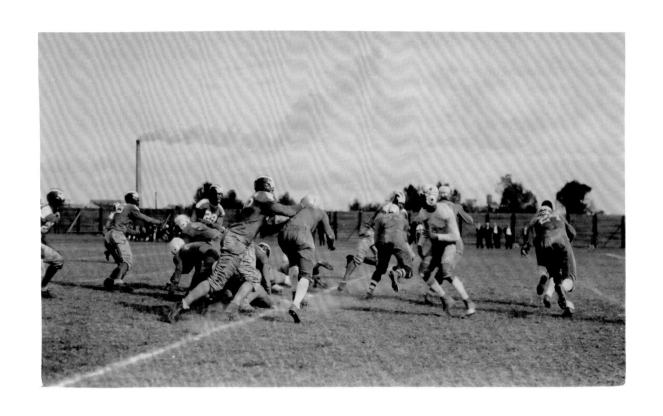

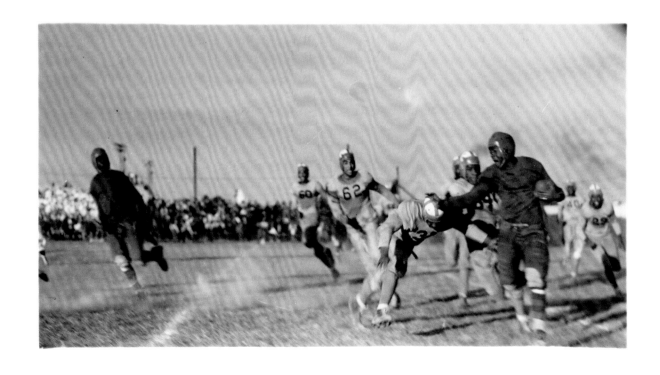

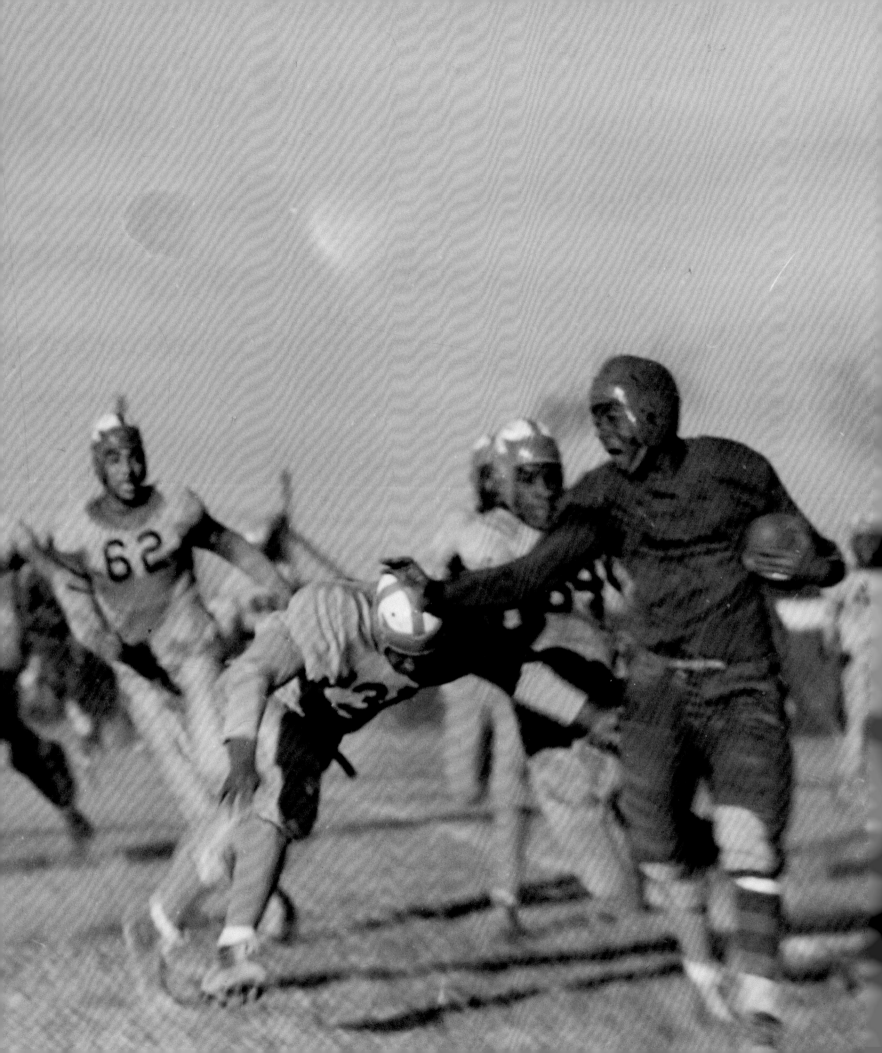

Plate 83
Nolan A. Marshall, Sr.
Charles Evans–Xavier
University Football Squad, 1954
Gelatin silver print

Plate 85
Austin Hansen
View of Elevated Subway Tracks, ca. 1950
Gelatin silver print

Plate 86
Austin Hansen
*Untitled [Lionel Hampton, right,
with Orchestra]*, ca. 1945
Gelatin silver print

Plate 87
Austin Hansen
*Eartha Kitt Teaching a Dance Class
at the Harlem YMCA*, ca. 1955
Gelatin silver print

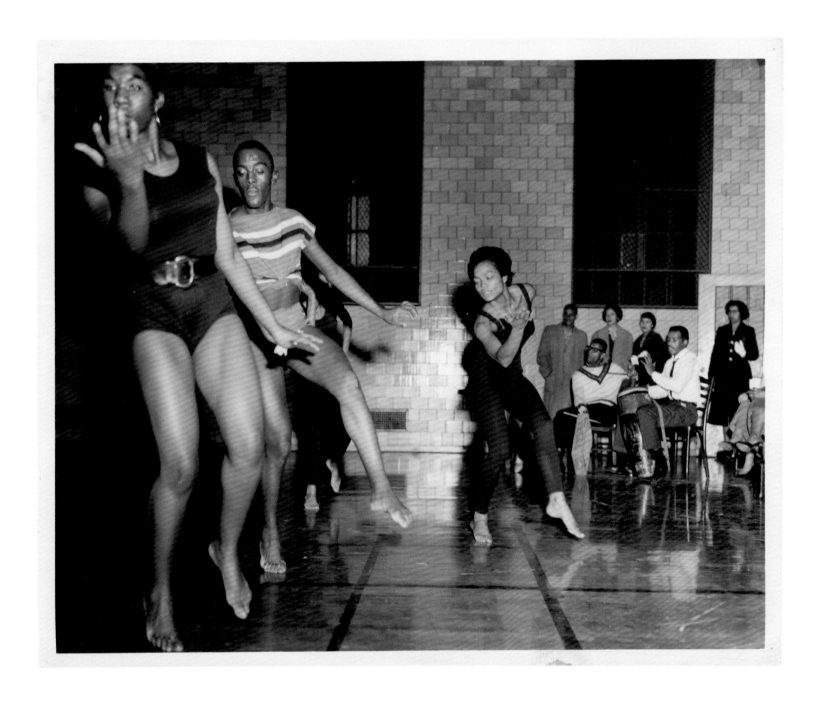

Plate 88
Emmanuel F. Joseph
Dancers, 1942
Gelatin silver print

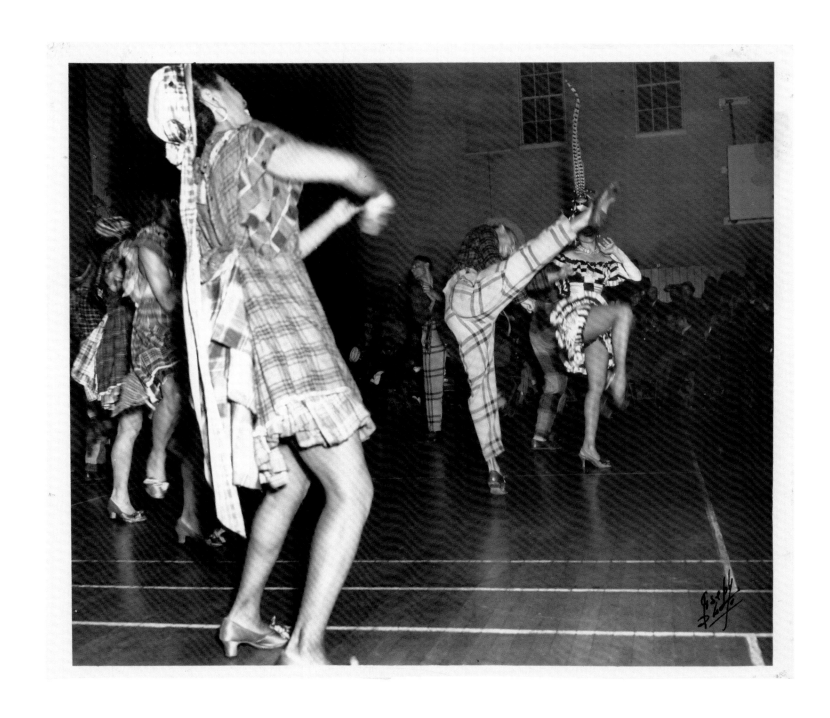

Plate 89
Hooks Brothers Studio
*Group Portrait of Young
Women on a Bus*, 1960s
Gelatin silver print

Plate 90
Hooks Brothers Studio
*Untitled [Onstage at
a Speakers Event]*, 1960s
Gelatin silver print

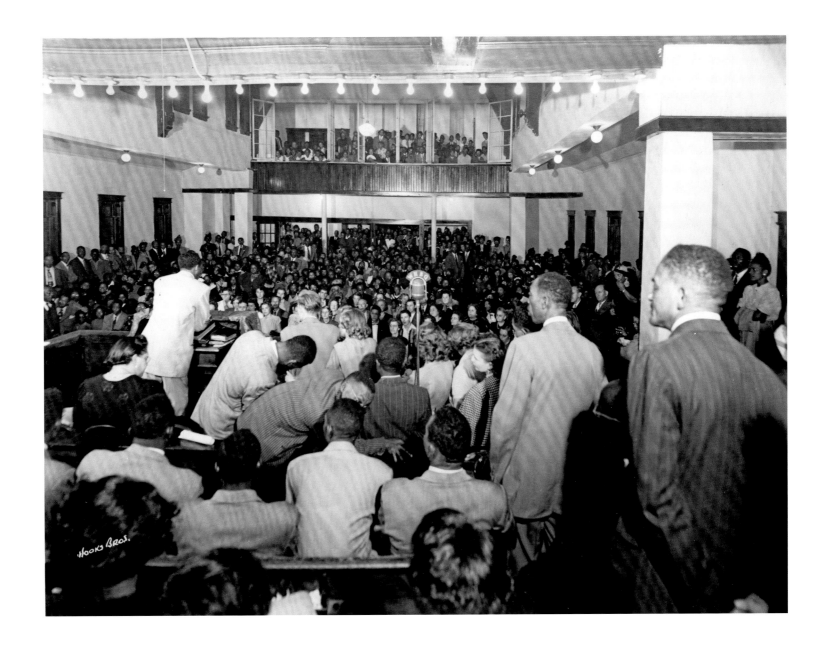

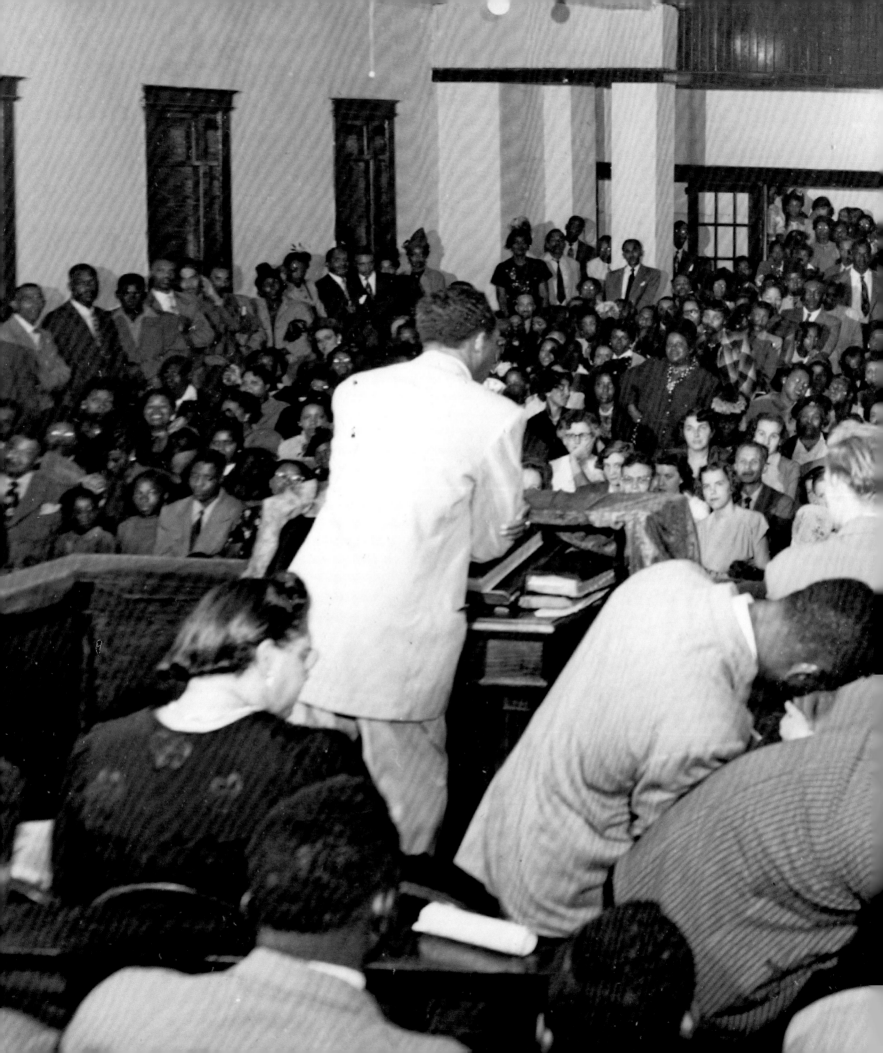

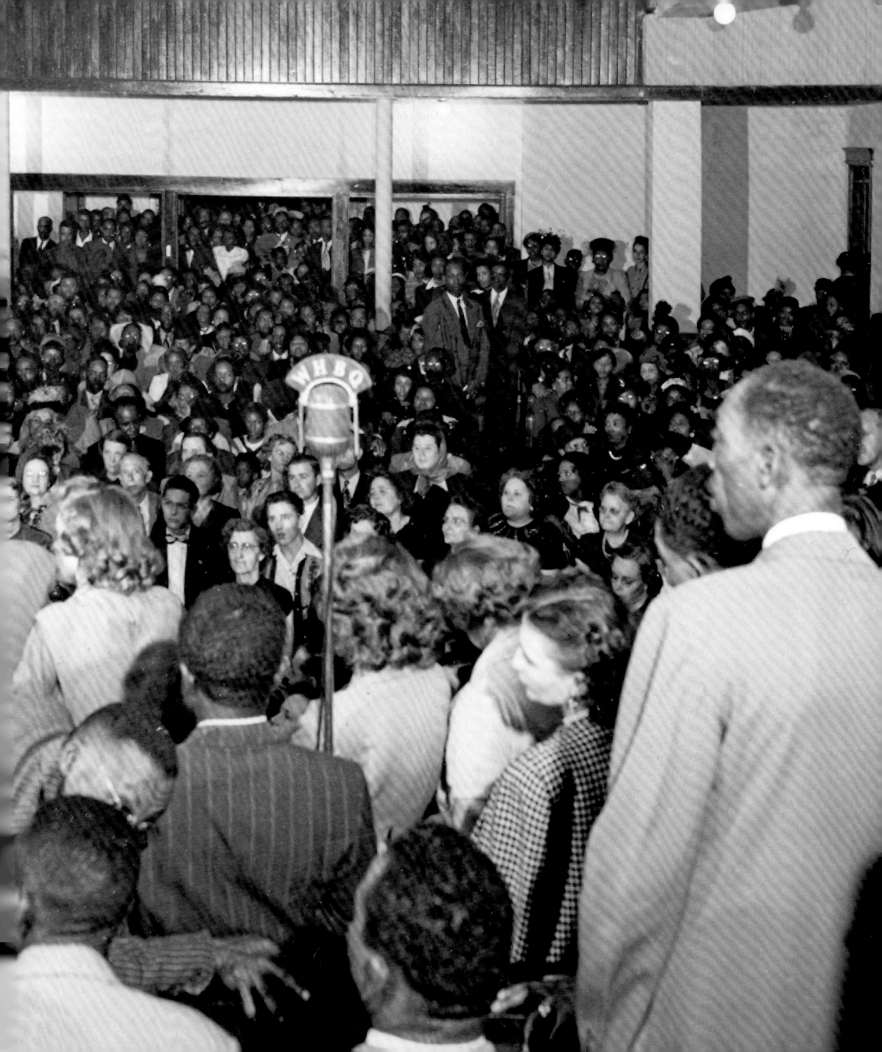

Plate 91
Harvey C. Jackson
*Opening of Greater Shiloh
Baptist Church*, 1926
Gelatin silver print

Plate 92
Woodard's Studio, Chicago, IL
Improved Benevolent Protective Order of
the Elks of the World (IBPOEW), 29th
Annual Convention, Chicago, Illinois,
August 29, 1928, 1928
Gelatin silver print

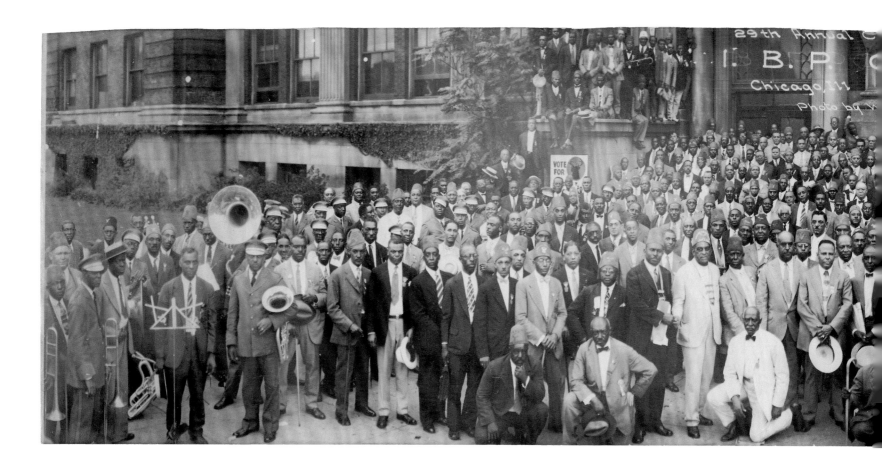

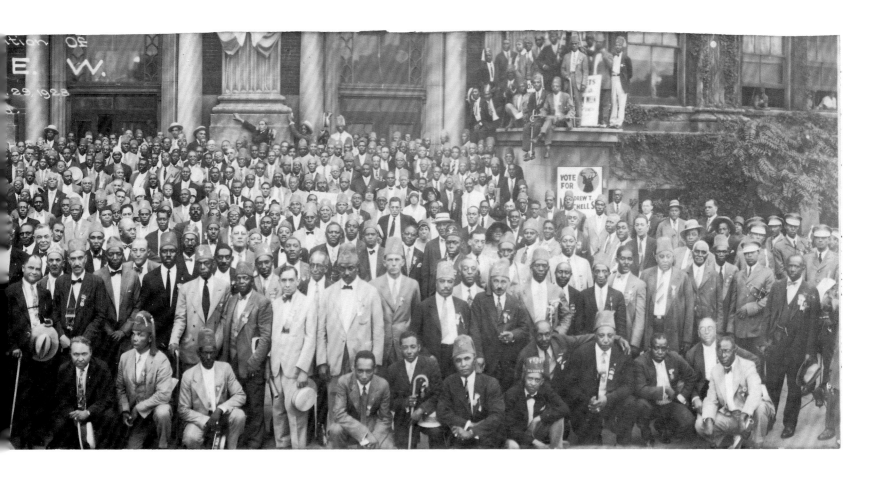

Plate 94
Robert Scurlock
Marian Anderson at the Lincoln
Memorial, April 9, 1939, 1939
Gelatin silver print

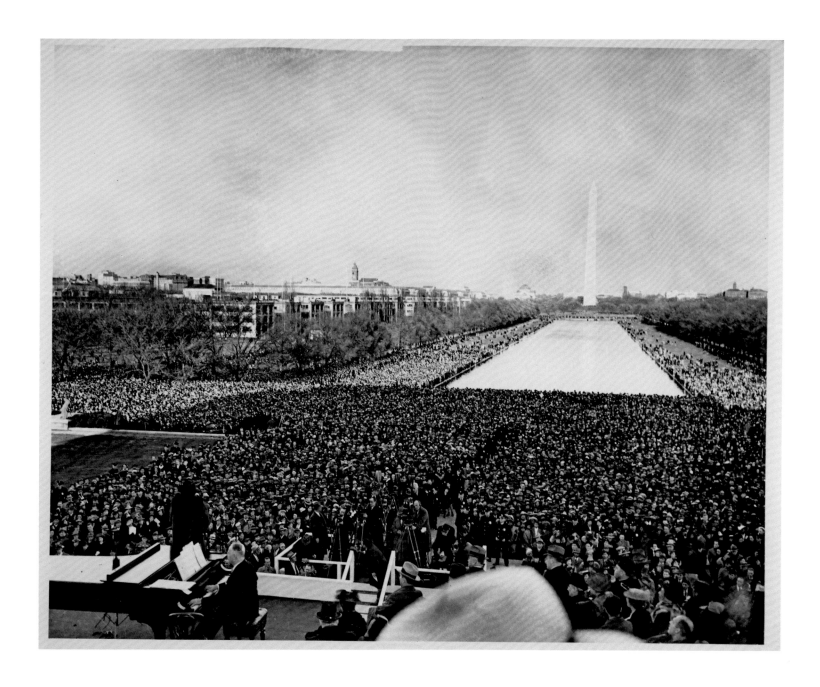

Plate 95
Ernest C. Withers
Memphis Sanitation Workers' Strike,
Memphis, TN, 1968, printed 1980s
Gelatin silver print

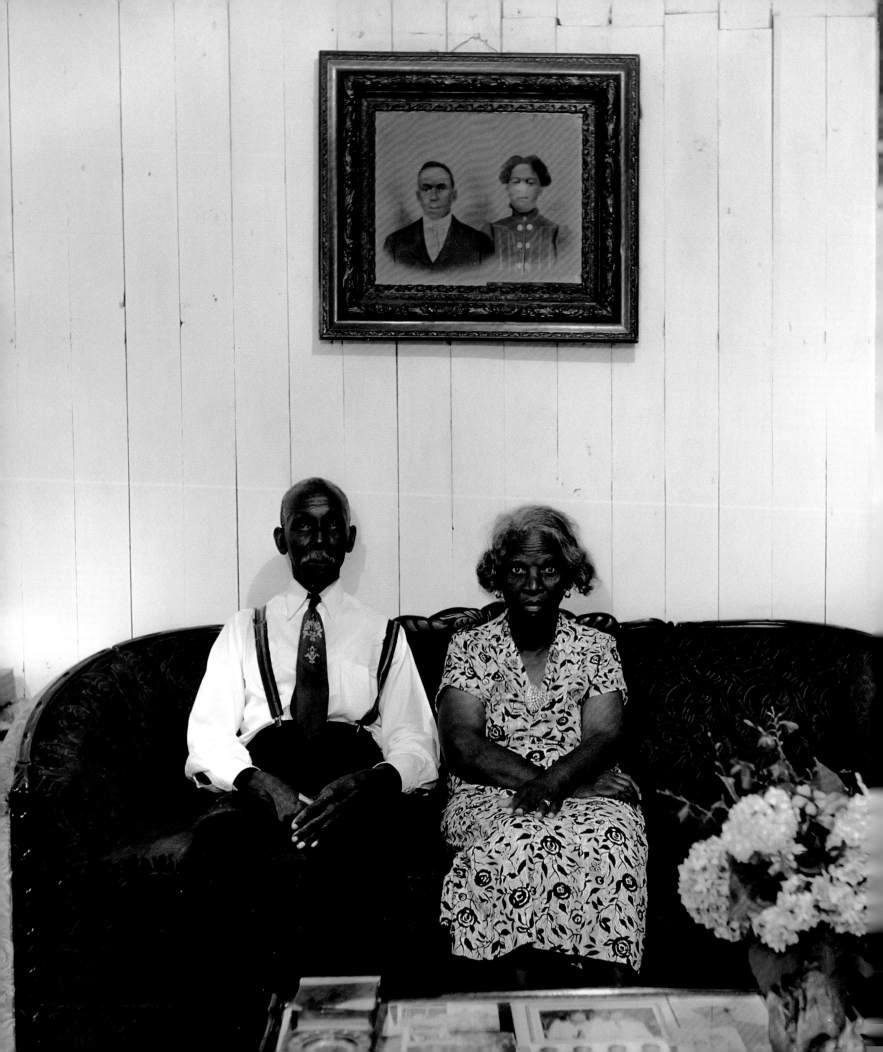

REFLECTIONS AND REFRACTIONS

Gordon Parks
Mr. and Mrs. Albert Thornton,
Mobile, Alabama (detail), 1956, printed later,
Pigmented ink print

Many of the photographers in this volume would likely find the ways that people make, consume, and distribute photographs in 2023 somewhat unrecognizable. Professional portrait studios with fixed addresses are fewer in number, and rarer still are large format film cameras that require wheels to move them. Increasingly, many photographs never even exist as physical prints but can be sent around the globe in an instant. Still, if those first generations of Black American studio photographers were to witness photography today, and specifically work by contemporary Black artists, they might recognize a familiar set of concerns, in particular the continued imperative to use the camera, and photographs, as a means of asserting Black American identity.

While the following works were produced in circumstances removed from a traditional commercial studio, they reflect the histories of Black studio portraiture that precede them, in either practice or form. A portrait by Gordon Parks made on assignment for *Life* magazine illustrates the fundamental importance that photographs held in so many Black homes. Photographers like Polo Silk moved outside of a brick-and-mortar studio, selling instant portraits made in front of mobile backdrops at concerts and club nights. Other works, including stylized self-portraiture and historical images that have been re-mixed and re-photographed, illustrate Black photographers' continued engagement with ideas of self-presentation, visual politics, and community that animated the work of Black American studio photographers for over a century.

Plate 96
Gordon Parks
Mr. and Mrs. Albert Thornton,
Mobile, Alabama, 1956
1956, printed later
Pigmented ink print

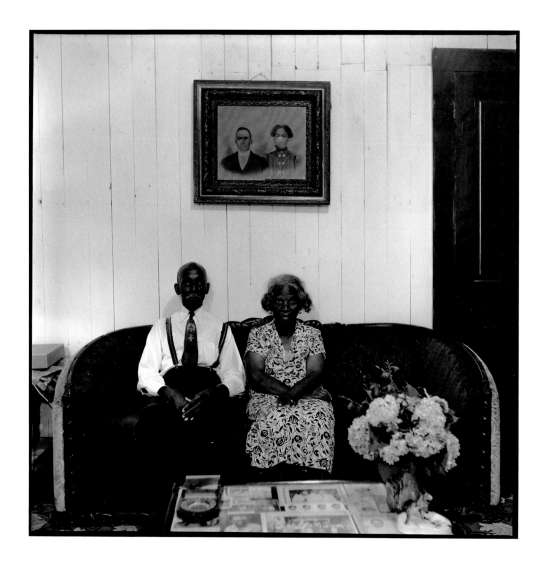

Plate 98
Selwhyn Sthaddeus
"Polo Silk" Terrell
*Lo Life, Lo Down, Club
Detour*, 1992
Unique Polacolor Print

Plate 99
Selwhyn Sthaddeus
"Polo Silk" Terrell
Sunday Funday,
Shakespeare Park, 1997
Unique Polacolor Print

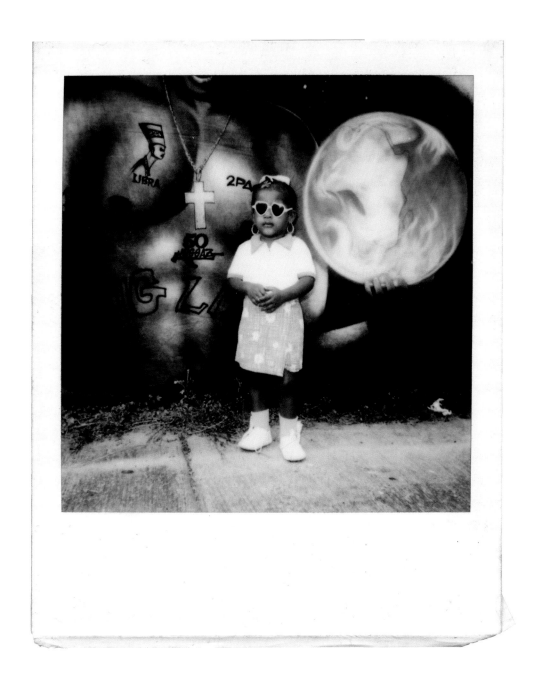

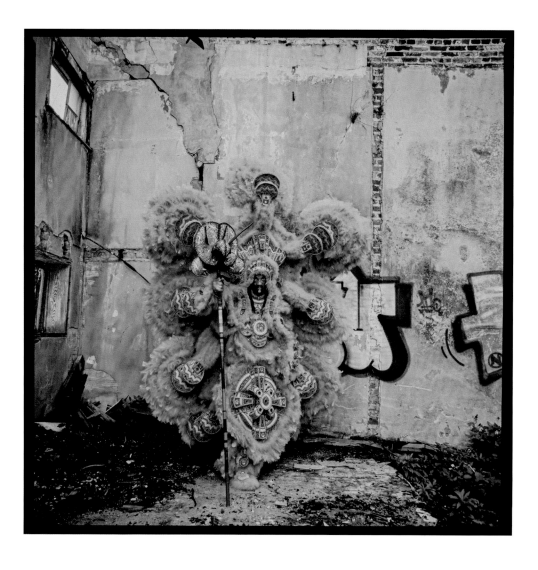

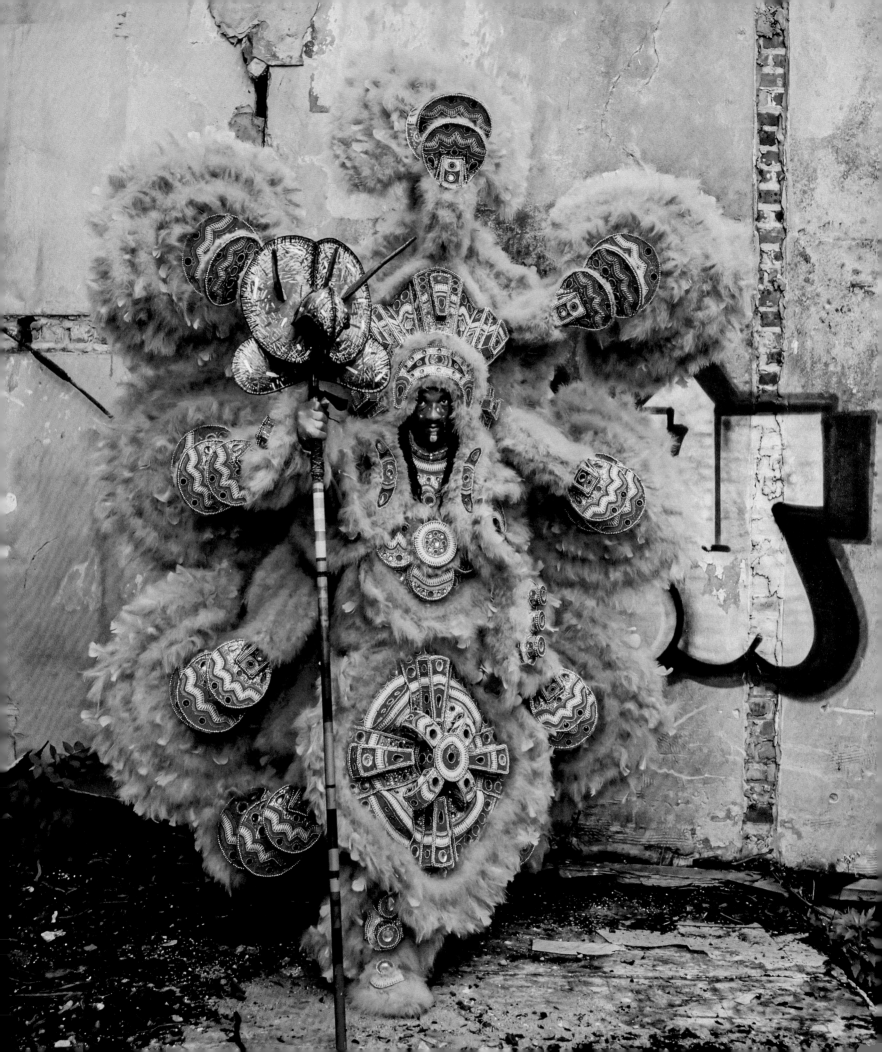

Plate 101
Endia Beal
Kennedy, 2016
Pigmented ink print

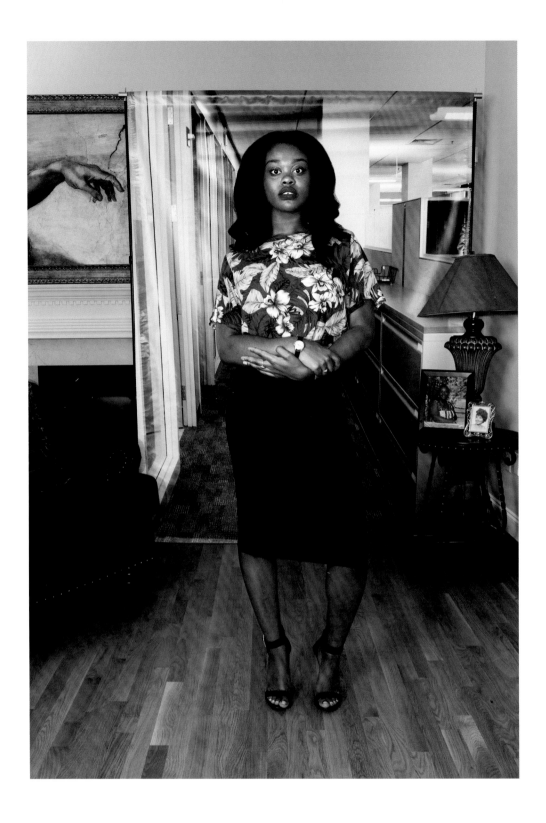

Plate 102
Endia Beal
Kierra and Kayla, 2016
Pigmented ink print

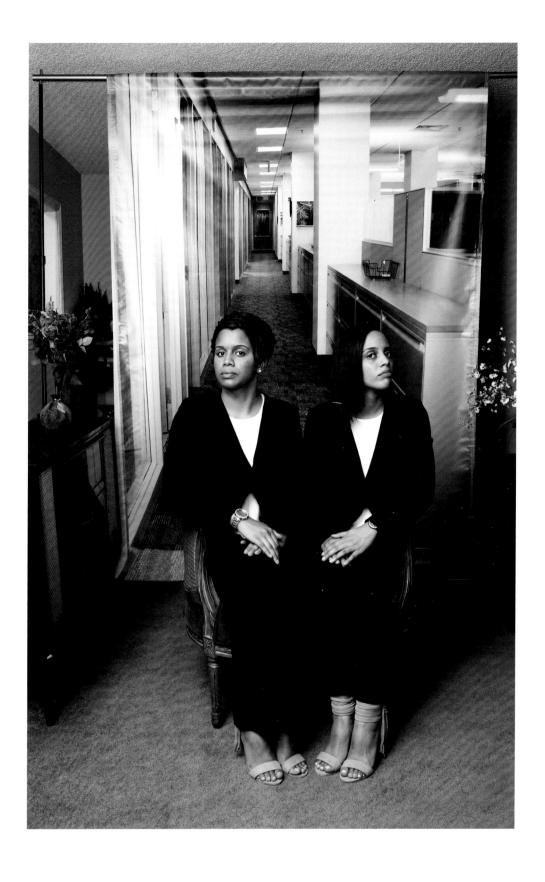

Plate 103
Tiffany Smith
Perpetual Tourist, 2015
Pigmented ink print

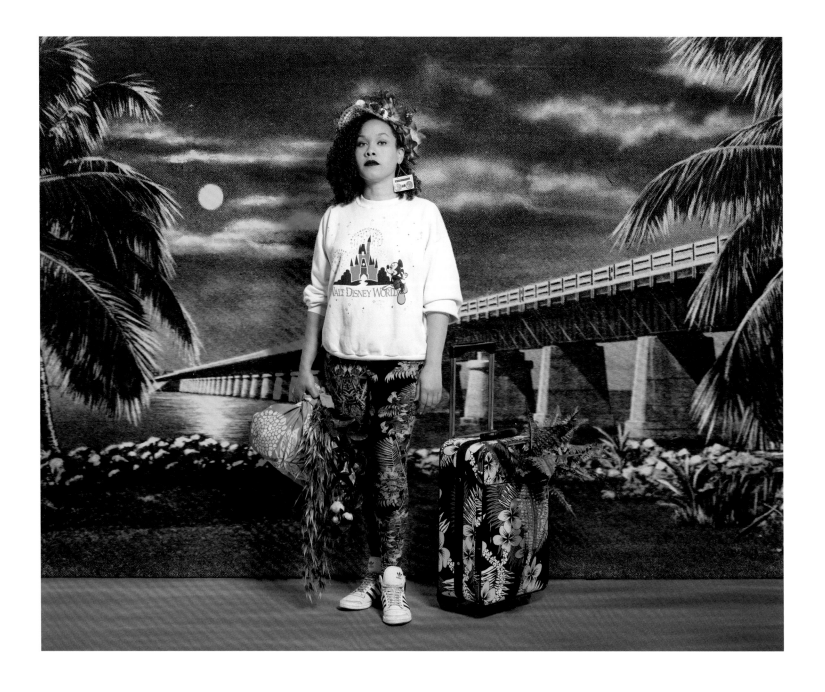

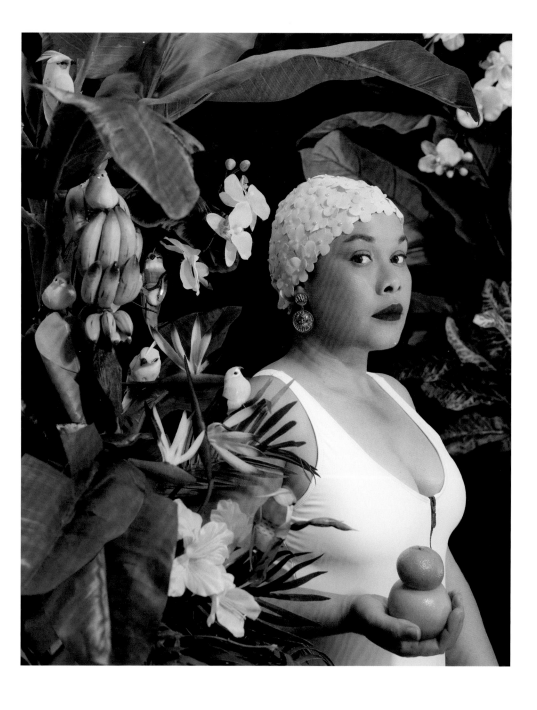

Plate 105
Elliott Jerome Brown Jr.
Oftentimes, justice for Black
people takes the form of forgiveness,
allowing them space to reclaim
their bodies from wrongs made
against them, 2018
Pigmented ink print

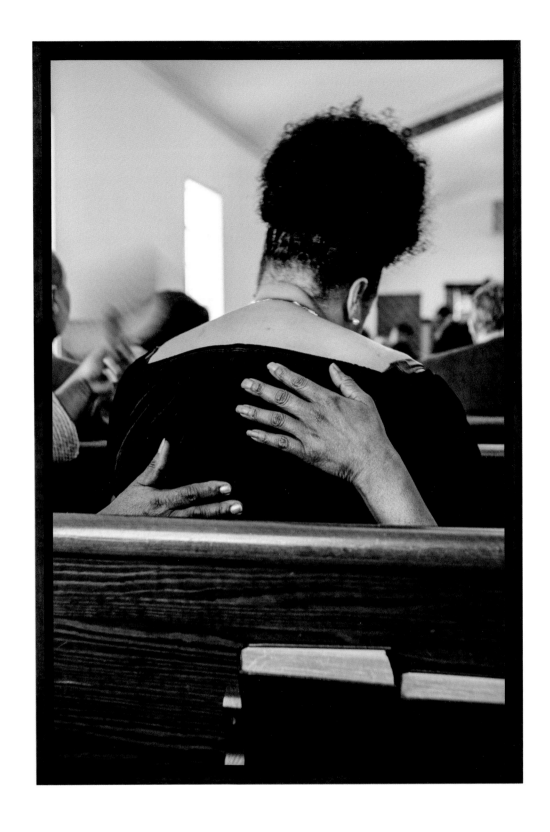

Plate 106
Aaron Turner
*Observations of Perspective
(legacy continued)*, from the series
Black Alchemy Vol. 3, 2021
Gelatin silver print

Plate 107
Aaron Turner
*The Joy of Roquemore #3
(in a dark room)*, from the series
Black Alchemy Vol. 3, 2021
Gelatin silver print

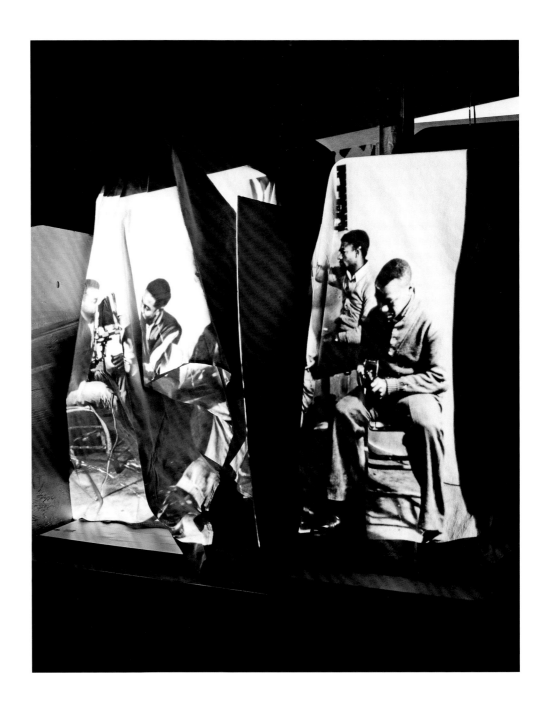

Plate 108
Alanna Airitam
How to Make a Country, 2019
Pigmented ink print
encased in resin, oil paint,
hand-welded metal frame

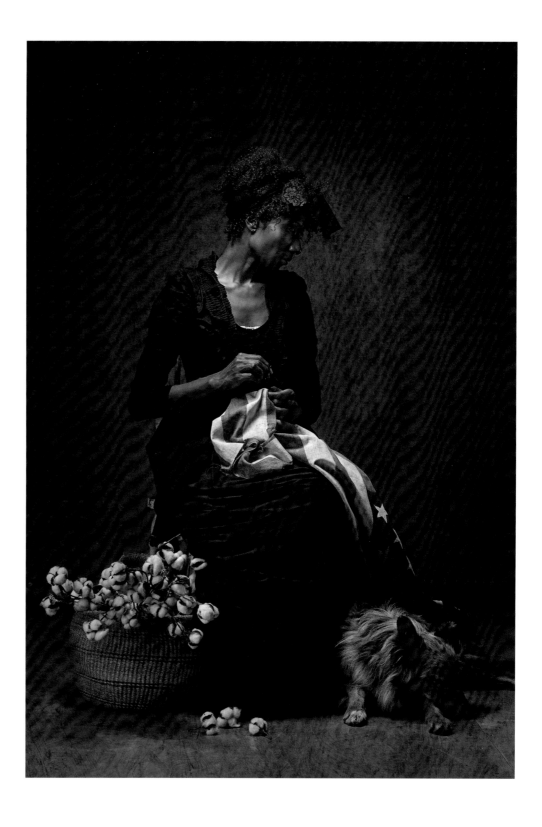

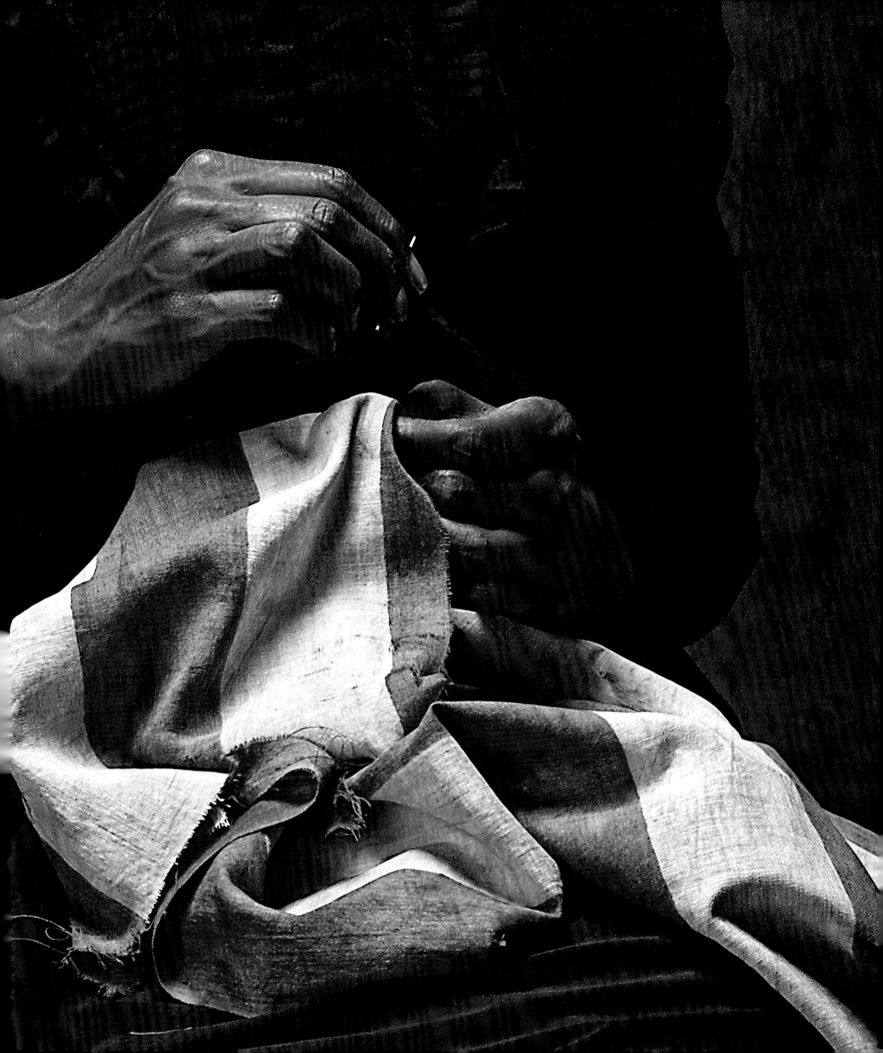

EXHIBITION CATALOG

Called to the Camera:
Black American Studio Photographers

New Orleans Museum of Art
September 16, 2022–January 8, 2023

PHOTOGRAPHS

Alanna Airitam
(American, born 1971)
Based in Tucson, AZ

How to Make a Country, 2019
Pigmented ink print encased in resin, oil paint,
hand-welded metal frame,
20 ¾ x 14 ¾ x 1 ½ in (52.7 x 37.5 x 3.81 cm)
Courtesy of the artist

Rev. Henry Clay Anderson,
(American, 1911-1998)
Active in Greenville, MS

A hand-tinted portrait of a young woman, 1950s
Gelatin silver print, hand colored
10 x 8 in. (25.4 x 20.3 cm)
Collection of the Smithsonian National Museum
of African American History and Culture, Gift of
Charles Schwartz and Shawn Wilson, 2012.137.2.3

Studio portrait of a woman in a nurse's uniform, 1950s
Gelatin silver print
10 x 8 in. (25.4 x 20.3 cm)
Collection of the Smithsonian National Museum
of African American History and Culture, Gift of
Charles Schwartz and Shawn Wilson, 2012.137.5.4

Studio Portrait of Father and Child, 1950s
Gelatin silver print
10 x 8 in. (25.4 x 20.3 cm)
Collection of the Smithsonian National Museum
of African American History and Culture, Gift of
Charles Schwartz and Shawn Wilson, 2012.137.8.2

Rev. Henry Clay Anderson,
(American, 1911-1998, active in Greenville, MS)
Indoor portrait of a woman with a telephone, 1950s
Gelatin silver print
10 x 8 in. (25.4 x 20.3 cm)
Collection of the Smithsonian National Museum
of African American History and Culture, Gift of
Charles Schwartz and Shawn Wilson, 2012.137.11.30

Studio portrait of a young girl, 1950s
Gelatin silver print
10 x 8 in. (25.4 x 20.3 cm)
Collection of the Smithsonian National Museum
of African American History and Culture, Gift of
Charles Schwartz and Shawn Wilson, 2012.137.19.21

Studio Portrait of a young man in a cowboy hat,
1950s-1960s
Gelatin silver print
10 x 8 in. (25.4 x 20.3 cm)
Collection of the Smithsonian National Museum
of African American History and Culture, Gift of
Charles Schwartz and Shawn Wilson, 2012.137.6.4

Studio Portrait of children, 1950s-1960s
Gelatin silver print
8x10 in. (25.4 x 20.3 cm)
Collection of the Smithsonian National Museum
of African American History and Culture, Gift of
Charles Schwartz and Shawn Wilson, 2012.137.12.6

Self-Portrait of Rev. Henry Clay Anderson, ca. 1960
Gelatin silver print
10 x 8 in. (25.4 x 20.3 cm)
Collection of the Smithsonian National Museum
of African American History and Culture, Gift of
Charles Schwartz and Shawn Wilson, 2012.137.6.40

Studio portrait of a woman, 1960s
Gelatin silver print
10 x 8 in. (25.4 x 20.3 cm)
Collection of the Smithsonian National Museum
of African American History and Culture, Gift of
Charles Schwartz and Shawn Wilson, 2012.137.14.23

Studio portrait of a woman with a telephone, 1960s
Gelatin silver print
10 x 8 in. (25.4x 20.3 cm)
Collection of the Smithsonian National Museum
of African American History and Culture, Gift of
Charles Schwartz and Shawn Wilson, 2012.137.5.2

Studio portrait of a mother and infant, 11960s-1970s
Gelatin silver print
10 x 8 in. (25.4x 20.3 cm)

Collection of the Smithsonian National Museum
of African American History and Culture, Gift of
Charles Schwartz and Shawn Wilson, 2012.137.8.4

Studio portrait of a young man in an Army uniform,
1960-1970s
Gelatin silver print
10 x 8 in. (25.4 x 20.3 cm)
Collection of the Smithsonian National Museum
of African American History and Culture, Gift of
Charles Schwartz and Shawn Wilson, 2012.137.6.1

Group Portrait of Women, 1960s-1970s
Gelatin silver print
8 x 10 in. (20.3 x 25.4 cm)
Collection of the Smithsonian National Museum
of African American History and Culture, Gift of
Charles Schwartz and Shawn Wilson, 2012.137.3.47

Studio portrait of a woman, 1960-1970s
Gelatin silver print
10 x 8 in. (25.4 x 20.3 cm)
Collection of the Smithsonian National Museum
of African American History and Culture, Gift of
Charles Schwartz and Shawn Wilson, 2012.137.5.32

Studio Family portrait, 1960-1970s
Chromogenic print
8 x 10 in. (20.3 x 25.4 cm)
Collection of the Smithsonian National Museum
of African American History and Culture, Gift of
Charles Schwartz and Shawn Wilson, 2012.137.24.3

Studio Portrait of a Couple, ca. 1970s
Gelatin silver print
10 x 8 in. (25.4 x 20.3 cm)
Collection of the Smithsonian National Museum
of African American History and Culture, Gift of
Charles Schwartz and Shawn, 2012.37.4.9

Group Portrait of six men in printed shirts, 1960s-1970s
Gelatin silver print
10 x 8 in. (25.4 x 20.3 cm)
Collection of the Smithsonian National Museum
of African American History and Culture, Gift of
Charles Schwartz and Shawn Wilson, 2012.137.3.36

Thomas E. Askew
(American, ca.1847-1914)
Active in Atlanta, GA

Portrait of J.D. Rice, 1912
Gelatin silver print on card mount
Image: 5 ½ x 4 in. (13.9 x 10.16 cm),
Overall: 10 ¾ x 6 ¾ in. (27.3 x 17.1 cm)
Robert Langmuir African American Photograph
Collection, Stuart A. Rose Manuscript, Archives, and
Rare Book Library, Emory University

Walter Baker's Studio
(American, Walter Baker, ca. 1877-1926)
Active in New York, NY

Portrait of a Woman, holding a bouquet of flowers,
ca. 1920
Gelatin silver print, hand tinted
Image: 5 ½ x 3 ¾ in. (13.9 x 9.5 cm),
Overall: 10 ¼ x 6 ¾ in. (26 x 17.1 cm)
Robert Langmuir African American Photograph
Collection, Stuart A. Rose Manuscript, Archives, and
Rare Book Library, Emory University

James Presley Ball
(American, 1825-1904)
Active in Cincinnati, OH, Helena, MT, and
Seattle, WA

Elizabeth Ball Thomas, 1850s
Daguerreotype, sixth-plate
Cincinnati History Library & Archives, Cincinnati
Museum Center, SC #17- 370.

Alexander S. Thomas, ca. 1860
Daguerreotype, sixth-plate
Cincinnati Art Museum
Gift of James M. Marrs, MD., 1984.297

Portrait of a Woman, 1847-1860
Daguerreotype, sixth-plate
Anthony Barboza Collection, Prints and Photographs
Division, Library of Congress, Washington, D.C,
Dag. No. 1402

Frederick Douglass, 1867
Albumen print on carte-de-visite
Image: 3 11/16 x 2 ⅛ in. (9.4 x 5.4 cm.),
Card: 3 15/16 x 2 7/16 in. (10 x 6.2 cm)
Cincinnati History Library & Archives, Cincinnati
Museum Center, SC #17- 059

Mr. Crane, 1862-1868
Salt print
Image: 7 5/16 x 5 1/4 in. (18.5 x 13.3 cm);
Overall: 9 5/8 x 7 13/16 in. (24.5 x 19.9 cm)
Cincinnati Art Museum, Museum Purchase with
Funds provided by Carl Jacobs, 2006.200

Reginia Kuhn, 1860-1870
Albumen print on carte-de-visite
The William Gladstone Collection of African

American Photographs, Prints and Photographs
Division, Library of Congress, Washington, D.C.,
LOT 14022, no. 44 [P&P]

Ball & Thomas Photographers,
(American, Thomas C. Ball, 1828-1874, and
Alexander S. Thomas, 1826-1910)
Active in Cincinnati, OH

Portrait of a Man, in front of painted backdrop,
1858-1860
Daguerreotype, half-plate
Anthony Barboza Collection, Prints and Photographs
Division, Library of Congress, Washington, D.C.,
Dag. No. 1384

Portrait of a Sailor, 1861-1865
Albumen print on carte-de-visite
Overall: 3 15/16 x 2 ⅜ in. (10 x 6 cm)
The William Gladstone Collection of African
American Photographs, Prints and Photographs
Division, Library of Congress, Washington, D.C.,
Lot 14022, no 211

Mattie Allen, ca. 1874
Albumen print on carte-de-visite
Image: 3 ⅝ x 2 3/16 in. (9.2 x 5.6 cm), Card: 3 15/16 x 2
⅜ in. (10 x 6 cm)
Cincinnati History Library & Archives, Cincinnati
Museum Center, SC #17- 005

J.P. Ball & Son
(American, James Presley Ball (1825-1904) and
James Presley Ball, Jr. (1845-1923), Estelle V. Ball,
1857-1924)
Active in Cincinnati, OH, Helena, MT, and
Seattle, WA

Two Young Girls, 1891-1900
Collodion printing-out paper on cabinet card
Image: 5 ½ x 4 in. (13.9 x 10.1 cm),
Card: 6 7/16 x 4 3/16 in. (16.3 x 10.6 cm)
Cincinnati Art Museum, Gift of Allen W. Bernard,
2004.1291

Cornelius M. Battey
(American, 1873-1927)
Active in Cleveland, OH, New York, NY, and
Tuskegee, AL

Margaret Murray Washington, ca. 1917
Gelatin silver print
9 3/8 x 7 7/8 in. (23.8 x 20 cm)
Robert Langmuir African American Photograph
Collection, Stuart A. Rose Manuscript, Archives, and
Rare Book Library, Emory University

Tuskegee Institute Photo Studio, ca. 1920 (Attributed)
Gelatin silver print
4 ⅝ x 9 ⅜ in. (11.7 x 23.8 cm)
Robert Langmuir African American Photograph
Collection, Stuart A. Rose Manuscript, Archives, and
Rare Book Library, Emory University

Repair Shop, Tuskegee, ca. 1920 (Attributed)
Gelatin Silver Print
5 ⅞ x 9 ⅜ in. (14.9 x 23.8 cm)
Robert Langmuir African American Photograph
Collection, Stuart A. Rose Manuscript, Archives, and
Rare Book Library, Emory University

Endia Beal
(American, born 1985)
Based in North Carolina

Kennedy, 2016
Pigmented ink print
27 x 40 in. (68.6 x 101.6 cm)
Courtesy of the artist

Kierra and Kayla, 2016
Pigmented ink print
26 x 40 in. (66 x 101.6 cm)
Courtesy of the artist

Arthur P. Bedou,
(American, 1882-1966)
Active in New Orleans, LA

Group Photo of Glee Club at the Tuskegee Institute, 1909
Gelatin silver print
8 x 10 in. (20.3 x 25.4 cm)
Xavier University Archives and Special Collections

Artistic portrait of a pensive young woman, ca. 1910
Platinum print on card mount, interleaving
Image: Appox. 5 x 3 in., oval (12.7 x 7.6 cm),
Overall: 12 x 7 7/8 in. (30.5 x 20 cm)
Robert Langmuir African American Photograph
Collection, Stuart A. Rose Manuscript, Archives, and
Rare Book Library, Emory University

*Booker T. Washington on His Favorite Mount
Dexter*, 1915
Gelatin silver print
7 x 8 ¾ in. (17.8 x 22.2 cm)
The Historic New Orleans Collection, 2016.0139.2.1

Sisters of the Holy Family, Classroom Portrait, 1922
Gelatin silver print
7 ¾ x 9 ¾ in. (19.7 x 24.8 cm)
XULA University Archives and Special Collections

*Walter L. Cohen on the Day of His Inauguration as
Controller of Customs*, 1922
Gelatin silver print
7 ¾ x 9 ¾ in. (19.7 x 24.8 cm)
XULA University Archives and Special Collections

*Creole Wedding Party [Standing, Left to Right: Leroy
Jean Bywaters, Henry Alexander Hunt, Jr. Seated:
Unidentified, Mathilda Emily Vance Hunt]*, 1924
Gelatin silver print
9 ¾ x 7 ¾ in. (24.8 x 19.7 cm)
XULA University Archives and Special Collections
Arthur P. Bedou Photographs Collection

Portrait of a Woman in front of Trees, ca. 1925
Gelatin silver print
Approx. 9 x 7 in. (22.9 x 17.8 cm)
The Historic New Orleans Collection, Gift of
Rev. Gordon Smith

The Gold Rush – Xavier University Football Squad,
ca. 1930
Gelatin silver print
3 ½ x 5 in. (3.9 x 12.7 cm)
XULA University Archives and Special Collections

*The Gold Rush – Xavier University of Louisiana Football
Squad*, ca. 1930
Gelatin silver print
3 ½ x 5 in. (3.9 x 12.7 cm)
XULA University Archives and Special Collections

*The Gold Rush – Xavier University of Louisiana Football
Squad*, ca. 1930
Gelatin silver print
4 x 6 inches (10.2 x 15.2 cm)
XULA University Archives and Special Collections

Henry L. Wilcox and Constant Charles Dejoie, Sr., 1930s
Gelatin silver print
8 ¾ x 6 1/8 in. (22.2 x 15.6 cm)
The Historic New Orleans Collection, 2001.79.46

Untitled [believed to be Lawrence D. Crocker], 1930s
Gelatin silver print
Approx. 10 x 8 in. (25.4 x 20.3 cm)
XULA University Archives and Special Collections
Arthur P. Bedou Photographs Collection

Portrait of H.L. Wilcox, ca. 1932
Gelatin silver print
Image: 6 ½ x 4 ½ in. (16.5 x 11.4 in.),
Overall: 10 x 8 in. (25.4 x 20.3 cm)
The Historic New Orleans Collection, 2001.79.46

Graduates of Xavier University Prep, 1935
Gelatin silver print mounted in decorative folder
Image: 7 1/8 x 9 ¾ in. (18.1 x 24.8 cm)
Overall: 10 x 11 ½ in. (25.4 x 29.2 cm)
XULA University Archives and Special Collections
Arthur P. Bedou Photographs Collection

*Xavier University Students Dolores Johnson Sykes and
Odile Rawles Working in the School Laboratory*, ca. 1935
Gelatin silver print
7 ¾ x 9 ¾ in. (19.7 x 24.8 cm)
XULA University Archives and Special Collections
Historic Photographs of Xavier University of
Louisiana

*Xavier University of Louisiana Spectators in
Bleachers*, 1936
Gelatin silver print
7 7/8 x 10 in. (20 x 25.4 cm)
XULA University Archives and Special Collections
Arthur P. Bedou Photographs Collection

*Miss Toledo Welch, Homecoming Queen, with the
Homecoming Maids at the Annual Homecoming Game of
Xavier University*, 1937
Gelatin silver print, with hand tinting
5 x 7 1/8 in. (12.7 x 18.1 cm)
XULA University Archives and Special Collections

*Photograph Before the Xavier University of Louisiana
Baccalaureate Service Held in the Campus Gym*, 1942
Gelatin silver print
7 ¾ x 9 ⅝ in. (19.7 x 24.4 cm)
XULA University Archives and Special Collections

Kwame Brathwaite
American, born 1938
Based in New York, NY

Untitled (Ethel Parks at AJASS Studios Photoshoot), ca.
1968, printed 2018
Pigmented ink print
Image: 15 x 15 in (38.1 x 38.1 cm), Overall: 18 x 17 5/8 in.
(45.72 x 44.7675 cm)
New Orleans Museum of Art: Gift of Philip Martin
and Portia Hein in honor of the museum staff at the
New Orleans Museum of Art

Elliott Jerome Brown Jr.
American, born 1993
Based in New York, NY

*Oftentimes, justice for Black people takes the form of
forgiveness, allowing them space to reclaim their bodies
from wrongs made against them*, 2018
Pigmented ink print
36 x 23 1/2 in. (91.44 x 59.69 cm)
New Orleans Museum of Art, Museum Purchase, Tina
Freeman Fund, 2022.8

Leon W. Brown
(American, ca. 1895-1967)
Active in Birmingham, AL

Parker High School [composite], 1950
Gelatin silver print
Image: 10 ⅝ x 13 ⅜ in. (27 x 34 cm), Overall: 11 ¼ x 14 in.
(28.6 x 35.6 cm)
African American Photograph Collection, Stuart A.
Rose Manuscript, Archives, and Rare Book Library,
Emory University

The Browns
(American, George O. Brown, 1852-1910, Bessie
Gwendolyn Brown 1881-1977, George W. Brown,
1885-1946)
Active in Richmond, VA

Portrait of Nadine, ca. 1920
Gelatin silver print
Image 5 ¾ x 3 7/8 in. (14.6 x 9.8 cm),
Overall: 6 ⅜ x 4 ½ in (16.2 x 11.4 cm)
Robert Langmuir African American Photograph
Collection, Stuart A. Rose Manuscript, Archives, and
Rare Book Library, Emory University

Allen E. Cole
(American, 1883-1970)
Active in Cleveland, OH

Portrait of a Woman, seated, ca. 1925
Gelatin silver print in original mount,
Image 9 x 7 in. (22.9 x 17. 8 cm),
Overall: 12 ⅞ x 9 ¼ in. (32.7 x 24.4 cm)
Robert Langmuir African American Photograph
Collection, Stuart A. Rose Manuscript, Archives, and
Rare Book Library, Emory University

Florestine Perrault Collins,
(American, 1895–1988)
Active in New Orleans, LA

New Orleans Crescents Baseball Team, 1923
Gelatin silver print mounted on cardboard
11 ½ x 13 ½ in. (29.2 x 34.3 cm)
The Historic New Orleans Collection, 2019.0390

Portrait of a young woman and boy dressed in white,
1920-1928
Gelatin silver print
8 ¼ x 5 1/16 in. (21 x 12.9 cm)
The Historic New Orleans Collection, 2001.79.7

Portrait of a young woman dressed in white, 1920-1928
Gelatin silver print mounted in decorative folder
9 ¼ x 4 ¼ x in. (23.5 x 10.8 cm)
The Historic New Orleans Collection, 2001.79.8

Theodore St. Leger ("Ted Graduates"), 1940
Gelatin silver print on postcard
5 3/8 x 3 3/8 in. (13.7 x 8.6 cm)
The Historic New Orleans Collection, 2001.79.6

Buddy in costume with feathers, ca. 1940
Gelatin silver print
Approx. 5 x 3 ½ in. (12.7 x 8.9 cm)
The Historic New Orleans Collection, George Lewis
collection, 2015.0060.308

Roy DeCarava
(American 1919-2009)
Active in New York, NY

Bill and Son, 1967
Gelatin silver print
9 15/16 x 12 13/16 in. (25.2 x 32.5 cm)
New Orleans Museum of Art, Museum purchase
through the National Endowment for the Arts, 75.234

Edward Elcha
(American, 1885-1939)
Active in Springfield, MA, and New York, NY

The Men and Women of the Seven Syncopators, 1920-1921
Gelatin silver print
Image: 10 x 13 in. (25.4 x 33 cm),
Overall: 10 ¾ x 13 ¾ in. (27.3 x 34.9 cm)
Robert Langmuir African American Photograph
Collection, Stuart A. Rose Manuscript, Archives, and
Rare Book Library, Emory University

James C. Farley (Richmond Photograph Co.)
(American, born ca.1855)
Active in Richmond, VA

Portrait of a Woman, ca. 1885
Albumen print on carte-de-visite
Image: 3 ¾ x 2 3/8 in. (9.5 x 6 cm),
Overall: 4 1/8 x 2 ½ in. (10.2 x 6/4 cm)
The Elizabeth A. Burns Photography Collection,
New York, NY

Daniel Freeman
(American, 1868-1927)
Active in Washington, DC

Group portrait including AME Bishop Henry McNeal Turner [first row, second from right], ca. 1910
Gelatin silver print on card mount
Image: 10 ⅞ x 13 ½ in. (27.6 x 34.29 cm),
Mount: 11 ⅝ x 14 ⅜ in. (29.5 x 37.1 cm)
Robert Langmuir African American Photograph
Collection, Stuart A. Rose Manuscript, Archives, and
Rare Book Library, Emory University

William P. Greene
(American, b. 1876)
Active in Muskogee, OK

R. Emmett Stewart, ca. 1910
Gelatin silver print
Image: 9 ½ x 7 in. (24.1 x 17.8 cm),
Overall: 10 7/8 x 8 7/8 in. (27.6 x 22.5 cm)
Robert Langmuir African American Photograph
Collection, Stuart A. Rose Manuscript, Archives, and
Rare Book Library, Emory University

The Goodridge Brothers
(American, Glenalvin Goodridge, 1829-1867,
Wallace L. Goodridge, 1840-1922,
William O. Goodridge 1846-1890)
Active in York, PA and Saginaw, MI

Untitled [Portrait of a young girl], ca. 1860
Daguerreotype, sixth-plate
The Stanley B. Burns, MD Photography Collection,
New York, NY

William Goodridge Jr., November 9, 1883, 1883
Tintype
2 ½ x 2 ½ in. (6.35 x 6.35 cm)
New Orleans Museum of Art, Museum Purchase,
Tina Freeman Fund, 2022.20

Gertrude Watson Goodridge and William O. Goodridge, Jr., 1883
Tintype
3 ½ x 2 ⅜ in. (8.89 x 6.0325 cm)
New Orleans Museum of Art, Museum Purchase, Tina
Freeman Fund, 2022.27

Gertrude Watson Goodridge, Mrs. Watson, and William O. Goodridge, 1884
Tintype

3 1/2 x 2 3/8 in. (8.89 x 6.03 cm)
New Orleans Museum of Art, Museum Purchase,
Tina Freeman Fund, 2022.18

John F. Goodridge, Age 1 Year, 1886
Tintype
3 ½ x 2 ½ in. (8.89 x 6.35 cm)
New Orleans Museum of Art, Museum Purchase,
Tina Freeman Fund, 2022.24

William O., Gertrude W., William O. Jr., and John Goodridge, 1887
Tintype
3 1/2 x 2 1/2 in. (8.89 x 6.35 cm)
New Orleans Museum of Art, Museum Purchase,
Tina Freeman Fund, 2022.22

William and John Goodridge, 1887
Tintype
3 ⅝ x 2 ½ in. (9.2075 x 6.35 cm)
New Orleans Museum of Art, Museum Purchase,
Tina Freeman Fund, 2022.21

William Goodridge, Jr., with dalmatian, 1888
Tintype
3 1/4 x 2 3/8 in. (8.255 x 6.0325 cm)
New Orleans Museum of Art, Museum Purchase,
Tina Freeman Fund, 2022.19

Francis Grice
(American, born Port-Au-Prince, Haiti, ca.
1836-1893)
Active in New York, NY, San Francisco, CA, and
Salt Lake City, UT

Man and woman, seated, facing front, ca. 1855
Daguerreotype, sixth-plate
Anthony Barboza Collection, Prints and Photographs
Division, Library of Congress, Washington, D.C.,
Dag. No. 1336

Unidentified toddler girl, seated portrait facing front, 1855
Daguerreotype, sixth-plate
Anthony Barboza Collection, Prints and Photographs
Division, Library of Congress, Washington, D.C.,
Dag. No. 1507

Austin Hansen
(American, born U.S. Virgin Islands, 1910-1996)
Active in New York, NY

Morgan Smith, Standing on a Lightpole, ca. 1942
Gelatin silver print
10 x 8 in. (25.4x 20.3 cm)
Schomburg Center for Research in Black Culture,
New York Public Library

Untitled [Lionel Hampton, right, with Orchestra],
ca. 1945
Gelatin silver print
10 x 8 in. (25.4 x 20.3 cm)
Schomburg Center for Research in Black Culture,
New York Public Library

View of Elevated Subway Tracks, ca. 1950
Gelatin silver print
8 x 10 in. (20.3 x 25.4 cm)
Schomburg Center for Research in Black Culture,
New York Public Library

Dunbar Tenants Association, ca. 1950
Gelatin silver print
8 x 10 in. (20.3 x 25.4 cm)
Schomburg Center for Research in Black Culture,
New York Public Library

Members of Grand United Order of Odd Fellows in America Parade in Harlem, 1950s
Gelatin silver print
8 x 10 in. (20.3 x 25.4 cm)
Schomburg Center for Research in Black Culture,
New York Public Library

Women on Assembly Line [Greeting Card Company],
ca. 1955
Gelatin silver print
8 x 10 in. (20.3 x 25.4 cm)
Schomburg Center for Research in Black Culture,
New York Public Library

Eartha Kitt Teaching a Dance Class at the Harlem YMCA,
ca. 1955
Gelatin silver print
8 x 10 in. (20.3 x 25.4 cm)
Schomburg Center for Research in Black Culture,
New York Public Library

Roy Innis drying pictures for Hansen in [The Hansen] Studio on 135th Street in Harlem, 1958
Gelatin silver print
10 x 8 in. (25.4 x 20.3 cm)
Schomburg Center for Research in Black Culture,
New York Public Library

Professional League of Virgin Islanders, 1950s-1960s
Gelatin silver print
8 x 10 in. (20.3 x 25.4 cm)
Schomburg Center for Research in Black Culture,
New York Public Library

A. Philip Randolph, Channing Tobias, Hank Aaron, Hulan Jack, Joe Louis, [NAACP event], ca. 1960
Gelatin silver print
8 x 10 in. (20.3 x 25.4 cm)
Schomburg Center for Research in Black Culture,
New York Public Library

Portrait of a Couple, 1960s
Gelatin silver print
10 x 8 in. (25.4x 20.3 cm)
Schomburg Center for Research in Black Culture,
New York Public Library

Masonic Portrait, 1960s
Gelatin silver print
Approx. 10 x 8 in. (25.4x 20.3 cm)
Schomburg Center for Research in Black Culture,
New York Public Library

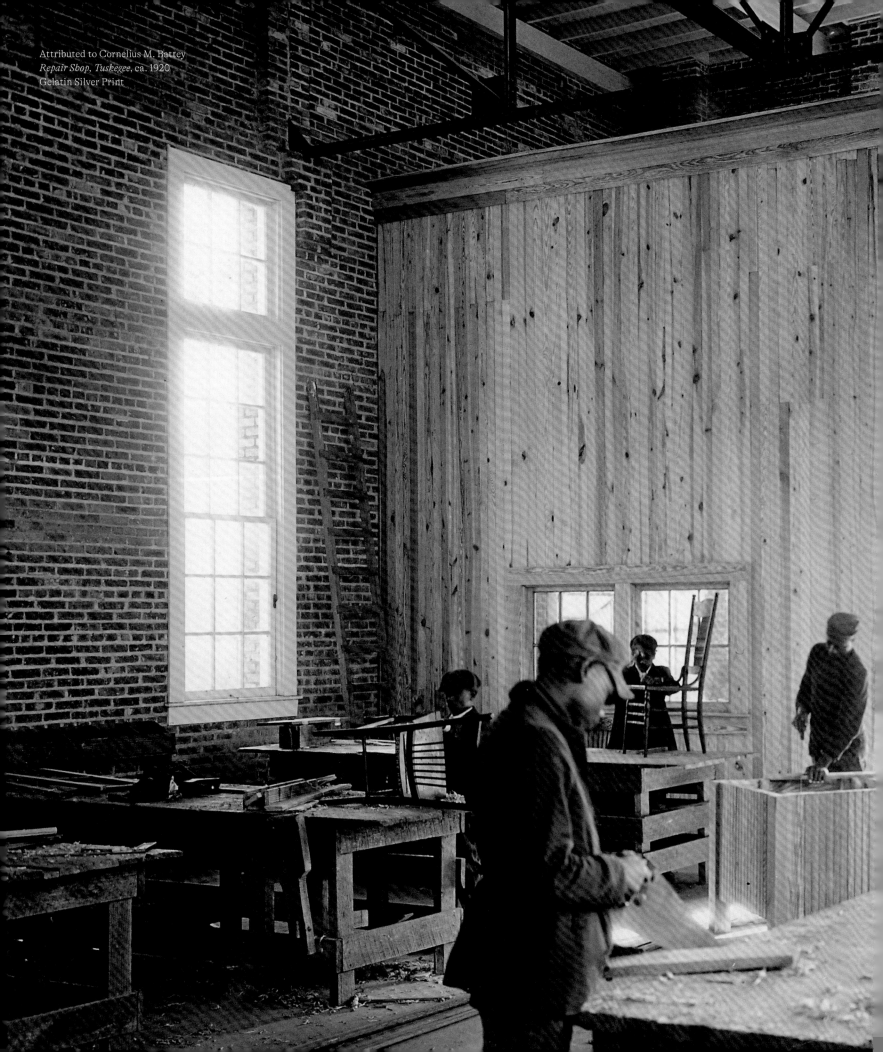

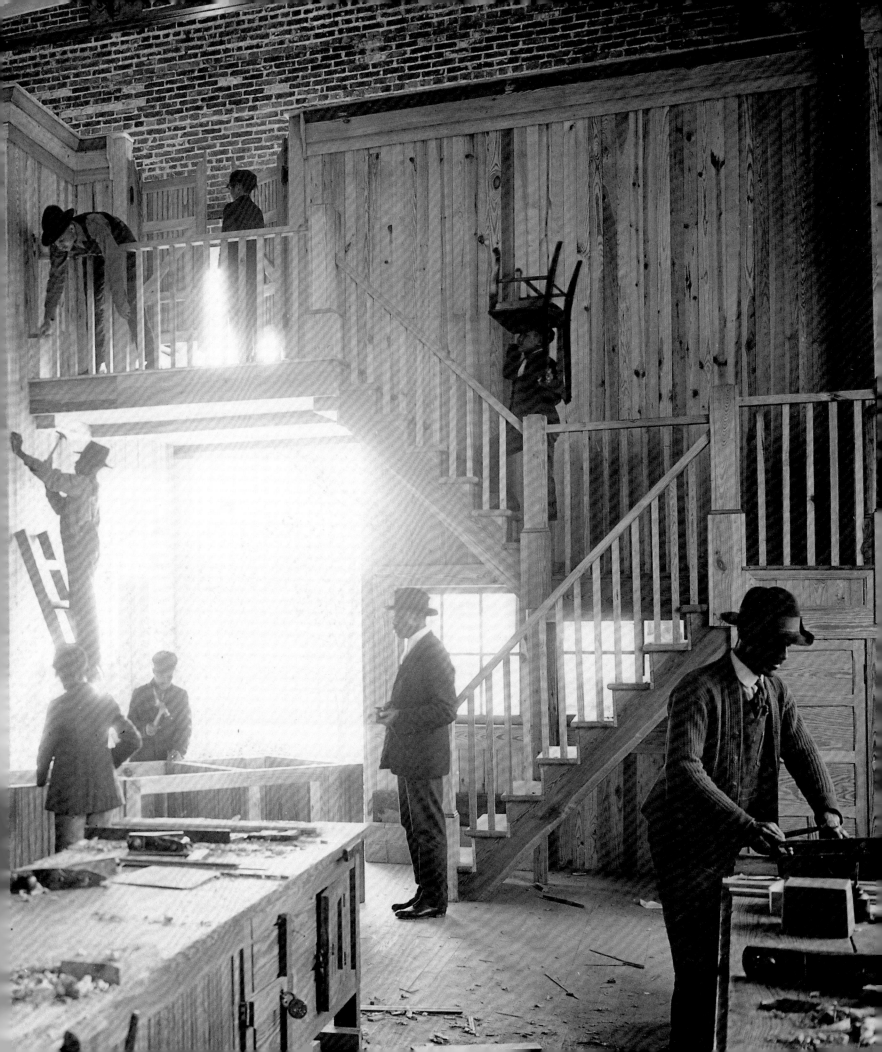

Mrs. Smalls, 1960s
Gelatin silver print
10 x 8 in. (25.4x 20.3 cm)
Schomburg Center for Research in Black Culture,
New York Public Library

Hooks Brothers Studio
(American, Henry A. Hooks, 1881-1978,
Robert B. Hooks, 1890-1974, Henry A. Hooks, Jr.,
1908-1995, and Charles J. Hooks, 1911-1984)
Active in Memphis, TN

Crowd on an Embankment, ca. 1915, printed later
Gelatin silver print
8 x 10 in. (20.3 x 25.4 cm)
Collection of Andrea & Rodney Herenton,
Memphis, TN

*Mortgage Burning, Hardeman County Training School,
Thanksgiving Day*, 1929
Glass Negative
Two plates, each 8 x 10 in. (20.3 x 25.4 cm)
Collection of Andrea & Rodney Herenton,
Memphis, TN

Portrait of a Woman and a Man, ca. 1930
Gelatin silver print
10 x 8 in. (25.4x 20.3 cm)
Collection of Andrea & Rodney Herenton,
Memphis, TN

Untitled [Painted Backdrop], ca. 1935
Gelatin silver print
6 ¾ x 4 ⅝ in. (17.1 x 11.7 cm)
Collection of Andrea & Rodney Herenton,
Memphis, TN

Untitled [Man in Dollar Bill Suit with Group], ca. 1940
Gelatin silver print
8 x 10 in (20.3 x 25.4 cm)
Collection of Andrea & Rodney Herenton,
Memphis, TN

Untitled [Two Women on a Bench], 1941-1942
Gelatin silver print
6 ⅞ x 5 in. (17.5 x 12.7 cm)
Collection of Andrea & Rodney Herenton,
Memphis, TN

Hooks School of Photography Composite Portrait, 1948
Gelatin silver print
6 3/8 x 8 7/16 in. (16.2 x 21.4 cm),
Overall: 8 x 10 in. (20.3 x 25.4 cm)
Collection of Andrea & Rodney Herenton,
Memphis, TN

Untitled [Woman in oyster print dress], ca. 1950
Gelatin silver print in decorative sleeve
Image: 3 ¾ x 3 in. (9.5 x 7.6 cm),
Overall: 6 ¼ x 4 3/8 in. (15.9 x 11.1 cm)
Collection of Andrea & Rodney Herenton,
Memphis, TN

*Untitled [Hooks School of Photography Students Looking
at Prints]*, ca. 1950
Gelatin silver print
8 ⅛ x 10 in. (20.6 x 25.4 cm)
Collection of Andrea & Rodney Herenton,
Memphis, TN

Student Portraits, 1950s
Gelatin silver print, one figure redacted
8 x 10 in (20.3 x 25.4 cm)
Collection of Andrea & Rodney Herenton,
Memphis, TN

Student Portraits, 1950s
Gelatin silver print, four figures redacted
8 x 10 in (20.3 x 25.4 cm)
Collection of Andrea & Rodney Herenton,
Memphis, TN

Student Portraits, 1950s
Gelatin silver print
8 x 10 in (20.3 x 25.4 cm)
Collection of Andrea & Rodney Herenton,
Memphis, TN

Student Portraits, 1950s
Gelatin silver print
8 x 10 in (20.3 x 25.4 cm)
Collection of Andrea & Rodney Herenton,
Memphis, TN

Hooks Photography School Students at Print Dryer,
ca. 1950
Gelatin silver print
8 ⅛ x 10 in. (20.6 x 25.4 cm)
Collection of Andrea & Rodney Herenton,
Memphis, TN

Untitled [Hooks School of Photography Students,]
ca. 1950
Gelatin silver print
8 ⅛ x 10 in. (20.6 x 25.4 cm)
Collection of Andrea & Rodney Herenton,
Memphis, TN

A Birthday Party, ca. 1955
Gelatin silver print
8 x 10 in. (20.3 x 25.4 cm)
Collection of Andrea & Rodney Herenton,
Memphis, TN

Lampodus Club of Omega Psi Phi Fraternity, 1955
Gelatin silver print
9 ¾ x 7 5/8 in (24. 8 x 19.4 cm)
Collection of Andrea & Rodney Herenton,
Memphis, TN

Untitled [Woman and Man posing on a car], ca. 1955
Gelatin silver print
8 x 10 in. (20.3 x 25.4 cm)
Collection of Andrea & Rodney Herenton,
Memphis, TN

Family in Front of Home, ca. 1955
Gelatin silver print
8 x 10 in (20.3 x 25.4 cm)
Collection of Andrea & Rodney Herenton,
Memphis, TN

Untitled [Studio Curtain Study], ca. 1960
Gelatin silver print
10 x 8 in (25.4x 20.3 cm)
Collection of Andrea & Rodney Herenton,
Memphis, TN

Untitled [Copy Work, Couples Portrait], ca. 1960
Gelatin silver print collage, tape
Image: 9 3/8 x 7 5/8 (23.8 x 19.4 cm),
Overall: 10 x 8 in. (25.4 x 20.3 cm)
Collection of Andrea & Rodney Herenton,
Memphis, TN

Untitled, [Onstage at a Speakers Event], 1960s
Gelatin silver print
8 x 10 in (20.3 x 25.4 cm)
Collection of Andrea & Rodney Herenton,
Memphis, TN

Group Portrait of Young Women on a Bus, 1960s
Gelatin silver print
8 x 10 in (20.3 x 25.4 cm)
Collection of Andrea & Rodney Herenton,
Memphis, TN

*Untitled [Copy Work, Retouching of Institutional
Identification Photo]*, ca. 1960
Gelatin silver prints
5 x 8 1/8 in. (12.7 x 20. 6 cm)
Collection of Andrea & Rodney Herenton,
Memphis, TN

*8 Student Portrait Proofs, Manassas High School. Varsity
Scholarship Team*, 1965
Gelatin silver prints
5 ¼ x 4 1/8 in., each (13.3 x 10.5 cm)
Collection of Andrea & Rodney Herenton,
Memphis, TN

Portrait of a Woman, Graduation, ca. 1965
Gelatin silver print
9 ¾ x 7 15/16 in. (24.8 x 20.2 cm)
Collection of Andrea & Rodney Herenton,
Memphis, TN

Portrait of a Woman, Graduation, ca. 1965,
Gelatin silver print, hand tinted
9 ¾ x 7 15/16 in. (24.8 x 20.2 cm)
Collection of Andrea & Rodney Herenton,
Memphis, TN

Untitled [Universal Life Insurance Policy] ca. 1965
Gelatin silver print
Image: 2 ¾ x 4 5/8 in. (7 x 11.7 cm),
Overall: 3 ½ x 5 ¼ in. (8.9 x 13.3 cm)
Collection of Andrea & Rodney Herenton,
Memphis, TN

Untitled [Woman in Fur Coat Posing in Front of Car],
ca. 1965
Gelatin silver print
8 x 10 in (20.3 x 25.4 cm)
Collection of Andrea & Rodney Herenton,
Memphis, TN

Untitled [Camera Room], 1947
Gelatin silver print
8 x 10 in (20.3 x 25.4 cm)
Collection of Andrea & Rodney Herenton,
Memphis, TN

Al Green in the Hooks Brothers Studio, ca. 1968
Gelatin silver print
10 x 8 in (25.4x 20.3 cm)
Collection of Andrea & Rodney Herenton,
Memphis, TN

Haircut Self-Portrait, ca. 1970
Gelatin silver print
Collection of Andrea & Rodney Herenton,
Memphis, TN

Bride and Groom, 1971
Chromogenic print
13 ¾ x 10 5/8 in. (34.9 x 27 cm)
Collection of Andrea & Rodney Herenton,
Memphis, TN

Portrait of a Woman, 1972
Gelatin silver print
13 ⅞ x 11 in. (35.2 x 27.9 cm)
Collection of Andrea & Rodney Herenton,
Memphis, TN

Portrait of a Man, 1972
Gelatin silver print
13 ⅞ x 11 in. (35.2 x 27.9 cm)
Collection of Andrea & Rodney Herenton,
Memphis, TN

Untitled [Woman leaning against column], 1975
Gelatin silver print, hand tinted
10 x 8 in (25.4x 20.3 cm)
Collection of Andrea & Rodney Herenton

Harvey C. Jackson
(American, 1876-1957)
Active in Detroit, MI

Opening of Greater Shiloh Baptist Church, 1926
Gelatin silver print
11 x 14 in. (27.9 x 35.6 cm)
The Stanley B. Burns, MD Photography Collection,
New York, NY

William H. Jordan
(American, 1886-1976)
Active in Cleveland, OH

Art & Ms. Sims, ca. 1940
Gelatin silver print on postcard
5 ⅜ x 3 ⅞ in. (13.7 x 9.8 cm)
The Jason L. Burns Photography Collection,
New York, NY

Portrait of a Couple, ca. 1940
Gelatin silver print on postcard
5 ⅜ x 3 ⅞ in. (13.7 x 9.8 cm)
The Jason L. Burns Photography Collection,
New York, NY

Bennie F. Neser, ca, 1940
Gelatin silver print on postcard
5 ⅜ x 3 ⅞ in. (13.7 x 9.8 cm)
The Jason L. Burns Photography Collection,
New York, NY

Portrait of a Man, ca, 1940
Gelatin silver print on postcard
5 ⅜ x 3 ⅞ in. (13.7 x 9.8 cm)
The Jason L. Burns Photography Collection,
New York, NY

Emmanuel F. Joseph,
(American, born St. Lucia, 1900-1979)
Active in Oakland, CA

Dancers, 1942
Gelatin silver print
Image: 7 ½ x 9 in. (19.1 x 22.9 cm),
Overall: 7 15/16 x 9 ¾ in. (20.2 x 24.8 cm)
Robert Langmuir African American Photograph
Collection, Stuart A. Rose Manuscript, Archives, and
Rare Book Library, Emory University

Dorie Miller standing with two other men, 1943
Gelatin Silver Print
Image: 7 ½ x 8 ⅞ in. (19.1 x 22.5 cm),
Overall: 8 x 10 in. (20.3 x 25.4 cm)
Robert Langmuir African American Photograph
Collection, Stuart A. Rose Manuscript, Archives, and
Rare Book Library, Emory University

Arthur L. Macbeth
(American, 1862-1944)
Active in Charleston, SC, Norfolk, VA, and
Baltimore, MD

Portrait of a Woman, posing beside a chair, ca. 1910
Gelatin silver print on cabinet card
Image: 8 ⅞ x 5 ⅞ in. (22.5 x 14.9 cm),
Card: 9 ¼ x 6 ¼ in (23.5 x 15.9 cm)
Robert Langmuir African American Photograph
Collection, Stuart A. Rose Manuscript, Archives, and
Rare Book Library, Emory University

Family of Arthur L. Macbeth of Baltimore, MD (Formerly of Charleston, SC), ca. 1913
Gelatin silver print
Image: 8 ¼ x 10 in. (21 x 25.4 cm),
Overall: 9 ¾ x 11 in. (24.8 x 27.9 cm)

Robert Langmuir African American Photograph
Collection, Stuart A. Rose Manuscript, Archives, and
Rare Book Library, Emory University

Nolan A. Marshall Studio
(American, Nolan A. Marshall, Sr., 1924 – 2003,
Nolan A. Marshall, Jr., born 1950)
Active in New Orleans, LA

Photograph of Mother Agatha Ryan, S.B.S. and Bishop Joseph Bowers, 1953
Gelatin silver print
8 x 9 ¾ in. (20.3 x 24.8 cm)
XULA University Archives and Special Collections

Charles Evans – Xavier University Football Squad, 1954
Gelatin silver print
9 ¾ x 8 in (25.8 x 20.3 cm)
XULA University Archives and Special Collections

Mr. Numa Rousseve Teaching Painting Students at Xavier University of Louisiana, ca. 1955
Gelatin silver print
8 x 9 ¾ in. (20.3 x 24.8 cm)
XULA University Archives and Special Collections

Xavier University of Louisiana Men's Basketball Game Versus Morris Brown College, 1960
Gelatin silver print
8 x 9 ¾ in. (20.3 x 24.8 cm)
XULA University Archives and Special Collections

Bernard Dyer (Graduate), 1970
Gelatin silver print in lender's frame
Overall: 13 3/8 x 11 ½ in.
Collection of Bernard Dyer, New Orleans, LA

Bernard Dyer (Living My Life), 1994-1995
Pigmented ink print in lender's frame
24 x 20 in. (60.9 x 50.8 cm)
Collection of Bernard Dyer, New Orleans, LA

William C. Maxwell
(American, 1876-1958)
Active in Saint Louis, MO

Cousin Mary [text on verso], 1910s
Gelatin silver print on postcard
5 ⅜ x 3 ⅜ in. (13.7 x 8.6 cm)
The Elizabeth A. Burns Photography Collection,
New York, NY

Untitled [Woman standing with flowers], ca. 1920
Gelatin silver print on card mount
Image: 4 ½ x 3 ¼ in. (11.4 x 8.3 cm),
Overall: 7 x 6 in. (17.8 x 15.2 cm)
The Elizabeth A. Burns Photography Collection,
New York, NY

Untitled [Woman in white dress], ca. 1920
Gelatin silver print in decorative sleeve
Image 7 x 5 in. (17.8 x 12.7 cm),

Overall: 11 x 6 ½ in. (27.9 x 16.5 cm)
The Elizabeth A. Burns Photography Collection,
New York, NY

Untitled [Portrait of a Man and Woman], 1920s
Gelatin silver print mounted on card
Image: 5 ½ x 4 15/16 in. (14 x 12.5 cm),
Overall: 9 x 6 in. (22.9 x 15.2 cm)
The Elizabeth A. Burns Photography Collection,
New York, NY

Untitled [Vignette portrait of a woman], 1910s
Gelatin silver print in decorative sleeve
Image: 6 ¼ x 4 ¼ in. (15.9 x 10.8 cm),
Overall: 10 ¾ x 6 ⅝ in. (27.3 x 16.3 cm)
The Elizabeth A. Burns Photography Collection,
New York, NY

 Edgar W. Moorer
 (American, born 1901, death unknown)
 Active in Philadelphia

Wedding Party in Studio, ca. 1955
Gelatin Silver Print
Image: 7 ¾ x 9 ⅜ in. (19.7 x 23.8cm),
Overall: 8 x 10 in. (20.3 x 25.4 cm)
The Stanley B. Burns, MD Photography Collection,
New York, NY

 John W. Mosley
 (American, 1907-1969)
 Active in Philadelphia, PA

*In the Stands, Howard University vs. Lincoln University
Football Game*, ca. 1940
Gelatin silver print
Image: 7 ¼ x 10 in. (18.4 x 25.4 cm),
Overall: 7 7/8 x 10 ⅜ in. (20 x 26.9 cm)
Robert Langmuir African American Photograph
Collection, Stuart A. Rose Manuscript, Archives, and
Rare Book Library, Emory University

Women of the Friday Nite Club [sic], ca. 1955
Gelatin silver print
Image: 7 ¾ x 9 ¼ in. (19.7 x 23.5 cm),
Overall: 8 1/16 x 10 in. (20.5 x 25.4 cm)
Robert Langmuir African American Photograph
Collection, Stuart A. Rose Manuscript, Archives, and
Rare Book Library, Emory University

 Jeanne Moutoussamy-Ashe
 (American, born 1951)
 Based in Connecticut

Harlem Window, New York, 1978
Gelatin silver print mounted on board
Image: 9 x 6 in. (22.86 x 15.24 cm),
Overall: 12 x 10 in. (30.48 x 25.4 cm)
New Orleans Museum of Art, Museum Purchase,
E-2022-38.1

 Gordon Parks
 (American, 1912-2006)
 Active in New York, NY and globally

Mr. and Mrs. Albert Thornton, Mobile, Alabama,
1956, printed later
Pigmented ink print
28 x 28 in. (71.1 x 71.1 cm)
New Orleans Museum of Art, Gift of the Gordon Parks
Foundation in Honor of Arthur Roger, 2017.181

 Villard Paddio
 (American, ca.1894-1947)
 Active in New Orleans, LA

Dillard University Medical Convention, 1935,
printed later
Gelatin silver print
7 x 20 in. (17.8 x 50.8 cm)
The Charles L. Franck Studio Collection at
The Historic New Orleans Collection
1979.325.6715

 Perrault's Studio
 Arthur J. Perrault
 (American, 1900 – 1960)
 Active in New Orleans, LA

"Hi Frecks, Love Always, John," ca. 1945
Gelatin silver print in decorative sleeve, with signature
Image: 4 ¾ x 3 ¼ in. (12.1 x 8.3 cm),
Overall: 7 x 5 in. (17.8 x 12.7 cm)
Robert Langmuir African American Photograph
Collection, Stuart A. Rose Manuscript, Archives, and
Rare Book Library, Emory University

 Prentice H. Polk,
 (American, 1898-1984)
 Active in Tuskegee, AL

Always Thinking of You, Love, Your Son, John, ca. 1945
Gelatin silver print in studio sleeve, with signature
Image: 3 x 2 in. (7.6 x 5.1 cm),
Overall: 4 ¾ x 3 ¼ in. (12.1 x 8.3 cm)
Robert Langmuir African American Photograph
Collection, Stuart A. Rose Manuscript, Archives, and
Rare Book Library, Emory University

 Paul Poole
 (American, 1886-1954)
 Active in Atlanta, GA

Portrait of a Man, ca. 1920
Gelatin silver print in decorative mount
Image: 9 ⅞ x 7 in. (25.1 x 17.8 cm),
Overall: 12 ¾ x 8 ¾ in. (32.4 x 22.2 cm)
Robert Langmuir African American Photograph
Collection, Stuart A. Rose Manuscript, Archives, and
Rare Book Library, Emory University

*Portrait of a Woman, Wearing Graduation Cap and
Gown*, ca. 1930
Gelatin silver print in original mount
Image: 5 ¾ x 3 ¾ in. (14.6 x 9.5 cm),
Overall: 9 ¼ x 6 ¼ in. (23.5 x 15.9 cm)
Robert Langmuir African American Photograph
Collection, Stuart A. Rose Manuscript, Archives, and
Rare Book Library, Emory University

Roberts Studio
(American, Richard Samuel Roberts, 1880-1936
and Wilhelmina Pearl Selena Williams Roberts,
1881– 1977)
Active in Fernandina, FL and Columbia, SC

Portrait of a Woman, holding a bouquet of roses, ca. 1925
Gelatin silver print in original mount
Image: 7 ½ x 4 ½ in. (19.1 x 11.4 cm),
Overall: 10 ¾ x 6 in. (26.3 x 15.2 cm)
Robert Langmuir African American Photograph
Collection, Stuart A. Rose Manuscript, Archives, and
Rare Book Library, Emory University

 Addison Scurlock
 (American, 1883-1964)
 Active in Washington, DC

Senior Commercial Class, Howard University, 1911
Gelatin silver print
Overall: 12 ¼ x 16 ¼ in. (31.1 x 41.3 cm)
New Orleans Museum of Art, Museum Purchase,
Tina Freeman Fund, 2021.78

Portrait of Man, with Mustache, ca. 1915
Gelatin silver print on card mount
Image: 4 ½ x 3 ¾ in. (11.4 x 9.5 cm),
Overall: 8 ⅞ x 5 ⅞ in. (22.5 x 14.9 cm)
Robert Langmuir African American Photograph
Collection, Stuart A. Rose Manuscript, Archives, and
Rare Book Library, Emory University

Carter G. Woodson, 1915, printed later
Gelatin silver print mounted on cardboard
Image: 9 ½ x 7 in. (24.1 x 17.8 cm),
Overall: 13 ½ x 10 ⅛ in. (34.3 x 25.7 cm)
Robert Langmuir African American Photograph
Collection, Stuart A. Rose Manuscript, Archives, and
Rare Book Library, Emory University

Portrait of a Man, with Two Dogs, ca. 1915
Gelatin silver print
Image: 8 x 5 3/8 in. (20.3 x 13.7 cm),
Overall: 11 ¾ x 8 ¾ in. (29.8 x 22.2 cm)
Robert Langmuir African American Photograph
Collection, Stuart A. Rose Manuscript, Archives, and
Rare Book Library, Emory University

Mother, Father, and Daughter, Posing Together, ca. 1920
Gelatin silver print
Image: 3 7/8 x 5 ¾ in. (9.8 x 14.6 cm),
Overall: 6 ¾ x 8 ¾ in. (17.1 x 21 cm)
Robert Langmuir African American Photograph
Collection, Stuart A. Rose Manuscript, Archives, and
Rare Book Library, Emory University

Mary Church Terrell, ca. 1920
Gelatin silver print
6 5/16 x 4 5/16 in. (16 x 10.9 cm)
Prints and Photographs Division, Library of Congress,
Washington, D.C., LOT 13074, no. 511 [item] [P&P]

Howard University, May Festival, ca. 1925
Gelatin silver print
Image: 7 ¼ x 17 ½ in. (18.4 x 44.5 cm), Overall: 11 x 20 in
(27.9 x 50.8 cm)
New Orleans Museum of Art, Museum Purchase,
E-2022-20.1

Portrait of Julia Robinson, ca. 1930
Gelatin silver print
Image: 6 ½ x 4 ½ in. (16.5 x 11.4 cm),
Overall: 9 ¼ x 6 ⅛ in. (23.5 x 15.6 cm)
Robert Langmuir African American Photograph
Collection, Stuart A. Rose Manuscript, Archives, and
Rare Book Library, Emory University

*Ninth Meeting of Collegiate Deans and Educators in Negro
Schools, Howard University*, 1935
Gelatin silver print
Image: 8 ¾ x 30 ½ in. (22.2 x 77.45 cm) , Overall: 9 x 30
in. (22.86 x 76.2 cm)
New Orleans Museum of Art, Museum Purchase,
Tina Freeman Fund, 2021.77

Major Jerome L. Bunch, 1937
Gelatin silver print in decorative mount
Image: 6 ⅜ x 4 ¼ in. (16.2 x 10.8 cm),
Overall: 9 ¼ x 6 ⅛ in. (23.5 x 15.6 cm)
The Stanley B. Burns, MD Photography Collection

 Robert Scurlock,
 (American 1917-1994)
 Active in Washington, DC

*Marian Anderson at the Lincoln Memorial, April 9,
1939*, 1939
Gelatin silver print
Image: 7 ¾ x 9 ½ in. (19.7 x 24.1 cm), 8 x 10 in.
(20.3 x 25.4 cm)
The Stanley B. Burns, MD Photography Collection,
New York, NY

 Morgan and Marvin Smith Studio
 (American, Morgan Smith, 1910-1993,
 Marvin Smith, 1910-2003)
 Active in New York, NY

Harlem [It's Spring, Buy a Pontiac], 1939
Gelatin silver print
Overall: 10 x 8 in. (25.4 x 20.3 cm)
Schomburg Center for Research in Black Culture,
New York Public Library

155ᵗʰ St. Viaduct, Car Accident, 1940
Gelatin silver print
Overall: 10 x 8 in .(25.4 x 20.3 cm)
Schomburg Center for Research in Black Culture,
New York Public Library

Marvin Painting a Self-Portrait, ca. 1940
Gelatin silver print
10 x 8 in (25.4x 20.3 cm)
Schomburg Center for Research in Black Culture,
New York Public Library

*Marvin and Morgan Smith and Sarah Lou Harris
Carter*, 1942
Gelatin silver print
10 x 8 in (25.4x 20.3 cm)
Schomburg Center for Research in Black Culture,
New York Public Library

Serina Simpson, ca. 1945
Gelatin silver print
10 x 8 in (25.4x 20.3 cm)
Schomburg Center for Research in Black Culture,
New York Public Library

*Untitled [One Model, One photographer working in
studio, photocollage on wall]*, ca. 1945
Gelatin silver print
8 x 10 in (20.3 x 25.4 cm)
Schomburg Center for Research in Black Culture,
New York Public Library

Milton Jackson, 1946
Gelatin silver print
10 x 8 in. (25.4 x 20.3 cm)
Schomburg Center for Research in Black Culture,
New York Public Library

Gordon Parks in the Smith Studio, c. 1946
Gelatin silver print
10 x 8 in (25.4 x 20.3 cm)
Schomburg Center for Research in Black Culture,
New York Public Library

Paul Meeres Jr. and Partner, M. Smith Studio Backdrop,
ca. 1948
Gelatin silver print
10 x 8 in. (25.4 x 20.3 cm)
Schomburg Center for Research in Black Culture,
New York Public Library

*Untitled [Proof sheets from the wedding of Nat King Cole
and Maria Ellington, #2 & #3]*, 1948
Gelatin silver prints
Approx. 10 x 8 in.
Schomburg Center for Research in Black Culture,
New York Public Library

Langston Hughes, ca. 1950
Gelatin silver print
10 x 8 in. (25.4 x 20.3 cm)
Schomburg Center for Research in Black Culture,
New York Public Library

*An Art Class at Romare Bearden's Studio, 243 W. 125ᵗʰ
Street*, 1954
Gelatin silver print
Schomburg Center for Research in Black Culture,
New York Public Library

 Tiffany Smith
 (American, born 1980)
 Based in Brooklyn, NY

Perpetual Tourist, 2015
Pigmented ink print
24x30 inches (60.9 x 76.2 cm)
Courtesy of the artist

Yellow Bird in Banana Tree, 2022
Pigmented ink print
30 x 24 in (76.2 x 60.9 cm)
Courtesy of the artist

 The Teal Studio,
 (American, A.C. Teal, ca. 1892-1956, Elnora Teal,
 1904-1962)
 Active in Houston, TX

"Lovingly, Christine," ca. 1940
Gelatin silver print in decorative mount
Image: 2 ⅝ x 1 ¾ in. (6.7 x 4.4 cm),
Overall: 5 ¼ x 3 ⅛ in. (13.3 x 7.9 cm)
Robert Langmuir African American Photograph
Collection, Stuart A. Rose Manuscript, Archives, and
Rare Book Library, Emory University

 Selwhyn Sthaddeus "Polo Silk" Terrell
 (American, born 1964)
 Based in New Orleans, LA

Lo Life, Lo Down, Club Detour, 1992
Unique Polacolor Print
Image: 3 1/8 x 3 in (7.9375 x 7.62 cm),
Overall: 4 1/4 x 3 1/2 in (10.795 x 8.89 cm)
New Orleans Museum of Art, Museum Purchase,
Tina Freeman Fund, 2021.68

Sunday Funday, Shakespeare Park, 1997
Unique Polacolor Print
Image: 3 x 3 in (7.62 x 7.62 cm), Overall: 4 1/4 x 3 1/2 in
(10.795 x 8.89 cm)
New Orleans Museum of Art, Museum Purchase,
Tina Freeman Fund, 2021.72

 Alexander S. Thomas
 (American, 1826-1910)
 Active in Cincinnati, OH

Edward J. Berry, 1878-1886
Albumen Print on carte-de-visite
Image: 3 ¾ x 2 15/16 in. (9.5 x 7.5 cm),
Card: 4 x 2 7/16 in. (10.2 x 6.2 cm)
Cincinnati Museum Center, Cincinnati History
Library and Archives, SC#17-297

Unidentified man, 1878-1886
Albumen print on carte-de-visite,
Image: 3 3/16 x 2 15/16 in. (8.1 x 7.5 cm),
Card: 4 ⅛ x 3 ¼ in. (10.5 x 8.3 cm)
Cincinnati Museum Center, Cincinnati History
Library and Archives, SC# 17-299

Aaron Turner,
(American, born 1990)
Based in Little Rock, AR

Observations of Perspective (legacy continued),
from the series *Black Alchemy Vol. 3*, 2021
Gelatin silver print
24 x 20 in (60.9 x 50.8 cm)
Courtesy of the artist

The Joy of Roquemore #3 (in a dark room),
from the series *Black Alchemy Vol. 3*, 2021
Gelatin silver print
24 x 20 in (60.9 x 50.8 cm)
Courtesy of the artist

James Van Der Zee
(American, 1886-1983)
Active in Newark, NJ and New York, NY

Self-Portrait, Lennox, Massachusetts, 1908
Gelatin silver print
10 7/8 x 7 11/16 in. (27.6 x 19.5 cm)
Museum purchase, City of New Orleans Capital Funds
and P. Roussel Norman Fund, 76.57

The Guarantee Photo Studio, ca. 1920
Gelatin silver print
5 x 7 in. (12.7 x 17.8 cm)
New Orleans Museum of Art, Museum purchase,
City of New Orleans Capital Funds and P. Roussel
Norman Fund, 76.50

Nude, 1923
Gelatin silver print
8 1/8 x 6 3/4 in. (20.7 x 17.1 cm)
Lent by The Metropolitan Museum of Art, Gift of
James Van Der Zee Institute, 1970 (1970.539.27)

Marcus Garvey, 1924
Gelatin silver print
4 15/16 x 4 in. (12.5 x 10.1 cm.)
New Orleans Museum of Art, Museum purchase,
City of New Orleans Capital Funds and P. Roussel
Norman Fund, 76.51

Untitled (Bride and Groom), 1925
Gelatin silver print, hand tinted
10 x 7 9/16 in. (25.4 x 19.2 cm)
New Orleans Museum of Art, Museum purchase,
City of New Orleans Capital Funds and P. Roussel
Norman Fund, 76.56

Black Cross Nurses' Parade, ca. 1925
Gelatin silver print
8 1/16 x 10 in. (20.5 x 25.4 cm)
Museum purchase, City of New Orleans Capital Funds
and P. Roussel Norman Fund, 76.54

Untitled (Bride and Groom), 1926
Gelatin silver print
9 15/16 x 7 15/16 in. (25.2 x 20.2 cm)

New Orleans Museum of Art,
Museum purchase, City of New Orleans Capital Funds
and P. Roussel Norman Fund, 76.53

Wedding Day, Harlem (Future Expectations),
1926, printed later
Gelatin silver print
9 7/16 x 6 15/16 in. (24 x 17.6 cm)
Prints and Photographs Division, Library of Congress,
Washington, D.C., PH - Van Der Zee (J.), no. 1-12
(Portfolio) [P&P]

Family Album (Memories), New York, 1938
Gelatin Silver Print
9 15/16 x 7 15/16 in. (25.3 x 20.2 cm)
Cincinnati Art Museum, Museum Purchase with
funds provided by Carl Jacobs and the Fleischmann
Foundation in memory of Julius Fleischmann,
2001.242

Daddy Grace, 1938
Gelatin silver print
10 x 8 in (25.4x 20.3 cm)
New Orleans Museum of Art, Museum purchase,
City of New Orleans Capital Funds and P. Roussel
Norman Fund, 76.40

Augustus Washington
(American/Liberian, ca.1820-1875)
Active in Hartford, CT, 1843-1853 and Monrovia,
Liberia, 1853-1870s

Charles Edwin Bulkeley, ca. 1850
Daguerreotype, sixth-plate
Connecticut Historical Society, 1960.138.3

Sarah Taintor Bulkeley Waterman, ca. 1850
Daguerreotype, sixth-plate
Connecticut Historical Society, 1995.203.0

Sarah McGill Russwurm, *holding a daguerreotype case*,
ca. 1854-1855
Daguerreotype, sixth-plate
Prints and Photographs Division, Library of Congress,
Washington, D.C., Dag. No. 1029

Urias A. MacGill, ca. 1854-55
Daguerreotype, sixth-plate
Prints and Photographs Division, Library of Congress,
Washington, D.C., Dag. no. 1028

John Hanson, 1856
Daguerreotype, sixth-plate
Prints and Photographs Division, Library of Congress,
Washington, D.C., Dag. No. 1003

Eric Waters,
(American, born 1946)
Active in New Orleans, LA

*Darryl Montana, Lavender Suit, (Triceratops Staff
Sculpted by John Scott)*, 2008
Pigmented ink print

Image: 40 x 40 in. (101.6 x 101.6 cm), Paper: 44 x 44 in.
(111.8 x 111.8 cm)
Museum Purchase, Tina Freeman Fund, 2020.48

Ernest C. Withers,
(American, 1922-2007)
Active in Memphis, TN

*Memphis Sanitation Workers' Strike, Memphis,
TN*, 1968, printed 1980s
Gelatin silver print
Image: 17 ¼ x 30 in. (43.815 x 76.2 cm),
Paper: 24 x 38 in. (60.96 x 96.52 cm)
New Orleans Museum of Art, Museum Purchase with
funds provided by Paul Embree in Honor of Del and
Ginger Hall's 50th Anniversary, 2021.76

Woodard's Studio
(American, started by William E. Woodard,
born 1892-death unknown)
Active in Chicago, IL, Cleveland, OH, Kansas
City, MO, and New York, NY, 1920-1940s

Woodard's Studio, Kansas City
Portrait of a Woman, with Flowers, ca. 1925
Gelatin silver print in original decorative mount
Image: 8x 6 in. (20.3 x 15.2 cm),
Overall: 9 ⅞ x 7 ⅜ in. (25 x 18.7 cm)
Robert Langmuir African American Photograph
Collection, Stuart A. Rose Manuscript, Archives, and
Rare Book Library, Emory University

Woodard's Studio, Chicago, IL
*Improved Benevolent Protective Order of the Elks of the
World (IBPOEW), 29ᵗʰ Annual Convention, Chicago,
Illinois, August 29,1928*, 1928
Gelatin silver print
7 ¾ x 32 ⅝ in. (19.7 x 82.9 cm)
Robert Langmuir African American Photograph
Collection, Stuart A. Rose Manuscript, Archives, and
Rare Book Library, Emory University

Woodard's Studio, Chicago, IL
Untitled [Young man with puppy], ca. 1945
Gelatin silver print in decorative mount
Image: 10 x 8 in. (25.4 x 20.3 cm),
Overall: 13 x 9 ¾ in. (33 x 24.8 cm)
The Jason L. Burns Photography Collection,
New York, NY

Woodard's Studio, Chicago, IL
Untitled [Young man in cowboy outfit], ca. 1945
Gelatin silver print in decorative mount
Image: 10 x 8 in. (25.4 x 20.3 cm),
Overall: 13 x 9 ¾ in. (33 x 24.8 cm)
The Jason L. Burns Photography Collection,
New York, NY

Photographers Unidentified

Frederick Douglass, ca. 1855
Daguerreotype, sixth-plate
Lent by The Metropolitan Museum of Art, The Rubel
Collection, Gift of William Rubel, 2001 (2001.756)

Untitled [Portrait of a man with parted hair holding a small book], ca. 1855
Daguerreotype, sixth-plate
New Orleans Museum of Art, Gift of Stanley B. Burns, MD., 83.60.132

Caregiver with child, ca. 1855
Ambrotype, sixth-plate
Prints and Photographs Division, Library of Congress, Washington, D.C., AMB/TIN no. 1321 [P&P]

Portrait of a Man, ca. 1860
Daguerreotype, sixth-plate
New Orleans Museum of Art, Gift of Stanley B. Burns, MD, 83.60.131

Untitled [Woman in striped dress], ca. 1860
Tintype, sixth-plate, hand-tinted
The Elizabeth A. Burns Photography Collection

Portrait of a Soldier , 1860-1870
Tintype, quarter-plate
Prints and Photographs Division, Library of Congress, Washington, D.C., AMB/TIN, no. 1328 [P&P]

Portrait of a Man, ca.1860
Daguerreotype, sixth-plate
New Orleans Museum of Art, Museum Purchase, Tina Freeman Fund, 2021.75

Caregiver with child, ca. 1860
Ambrotype, sixth-plate,
New Orleans Museum of Art. Museum Purchase, 85.152

Untitled [Civilian holding Colt Army revolver, ring on pinky finger,] ca. 1870
Tintype
Image: 3 9/16 x 2 3/8 in. (9 x 6 cm),
Mat: 5 1/8 x 4 5/16 in. (13 x 11 cm)
Prints and Photographs Division, Library of Congress, Washington, D.C., AMB/TIN no. 5308 [P&P]

Portraits of Two Women, seated, ca. 1875
Tintypes, hand tinted, sixth-plates
New Orleans Museum of Art, Gift of Stanley B. Burns M.D., 84.106.53

Untitled [Two men with documents], ca. 1880
Tintype, sixth-plate
The Stanley B. Burns, MD Photography Collection

Untitled [Woman playing tabletop instrument], ca. 1880
Tintype, sixth-plate
The Elizabeth A. Burns Photography Collection

Portraits of Two Men, 1880s
Tintype, sixth-plates, in double case
New Orleans Museum of Art, Gift of Stanley B. Burns, MD., 83.60.19.1,.2

Portrait of a Woman, Standing Beside a Photographer's Chair, 1880s
Tintype, hand tinted, sixth-plates
New Orleans Museum of Art, Gift of Stanley B. Burns, MD, 83.60.12

Portraits of Two Children, ca. 1885
Tintype, sixth-plates, in double case
New Orleans Museum of Art,
Gift of Stanley B. Burns M.D., 84.106.58, .59

Portrait of Woman and Man, Foliage Backdrop, 1890s
Cased tintype, sixth-plate
New Orleans Museum of Art, Gift of Stanley B. Burns, MD., 83.60.20

Portrait of Two Men, Wearing Hats, ca. 1880
Cased tintype, sixth-plate
New Orleans Museum of Art, Gift of Stanley B. Burns, MD., 83.60.4

James Van Der Zee making a photograph, 1925
Gelatin silver print
Image: 3 ½ x 4 ½ in. (8.9 x 11.4 cm),
Overall:3 ⅞ x 4 ⅞ in. (9.8 x 12.4 cm)
Robert Langmuir African American Photograph Collection, Stuart A. Rose Manuscript, Archives, and Rare Book Library, Emory University

"Always Yours, 'Meda,'" ca. 1930
Gelatin silver print on real photo postcard
5 ¼ x 3 ½ in. (13.3 x 8.9 cm)
Robert Langmuir African American Photograph Collection, Stuart A. Rose Manuscript, Archives, and Rare Book Library, Emory University

"To My Sweet Baby Brother, From Sister," ca. 1945
Gelatin silver print in original sleeve mount
Image: 6 ½ x 4 ¾ in. (16.5 x 12.1 cm),
Overall: 9 ⅞ x 7 ⅛ in. (25.1 x 18.1 cm)
Robert Langmuir African American Photograph Collection, Stuart A. Rose Manuscript, Archives, and Rare Book Library, Emory University

Untitled [Man in hat, woman in black and white dress], ca. 1950
Gelatin silver print, hand tinted
5 3/8 x 3 3/8 in. (13.7 x 8.6 cm)
The Jason L. Burns Photography Collection, New York, NY

Untitled [Man in white shirt, woman in pink], ca. 1950
Gelatin silver print, hand tinted
5 ⅜ x 3 ½ in. (13.7 x 8.9 cm)
The Jason L. Burns Photography Collection, New York, NY

Untitled [Woman in peach dress, standing with flowers], ca. 1950
Gelatin silver print, hand tinted
5 ¼ x 3 ½ in. (13.3 x 8.9 cm)
The Elizabeth A. Burns Photography Collection, New York, NY

Untitled [Two women, floral backdrop], ca. 1950
Gelatin silver print, hand tinted
5 x 3 3/16 in. (12.7 x 8.1 cm)
The Elizabeth A. Burns Photography Collection, New York, NY

Photographer Unidentified, Brown's Photo Service (American, 20th Century)
Active in Philadelphia, PA
Untitled [Portrait of Woman Facing Mirror], ca. 1960s
Gelatin silver print
Image: 7 ½ x 9 3/8 in. (19.1 x 23.8 cm)
Overall: 8 x 10 in. (20.3 cm x 25.4 cm)
Robert Langmuir African American Photograph Collection, Stuart A. Rose Manuscript, Archives, and Rare Book Library, Emory University

DOCUMENTS, OBJECTS, AND EPHEMERA

Bedou Studio

Arthur P. Bedou's Bank Passbook, 1911 – 1918
Arthur P. Bedou Papers, The Historic New Orleans Collection

Special Offer Contract Coupon, ca. 1917
2 ⅜ x 4 in. (6 x 10.2 cm)
The William Russell Jazz Collection at The Historic New Orleans Collection, acquisition made possible by the Clarisse Claiborne Grima Fund, 520.3098.1

Vitava The Paper for Distinctive Portraiture, Eastman Kodak company, Rochester, NY, 1925
Arthur Bedou Papers, The Historic New Orleans Collection, Gift of Rev. Gordon Smith

Special Offer Contract Coupon, 1930
4 ⅜ x 6 in. (11.1 x 15.2)
The William Russell Jazz Collection at The Historic New Orleans Collection, acquisition made possible by the Clarisse Claiborne Grima Fund, 520.3098.2

Advertising Card, Bedou's Studio, 1935 Bienville Ave., New Orleans, ca. 1930
The William Russell Jazz Collection at The Historic New Orleans Collection, acquisition made possible by the Clarisse Claiborne Grima Fund

Leaflet from the Bedou Studios, 1707 Bienville Ave, ca. 1917
The William Russell Jazz Collection at The Historic New Orleans Collection, acquisition made possible by the Clarisse Claiborne Grima Fund

Photographs that LIVE, [Business Card for Arthur P. Bedou], ca. 1930
The William Russell Jazz Collection at The Historic New Orleans Collection, acquisition made possible by the Clarisse Claiborne Grima Fund

Hooks Brothers Studio

Afro-American Portrait Co. Coupon, 1913
Halftone ink Print
3 ⅜ x 7 ¼ in. (8.6 x 18.4 cm)
Collection of Andrea & Rodney Herenton,
Memphis, TN

Advertisement, Henry A Hooks, 1910
Halftone print ink print on cardboard
7 ⅜ x 4 ⅛ in. (18.7 x 10.5 cm)
Collection of Andrea & Rodney Herenton,
Memphis, TN
Yearbook Picture Schedule II, 1964
Ink print on paper
14 x 8 ½ in. (35.56 x 21.6 cm)
Collection of Andrea & Rodney Herenton,
Memphis, TN

School Portrait Records, Carver '65 [Register of Student Names and Corresponding Negative Numbers], 1965
Ink on writing paper, bound notebook
10 x 8 in. (25.5 x 20.3 cm)
Collection of Andrea & Rodney Herenton,
Memphis, TN

Hooks Brothers Ink Stamp, ca. 1960s
Collection of Andrea & Rodney Herenton,
Memphis, TN

Hooks Brothers # 6, ca. 1940s
Negative Holder
Collection of Andrea & Rodney Herenton,
Memphis, TN

Graflex Camera Lens in Handmade Mount, ca. 1960s
Wood, Glass, Camera Parts, Jar Lids
Collection of Andrea & Rodney Herenton,
Memphis, TN

Ground Glass in frame, early Early Twentieth Century
Glass, Wood, Metal Hardware
Collection of Andrea & Rodney Herenton,
Memphis, TN

Nolan Marshall Studio

McDonogh #35 Senior High School Yearbooks, 1969
and 2012
Collection of McDonogh #35 Senior High School,
New Orleans, LA

Selection of Graduation Portraits, Prom Photographs, and Wedding Portraits, 1990s-2010s
Digital Images
Collection of Nolan A. Marshall, Jr.

Walter L. Cohen Senior High School
Yearbook, 1976
Collection of Paulette Riley, New Orleans, LA

Washington Daguerrean Gallery

The Washington Daguerrean Gallery. Strange! Passing strange, yet true!.., 1851
Broadside
12 ½ x 9 1/16 in. (32 x 23 cm.), Connecticut Historical
Society Library, 1851 W317s

THE FOLLOWING WORKS BY
NON-BLACK PHOTOGRAPHERS WERE
ALSO EXHIBITED

E.S. Dunshee
(American, ca. 1825 - 1907)
Active in Massachusetts and Rhode Island
Portrait of a Man, with a Cane, ca. 1880
Tintype, sixth plate
New Orleans Museum of Art, Gift of Stanley B. Burns,
MD, 83.60.17

Francis Forshew,
(American, 1827-1895)
Active in Hudson, NY and New York, NY
Portrait of a Woman, 1870-1880
Albumen print on carte-de-visite
The William Gladstone Collection of African
American Photographs, Prints and Photographs
Division, Library of Congress, Washington, D.C.,
Lot 14022, no 103

B.F. Smith and Son,
(American, 19th Century)
Active in Portland, Maine
Frederick Douglass, 1864
Albumen print on carte-de-visite
Liljenquist Family Collection, Prints and Photographs
Division, Library of Congress, Washington, D.C.,
PH – Smith (B.F.& Son), no. 1 [P&P]

William W. Washburn,
(American, 1825-1903)
Active in New Orleans, LA
Untitled [Woman in Bonnet], 1870s
Tintype
The Elizabeth A. Burns Photography Collection,
New York, NY

Morgan and Marvin Smith
Harlem [It's Spring, Buy a Pontiac], (detail), 1939
Gelatin silver print

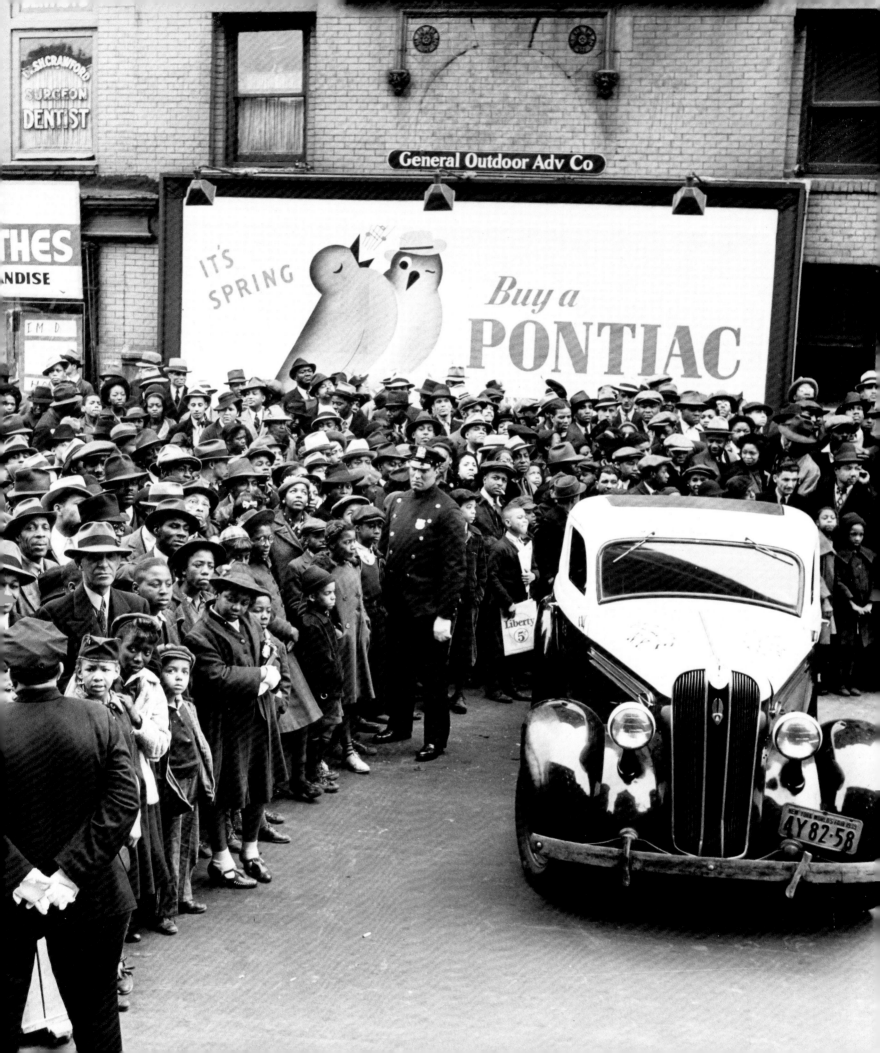

The Studio

This gallery is inspired by the reception room of the Scurlock Studio in Washington, DC, based on the 1911 photograph of the space made by Addison Scurlock, reproduced immediately to the left. At the beginning of the twentieth century, visiting a fine photography studio was a very special occasion. Photographers generally arranged their sitting areas so that clients felt pampered and comfortable. Accordingly, Scurlock's studio was arranged and conceived to meet the specific needs and desires of Black Washingtonians. The Scurlock Studio was located on a top floor above the traffic of a busy business district, a quiet and cozy oasis where his customers could have their best images made on their terms. Before they posed, patrons could view a wall of pictures arranged like the one in this gallery, and make a choice about how they wanted their own portrait to look. For Black Americans, beautiful, idealized portraits constituted an important corrective to a white visual culture that was derogatory and violent towards Black people.

The portraits on the wall to the left were made by photographers from all over the United States, and date from 1900 to 1945. Some of the earliest works reflect an enthusiasm during this period for stylized portraits marked by traits like shallow depth of field, soft focus, retouching of the negative, and hand-tinting—all techniques commonly associated with the pictorialist movement in photography. Much of the precise and detailed finishing work for these photographs was completed by Black women artists, whose names were often overshadowed by the owner of the studio in which they worked. On the opposite wall hangs a more in-depth look at the Scurlock Studio itself, including portraits and panoramic group photos. At the rear of the gallery is a selection of photographs bearing original inscriptions from the sitters, presented as they might be in someone's home.

NOTES

"WHERE THERE'S BEAUTY WE TAKE IT, AND WHERE THERE'S NONE WE CAN MAKE IT"
BRIAN PIPER

1 Battey had already published his work in *The Crisis* magazine and other places. He made portraits for a number of notable figures, including Frederick Douglass, W.E.B. DuBois, and Booker T. Washington. Battey opened a series of portrait studios with a succession of different partners in Cleveland and New York, and had worked as a retoucher in the commercial photography firm Underwood & Underwood.

2 Michael Bieze's scholarship has illustrated that Battey's emphasis on naturalism and hand-production found a powerful devotee in Booker T. Washington, because the photographer "insisted on producing lavish photogravure prints and pictorialist idealism, countering the cheap, mass produced stenographs and other forms of parlor entertainment." However, Washington did not select Battey to take up residence at Tuskegee, opting instead for Arthur P. Bedou of New Orleans in 1913. When Robert R. Moton took over at Tuskegee after Washington's death, he dismissed Bedou and offered Battey the position. Michael Bieze, *Booker T. Washington and the Art of Self-Representation* (New York: Peter Lang, 2008), 104.

3 A version of this photograph was published, unattributed, in W.C. Jackson, *A Boys' Life of Booker T. Washington* (New York: The MacMillan Company), 1922, p. 74. Washington, and the Tuskegee Institute, had relationships with many photographers, but given the date of its publication it seems likely that Battey did make this image.

4 Much like Washington tempered his language depending on the racial makeup, region, and politics of any given audience, he also deployed different kinds of photographs at different times.

5 At Tuskeegee, Battey saw to the education and training of more than a decade's worth of skilled camera workers, including Prentice H. Polk, who took over the department when Battey passed away in 1927.

6 Two important works of scholarship here are Deborah Wills and Barbara Krauthamer, *Envisioning Emancipation: Black Americans and the End of Slavery*, (Philadelphia: Temple University Press), 2012, and Matthew Fox-Amato, *Exposing Slavery: Photography, Human Bondage, and the Birth of Modern Visual Politics in America*, (New York: Oxford University Press), 2019.

7 In 1890 the US Census Bureau recorded 190 professional Black photographers and 247 photographers by 1900, numbers which continued to rise. Census enumerators counted 404 and 608 African American photographers, respectively, in 1910 and 1920. Census records do not specify what kind of work these photographers did, nor whether they owned the business. Juliet E. K. Walker, *The History of Black Business in America: Capitalism, Race, Entrepreneurship* (New York, 1998), 223, table 7.3; The Thirteenth Census of the United States, 1910, Volume 4, Occupation Statistics, table VI, 428-429, United States Census Bureau, www.census.gov; The Fourteenth Census of the United States, 1920, Volume 4, Occupation Statistics, table 5, 356-357, United States Census Bureau, www.census.gov.

8 *The Negro Business League Herald*, Washington, DC, v1, n8 (November, 1909), p. 2.

9 In the 1970s, renowned art historians Dr. Regenia Perry and David Driskell linked the exact beginnings of Black photography to the figure of Lion. Perry and Driskell included Lion's work in exhibitions at The Metropolitan Museum of Art and Los Angeles County Museum of Art, respectively, in 1976. Regenia A. Perry, *Selections of Nineteenth Century Afro-American Art*, (New York: The Metropolitan Museum of Art), 1976; David C. Driskell, *Two Centuries of Black American Art*, (New York: Random House), 1976. More recently, see Sara M. Picard, "Racing Jules Lion." *Louisiana History: The Journal of the Louisiana Historical Association* 58, no. 1 (2017): 5–37. Given the imprecise accounting of Lion's status, and current lack of consensus, an early portrait like *Daguerreotype portrait of young African American woman* (Figure 5) still presents an interesting question about what constituted Black American studio photography in those first decades, and how that classification may have changed over time. Clearly, this portrait demonstrates how Black Americans participated in photography as subjects from an early date in New Orleans. As our understanding of Lion's heritage changes, does our understanding of where this object fits into the history of Black photography also shift, and if so how?

10 "Daguerrean Gallery of the West," *Gleason's Pictorial Drawing Room Companion*, 6 (3) (Apr 1, 1854): 208. "As for the enterprising proprietor, he is the very essence of politeness – nor are his brothers less tinctured with this sweet spirit of human excellence and a disposition to please everyone who patronizes them. No wonder then that there is daily such a rush for this gallery! No wonder that its throng of fashion and beauty is so dense!"

11 Shirley Teresa Wajda, "The Commercial Photographic Parlor, 1839-1889," *Perspectives in Vernacular Architecture*, vol 6, *Shaping Communities* (1997): 219.

12 Alan Trachtenberg, *Reading American Photographs: Images as History: Mathew Brady to Walker Evans* (New York: Hill and Wang, 1989), 4.

13 Teresa Zackodnik, "The "Green-Backs" of Civilization: Sojourner Truth and Portrait Photography," *American Studies*, v46, n2 (Summer 2005), pp117-143.

14 In addition to Ball, Douglass posed for James Reed in New Bedford Massachusetts, James Hiram Easton in Minnesota (active 1862- late 1880s), and C.M. Battey. See, John Stauffer, Zoe Trodd, Celeste-Marie Brenner, *Picturing Frederick Douglass: An Illustrated Biography if the Nineteenth Century's Most Photographed American*, (New York: Liveright, 2015), xvii ; See also: *Pictures and Progress: Early Photography and the Making of African American Identity*, eds., Maurice Wallace and Shawn Michelle Smith (Durham: Duke University Press, 2012).

15 See Fox-Amato, *Exposing Slavery*.

16 Shawn Michelle Smith, *American Archives: Gender, Race, and Class in Visual Culture*, (Princeton: New Jersey: Princeton University Press, 1999), 4-5.

17 For more on this, see Ilisa Brbash, Molly Rogers, Deborah Willis, eds. *To Make Their Own Way in the World: The Enduring Legacy of the Zealy Daguerreotypes*, (New York: Aperture, 2020).

18 Shawn Michelle Smith, *Photography on the Color Line: W.E.B. Du Bois, Race, and Visual Culture* (Durham: Duke University Press, 2004).

19 Deborah Willis, *VanDerZee: Photographer, 1886-1983* (New York: Harry N. Abrams, 1993), 46-48.

20 Kevin Gaines, *Uplifting the Race: Black Leadership Politics and Culture in the Twentieth Century* (Chapel Hill: University of North Carolina Press, 1996), 68.

21 bell hooks, "In Our Glory: Photography and Black Life," *Picturing Us: African American Identity in Photography*, (New York: The New Press, 1994), 43-54, 49. For hooks, that utility extends to formal studio portraits and homemade snapshots, and while hooks acknowledges the importance of both kinds of photographs in Black homes, she makes a distinction between the two. hooks celebrates snapshots for their spontaneity, and as private representations of Blackness free from the white gaze, indirectly defining snapshots against professional photographs in that regard. hooks's analysis gives us an important critical lens through which to view these portraits - to consider how they could do harm even at the same time as they gave pleasure.

22 Quoted in Deborah Willis, "Photographing Memphis: The Memphis World" in *Photographs from the Memphis World, 1949-1964*, comp., Memphis Brooks Museum of Art, intr., Maria Pacini (Oxford: University Press of Mississippi, 2008), 13.

23 W.W. Holland, "Photography for Our Young People," *The Colored American Magazine*, v. 5, n. 1 (May 1902): 5-9.

24 Daniel Freeman, "Photography as a Business," in *Report of the Sixteenth Annual Convention of the National Negro Business League* (Boston: National Negro Business League, 1915), 215. Daniel Freeman served as vice president and president of the Negro Business League of the District of Columbia (NBLDC), 213-216.

25 Freeman, "Photography as a Business," 216.

26 Addison N. Scurlock, "Creating Business: A Paper Read Before the February Meeting of the Local Negro Business League," *Negro Business League Herald* 1, no.1 (April 1909), 7. For more on the relationship between photographers and the NNBL see, Brian Piper, "To Develop Our Business: Addison Scurlock, Photography, and the National Negro Business League, 1900-1920," *The Journal of African American History*, vol. 101, no. 4 (Fall 2016), 436-468.

27 W.E.B. Du Bois, "Photography," *The Crisis*, v26 n26, October 1923, p249-250.

28 Christian Peterson, Peterson, "Harry K. Shigeta of Chicago," *History of Photography*, 22, no. 2 (1998), 183-198.

29 Addison N. Scurlock to Emmett J. Scott, March 12, 1909, microfilm, reel 309, Booker T. Washington Papers, 1853-1946, Manuscript Division, Library of Congress, Washington, DC.

30 Jeffrey John Fearing, "African American Image, History, and Identity in Twentieth-Century Washington, D.C., as Chronicled Through the Art and Social Realism Photography of Addison N. Scurlock and the Scurlock Studios, 1904-1994" (PhD diss., Howard University, 2005), 146.; Not everyone found the Scurlock "look" attractive. Robert McNeill, who trained under Scurlock and worked as a photographer for the WPA recalled that "everything look[ed] so posed, so unreal. [Scurlock] was so busy making sure that the pictures were flattering, that everything looked like everything else." Nicholas Natanson, "Robert McNeill and

the Profusion of Virginia Experience," in *Visual Journal: Harlem and D.C. in the Thirties and Forties*, eds. Deborah Willis and Jane Lusaka (Washington: Smithsonian Institution Press, 1995), p. 100.

31 Juanita Williams Interview in *Portraits of Community: African American Photography in Texas*, ed., Alan Govenar (Austin: Texas State Historical Association,1996), 180.; Elnora Frazier Interview in *Portraits of Community*, 170.

32 Interview with Wilhelmina Wynn, n.d., Jeanne Moutoussamy-Ashe Manuscript Research Collection, 1984-1985, Manuscripts, Archives and Rare Books Division, Schomburg Center for Research in Black Culture, New York Public Library (hereafter, Wynn Interview, Moutoussamy-Ashe Collection.)

33 The number of professional female Black photographers counted in the US Census rose from forty-one in 1910 to 101 in 1920, a number which in actuality might have been higher given the number of women taking photographs under their husband's names.The Thirteenth Census of the United States, 1910, Volume 4, Occupation Statistics, table VI, 428-429, United States Census Bureau, www.census.gov; The Fourteenth Census of the United States, 1920, Volume 4, Occupation Statistics, table 5, 356-357, United States Census Bureau, www.census.gov.

34 Arthé Anthony suggests that Collins (then Florestine Bernard) was forbidden from working outside of the home by her first husband. Arthé A. Anthony, *Picturing Black New Orleans: A Creole Photographer's View of the Early Twentieth Century* (Gainesville: University Press of Florida, 2012), 41, 54.

35 At these locations Collins secured herself within a network of friends and family, catering largely to the light-skinned and middle-class Creole community. In 1934, however, she relocated to South Rampart Street and "[took] her business to midtown, to the heart of the African American commercial district, and expand[ed] her customer base to black people from all walks of life." Anthony, *Picturing Black New Orleans*, 7, 87.

36 Anthony, *Picturing Black New Orleans*, 69.

37 *Pictures Tell the Story: Ernest C. Withers Reflections in History*, eds. F. Jack Hurley, Brooks Johnson, Daniel J. Wolff (Norfolk, VA: Chrysler Museum of Art, 2000), 46.

38 W.E.B. Du Bois, "Photography," *The Crisis* (v26 n26) October 1923, 249-250.

39 Daniel Freeman, "Photography as a Business," National Negro Business League, *Report of the Sixteenth Annual Convention of the National Negro Business League* (Boston: National Negro Business League, 1915), 215.

40 Interview with Morgan and Marvin Smith by Louis Draper, August 18, 1982, M. Smith Papers, Manuscripts, Archives and Rare Books Division, Schomburg Center for Research in Black Culture, New York Public Library (hereafter, M. Smith Papers), p 22.

41 Draper Interview, M. Smith Papers, 9.

42 Kodak's Shirley Cards are perhaps the most well-known examples of the racial biases baked into photographic technology, but that phenomenon existed well before the wide-spread use of color processes. Lorna Roth, "Looking at Shirley, The Ultimate Norm: Colour Balance, Image Technologies, and Cognitive Equity," *Canadian Journal of Communication*,

v34, n1, (2009), 117. See also Richard Dyer, *White* (London: Routledge, 1997); Brian Winston, "A Whole Technology of Dyeing: A Note on Ideology and the Apparatus of the Chromatic Moving Image," *Daedalus*, v114 n4 (Fall, 1985).

43 Winston, "A Whole Technology of Dyeing," 109.

44 Louise Martin Interview in *Portraits of Community*, 217. Martin might have been referring to Charcoal Black paper from the manufacturer Dassonville.

45 Gladys P. Graham, "Harlem's Successful Business and Professional People," *The African: Journal of African Affairs*, October/November, 1947, 6-7. Graham quoted Morgan Smith, who referred to the lights as "Fink and Roselive, Baby."

46 Fearing, "African American Image, History, and Identity," 141.

47 Draper Interview, M. Smith Papers, 9. The Smiths' defensiveness might have been due to fears of being accused of colorism

48 Anthony, *Picturing Black New Orleans*, 89-90

49 Interview with Bernadine Wesley, Box 2, Winifred Hall File, Moutoussamy-Ashe Collection, hereafter, Wesley Interview.

50 Wesley Interview.

51 "Morgan Smith's Studio at 243 West 125th Street has had its face lifted and its size changed – and it is quite the smartest place for folks who like to pose." Thelma Berlack Boozer, "New York Chatter," New York Age ([Month Obscured] 23, 1945), M. Smith Papers.

52 *M&M Smith: For Posterity's Sake*, directed by Heather Lyons (Little City Productions, 1995), VHS, (New Day Films).

53 Marvin Smith, Interview with James Briggs Murray, June 30, 1998, Moving Picture Division, Schomburg Center for Research in Black Culture, New York Public Library (hereafter, Smith-Murray Interview).

54 Jim Haskins, *James Van DerZee: The Picture Takin' Man*, (Trenton, New Jersey: Africa World Press, 1991), 193-252. In 1969, curator Allon Schoener reproduced a number of James Van Der Zee's photographs as graphics in the exhibition *Harlem on My Mind: Cultural Capital of Black American, 1900-1968* at the Metropolitan Museum of Art in New York. Exhibition organizers drew controversy for their failure to include work by Black sculptors or painters in the exhibition. However, Harlem on My Mind did "introduce" Van Der Zee to the white art world. Forthcoming scholarship by art historian Dr. Emilie Boone promises to be an important reassessment of Van Der Zee's photographic practice.

55 Calvin Littlejohn Interview in *Portraits of Community*, 100.

56 Wynn Interview, Moutoussamy-Ashe Collection.

57 *Tri-State Defender*, November 8, 1952. Soon after *The Tri-State Defender* began publication in 1951, the paper routinely coupled their coverage with advertisements purchased by Withers, alongside ads for the Defender's own Photography Service. *The Memphis World* (1931-1973) counted at least 15 different professional photographers.

58 Benny Joseph Interview in *Portraits of Community*, 192.

59 Margaret Olin, "James VanDerZee: Putting Down Roots in Harlem" in *Touching Photographs* (Chicago: University of Chicago Press, 2012), 105.

60 Austin Hansen, Interview by James Briggs Murray, August 6, 1986, VHS, Moving Image and Recorded Sound Division, Schomburg Center for Research in Black Culture, New York Public Library.

61 Interview with Austin Hansen, August 6, 1986 in Moving Image and Recorded Sound, Schomburg Center. See also, Austin Hansen Papers, 1946-1985, Manuscript, Archives and Rare Books Division, Schomburg Center. Hereafter, Hansen Papers. Hansen's portrait studio sat half a block from the famous Harlem YMCA and in the center of a constellation of Black churches that employed him over six decades.

62 Ernest Withers and Daniel Wolff, *The Memphis Blues Again: Six Decades of Memphis Music Photographs* (New York: Viking Studio, 2001), 9.

63 On the power of snapshots see bell hooks, "In Our Glory: Photography and Black Life," *Picturing Us: African American Identity in Photography*, (New York: The New Press, 1994), 43-54; See also Richard K. Powell, *Cutting a Figure: Fashioning Black Portraiture* (Chicago: University of Chicago Press, 2008).

64 It would be difficult to overstate Ernest Withers' importance to Black Memphians' ability to see themselves portrayed in photographs, and in the press with dignity. Withers' story and legacy have become comp;licated following the 2010 discovery that he had worked as an informant for the FBI during this period. See Richard Cahan and Michael Williams, *Revolution in Black and White: Photographs of the Civil Rights Era by Ernest Withers*, (Chicago: CityFiles Press, 2019) and Preston Lauterbach, *Bluff City: The Secret Life of Photographer Ernest Withers*, (New York: W.W. Norton and Company, 2019).

65 F. Jack Hurley, "Photographing Struggle, Building Bridges," in *Pictures Tell the Story: Ernest C. Withers Reflections in History*, pp 30-31.

66 Newspaper clippings, "PV's Mystery Photographer!," October 24, 1942 and November 28, 1942, *The People's Voice*, Hansen Papers, Box 2. The Austin Hansen Photographs Collection at the Schomburg Center includes images of Hansen in disguise, as the "Mystery Photographer."

67 Arthe Anthony wrote, "I have often heard "don't be a Bedou," an expression still used by older [New Orleanian] Creoles to urge a photographer to hurry up and make a photograph." (*Picturing Black New Orleans*, 66) Chef Leah Chase expressed the same good-natured frustration with the photographer's fastidiousness. Leah Chase, in conversation with the author, February 14, 2019.

68 Fearing, "African American Image, History, and Identity," 98.

69 Quoted in Robert B. Cochran, *A Photographer of Note: Arkansas Artist Geleve Grice* (Fayetteville: The University of Arkansas Press, 2003), 47.

70 H.C. Anderson, *Separate, But Equal: The Mississippi Photographs of Henry Clay Anderson* (New York: Public Affairs, 2002), 20-21.

71 Calvin Littlejohn Interview in Portraits of Community, 100.

72 Nolan Marshall, Jr., conversation with the author, November 17, 2021. Nolan Marshall, Jr. took over the Marshall Studio in 1973

73 Nolan Marshall, Jr., conversation with the author, November 17, 2021.

74 Carver Picture Day Ledger, October 6, 1964. The Hooks Brothers Photograph Collection (Hereafter, Hooks Brothers Collection).

75 Yearbook Picture Schedule II, November 3-4, 1964. Hooks Brothers Collection.

76 Cochran, *A Photographer of Note*, 47.

77 Like many municipalities, Memphis slowly and begrudgingly complied with orders to integrate public schools. In 1961 Memphis integrated first grade classrooms, with the intention of advancing the effort one grade level at a time every school year. In the South, many of these photographers became unintended casualties of the struggle for racial equality in public education by the end of the 1960s. Much like Black educators who lost their jobs as schools were consolidated, many Black photographers lost their school contracts to white photographers preferred by newly installed white school principals, squeezed out after decades of committed work. Nolan Marshall, Jr., conversation with the author, November 17, 2021.

78 Earnestine Jenkins, "The Hooks Brothers of Memphis, Artist Photographers of the "New Negro" Movement in the Urban South," in *Memphis: 200 Years Together: An Anthology*, Karen B. Golightly and Jonathan Judaken, eds., (Memphis: Susan Schadt Press, 2019), p. 87.

79 The Hooks Brothers Studio was not alone in deploying a version of this slogan. The Woodard Studio used it in some advertisements. Arthur MacBeth put a version on officicl studio letterhead. MacBeth's version read "If you have beauty we take it, if you have none, we make it." Arthur L. MacBeth, Letter from Arthur L. MacBeth to *The Crisis*, December 6, 1930. W. E. B. Du Bois Papers (MS 312). Special Collections and University Archives, University of Massachusetts Amherst Libraries. (http://credo.library.umass.edu/view/full/mums312-b186-i087: Accessed January 8, 2022.)

80 Jenkins, "The Hooks Brothers of Memphis, 84-85.

81 In Washington, DC, Robert Scurlock opened a similar venture at the Capitol School of Photography from 1948-1952. See Chapter 5 of the author's dissertation, "We're Competent, Well Equipped, Minority Owned, and Strictly Business," in "Cameras at Work: African American Studio Photographers and the Business of Everyday Life, 1900-1970," PhD Dissertation, The College of William and Mary, 2016.

NOBODY'S "FAITHFUL SERVANT":
HENRY MARTIN REPRESENTS HIMSELF
JOHN EDWIN MASON

82 bell hooks, "In Our Glory," in Deborah Willis, ed., *Picturing Us: African American Identity In Photography*. (New York: New Press, 1994), 49.

83 Culbreth, David M. R. (David Marvel Reynolds). *The University of Virginia: Memoirs of Her Student-life and Professor*. (New York: The Neale Publishing Company, 1908), 457. Although the white physician, David M.R. Culbreth, shared the racial prejudices of the vast majority of white Americans in the early twentieth century, his memoir is factually reliable.

84 Culbreth, *Memoirs*, 459.

85 Exceedingly few descriptions of Henry Martin by African Americans have survived. None were part of the public record. No portraits of Martin have been found in the archives of Black photographers.

86 Culbreth, *Memoirs*, 457-58.

87 "Uncle Henry Pensioned," *College Topics*, 27 March 1909.

88 "Uncle Henry Is on Pension List," *Daily Progress*, 25 March 1909, p. 1.

89 Henry Martin, "To The Editors of College Topics." *College Topics*. 1890.

90 The smaller image in the book might well have been Culbreth's attempt to put Martin "back in his place" visually.

91 Wallace, Maurice O. (Maurice Orlando) and Shawn Michelle Smith. *Pictures and Progress: Early Photography and the Making of African American Identity*. (Durham: Duke University Press, 2012), 5.

92 Kevin K. Gaines. *Uplifting the Race: Black Leadership, Politics, and Culture in the Twentieth Century*. (Chapel Hill: University of North Carolina Press, 1996), 5.

93 hooks, "In Our Glory," 47-48.

94 Gaines, *Uplifting the Race*, 69.

THE ART OF BEING SEEN AS BEING SEEN
CARLA WILLIAMS

95 As a photographer, I primarily made self-portraits. It was essential for me to collapse the subject and photographer into one entity, but I still knew that without the camera I was merely killing time.

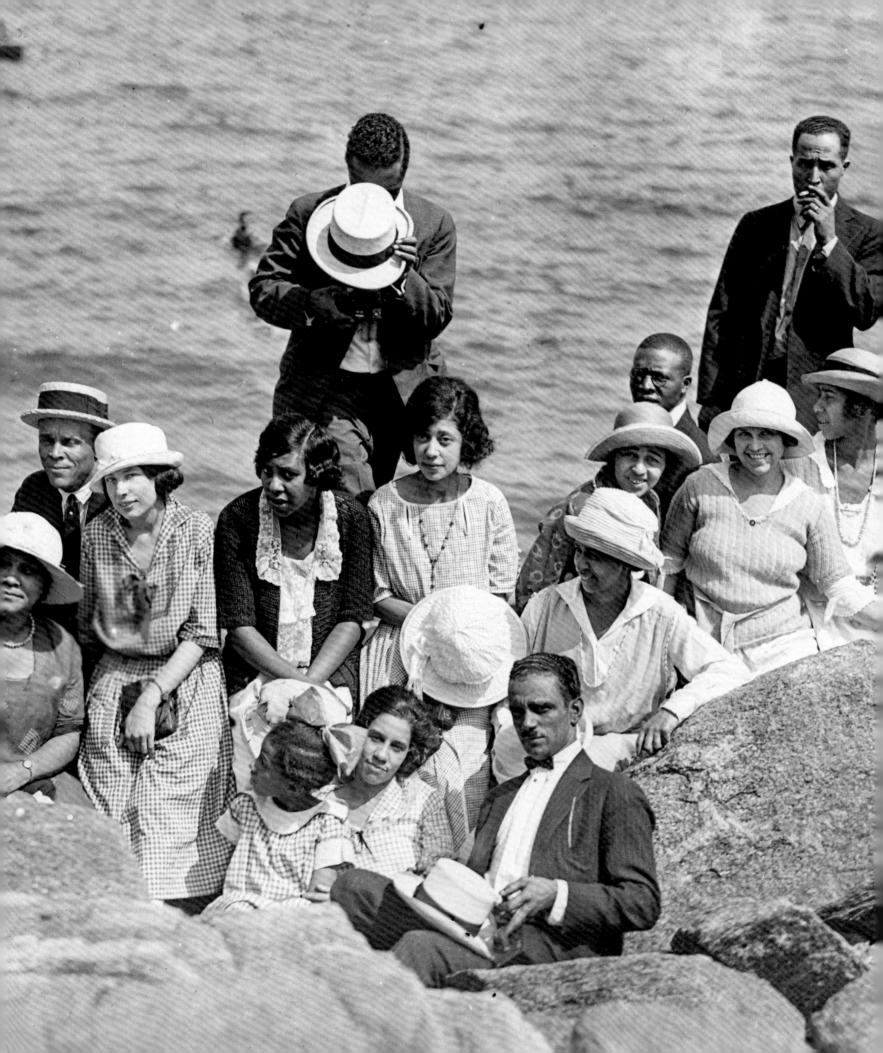

ACKNOWLEDGEMENTS

Brian Piper

Any project of this size requires the hands and minds of many folks. This research, exhibition, and catalog, have been the result of more than a decade of collective labor, and it feels like a futile effort to adequately acknowledge everyone that has helped shape what you hold in your hands right now. My one hope is that this project honors the lives and work of the photographers included herein. Any success in that endeavor is thanks to those named below (and more, that I will inevitably miss), and any errors are squarely my own.

At NOMA, I have been grateful for the support of Susan Taylor for realizing the importance of this inquiry, and for Lisa Rotondo-McCord's commitment and encouragement in seeing the project to fruition. An internal curatorial team that has included Mel Buchanan, Ndbuisi Ezeluomba, Katie Pfohl, Nic Aziz, Erin Greenwald, Anne Roberts, and Allison Young has been the source of creativity, inspiration,and guidance. Kennedi Andrus and Rebecca Villalpando provided crucial research and contributed greatly to NOMA's department of photographs. Chantelle Nabonne, Gabrielle Wyrick, Tracy Kennan, Connor Killian, Ilyanette Bernabel, Michelle Celestine, Kim McDowell, Ra'Jae Wolf, Trina Delpit, Charlie Tatum, Erin Voisin, Margaux Krane, Jenni Daniel, Kristen DiGioia, Mary Degnan, Jennifer Williams, and Kathryn Schneider have all contributed enthusiastically in ways that have improved the project. This is the book, but neither it nor the exhibition would have been possible without the dedication of Jennifer Ickes, Laura Povinelli, Nicole Sistrunk, Elizabeth Bahls, Tim Morales, Tao-Nha Hoang, Ingrid Seyb, Louise Neal, Travis Keene, Noelle Richard, Sam Hollier, and Alexander Buschman. Sesthasak Boonchai always came through with images on short time, and crucial counsel about how cameras and processes really work. Jonique Johnson brought unequaled passion, and clear eyes, to the project for which I am truly appreciative. From day one, Russell Lord has been a mentor and a confidant, sharing his ambitious and inspiring vision for the field of photographic history.

Photographer unidentified
James Van Der Zee making a photograph, (detail), 1925
Gelatin silver print

Over several years, this project has given me the opportunity to work with collectors who are passionate about photographs, and have contributed to this project in may ways. Robert Langmuir, Peter Cohen, and Dr. Stanley, Liz, and Jason Burns have been generous of their time and expertise, in addition to lending to the exhibition. Some special relationships have emerged, over time spent with Rodney Herenton and James Jaworowicz, researching the Hooks Brothers Studio Collection. This project has been made better by their trust and enthusiasm, which includes the support of Andrea Herenton. The city of Memphis is lucky to have their collective vision and stewardship in place to protect a rich and, as yet, understudied resource for the study of photography.

I owe a debt of gratitude to all of the artists included and this volume, but especially to Eric Waters, Selwhyn Sthaddeus Terrell, Alanna Airitam, Tiffany Smith, Endia Beal, Aaron Turner, Elliott Jerome Brown Jr., and Nolan Marshall, Jr. Your advice, insight, and important contributions to the field of photography enriched the project in ways I am still coming to realize fully.

This volume owes much to a team of great talent, creativity, and patience. Jon Key, Wael Morcos, Chuck Gonzalez, and everyone at MorcosKey have been a pleasure and inspiration to work with. Jennifer Ritner contributed steady, thoughtful and precise edits that elevated the text. You can read the rich and inspiring words of Carla Williams and John Edwin Mason here, but their concise essays belie the amount of time they have both given over to extended conversation in support of this project.

Called to the Camera has benefited from a circle of colleagues that provided scholarly counsel, correction, and direction. Emilie C. Boone, Anjuli Leibowitz, Amy Mooney, and Kara T. Olidge, all gave thoughtful comment on the working checklist and necessary themes. Dr. Pellom McDaniels was an early, and all-too-brief thought partner, whose influence remains. Clinton Fluker, Carrie Hintz, Gabrielle Dudley, Kathy Shoemaker, and the rest of the staff at the Stuart Rose Library at Emory University took extraordinary steps in support of the exhibition.

The exhibition benefited greatly from an Exhibition Advisory Committee that included Kayla Andrus, Malik Batholomew, Freddi Williams Evans, Delaney George, Ariel Wilson, Jari C. Honora, Jonique A. Johnson, Nolan A. Marshall, Barbara Waiters, and Ellene-Joi Whiley. You all taught me a great deal about the photographs in this volume, and your contributions to the interpretation of the exhibition materials and programming schedule have proven invaluable.

Both formally and informally, this project has benefitted from the advice of Julie T. Crooks, Seth Feman, Greg Harris, Michael Mery, Dalilah Scruggs, Nathaniel Stein, Micah Messenheimer, Lisa Volpe, Tuliza Fleming, David Haberstich, Makeda Best, Leslie King-Hammond, Eric Waters, Kalaamu Ya-Salaam, Shana M. Griffin, L. Kasimu Harris,

Arèsà, and Lisa Cates. Some fellow travelers - Wendy Korwin, Margaret Freeman, and Frank Cha – have been giving helpful feedback for years. Mikal Gaines has done the same, including insightful edits of this particular work.

Finally, my deepest thanks to Julie and Bill Piper, Corey Piper and Nina Patel for your constant encouragement. None of this would have been possible without the partnership of my wife, Dr. Elizabeth Neidenbach, whose knowledge and eye for detail kept things in line, and whose belief in empathetic and accessible historic and cultural work is a daily inspiration.

IMAGE CREDITS

Hooks Brothers Studio
Family in Front of Home (detail), ca. 1955
Gelatin silver print

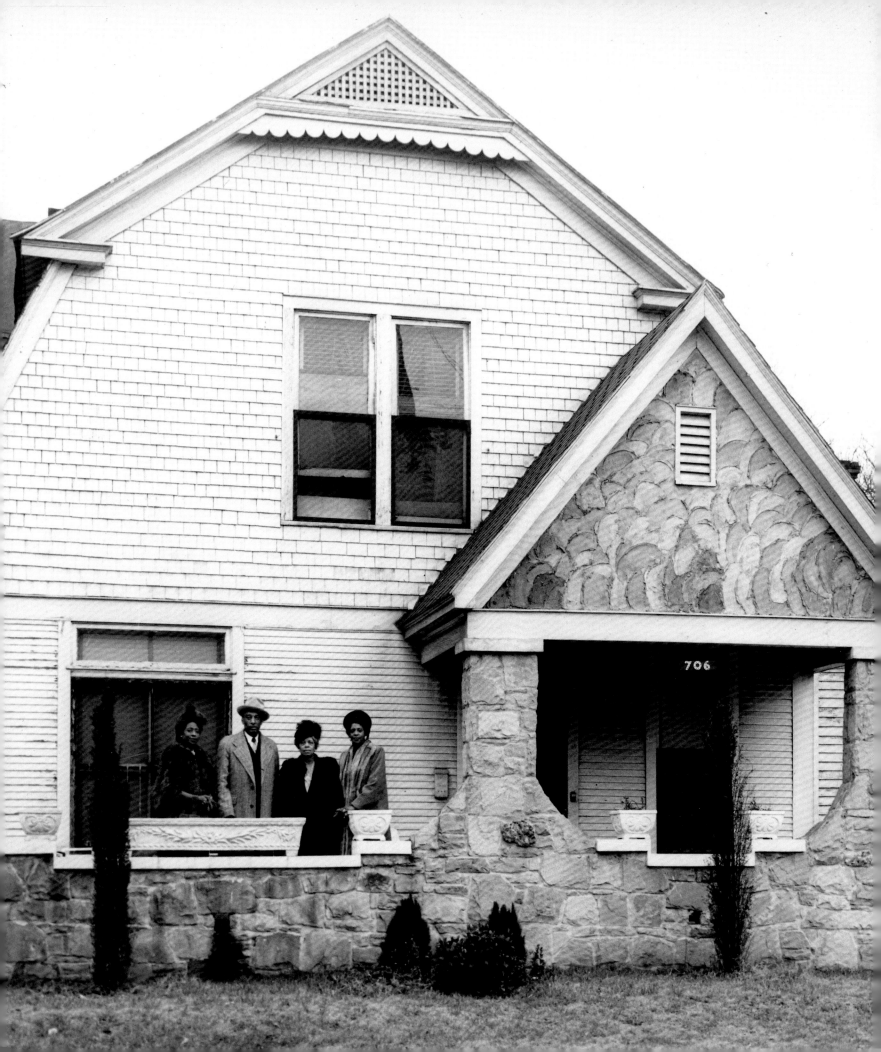